CRIPT AND VISUALS

AND // JOCK

LETTERING & ADDITIONAL EDITING
JOHN J HILL

ALEX GARLAND
INTRODUCTION

For over a year, there were four people working on Dredd. Allon Reich, Andrew Macdonald, Michael Elson, and me. Our challenge, as we saw it, was to make an edgy/trippy sci-fi movie for around 30 million dollars, that was appropriately faithful to the iconic British comic book character. Eventually, we reached a point where we felt we had a handle on how to make the film, but needed the addition of a new creative voice, who could define some of the key Judge/Mega-City One visuals.

That was pretty much the moment Michael came into the office and showed some illustrations that had appeared online, which were allegedly leaked official concept art for the Dredd movie. What interested Michael was not that the images were 'fake' concept art, but that the images were so good. Specifically, they had exactly the vibe/atmosphere we were aiming for. The artist turned out to be Jock, who had - unprompted - taken it upon himself to produce a few paintings of what he felt the film should look like.

I already knew of and greatly admired Jock. His range could be subtle, lyrical, bold, gritty, or muscular. The work had a breathing, living quality. They were beautifully drawn and observed, but not overworked to the point of stillness. He felt in the tradition of my childhood favourite Dredd artists - Carlos Ezquerra and Mike McMahon.

We immediately contacted him, and began a close and incredibly rewarding collaboration that lasted through the whole filmmaking process and, happily, beyond to the next project. Part of his huge contribution was a full-length comic-book version of the script, that we distributed to everyone from financiers to crew. His paintings and sketches were one of the quickest and most effective way of conveying the look and tone of the project. When - a very long time later - the picture was locked, I could see his input had pervaded the film at all levels.

As a kid, my favourite film books were the ones that showed concept art. I was fascinated by the through-line from the paintings to the final photography. I was never much interested in the words. I recommend the same approach to purchasers of this book.

Alex Garland

JOCK
INTRODUCTION

Judge Dredd was the comic that I read growing up - it was the comic that made me want to pursue drawing as a living and, in fact, was my first professional work too.

He's been pretty good to me over the years.

I was just finishing a stint as concept artist on a since-aborted adaptation of Frank Herbert's *Dune*, when I heard that the new *Judge Dredd* film was officially going ahead.

Firmly in concept mode, I drew three pieces of art based on my imagined 'real world' version of Dredd. I posted one of them online and was horrified to discover it was picked up by a website as official art from the new movie. Subsequently the art spread across all the major news sites, with them claiming it was a glimpse into pre-production of the new film.

What wasn't so bad was the response was very positive – everyone seemed to want a good Dredd film and they saw my art as a good omen.

I got a call from executive producer Michael Elson from the DNA offices – they had seen the art and would I be interested in working on the project?

I'm a great believer in making your own luck, but this was by far the most direct example I'd ever experienced.

My first meeting in London was with producers Andrew Macdonald, Allon Reich, and writer Alex Garland. I had a lot of respect for DNA and the films they made; they always had an interesting level of reality and integrity that got me hugely excited about the prospect of DREDD being in their hands.

I wasn't disappointed. Alex's vision for the film was so strong and distinct, a very direct introduction into the world of Dredd and Mega-City One. We produced a comic of the script and settled on a fairly loose style – somewhere between finished comic art and a storyboard that would get all the relevant information across in a timely manner.

While working in this quicker style I wasn't visualising some sequences as well as I felt I could, so I started painting environments and costumes too. This led to my work being extended into pre-production concept and costume design, all of which you'll find in this volume.

There were many others that contributed to the final look of DREDD on screen. In particular Neil Miller, who painted staggering concept shots and matte paintings of the city, and costume designer Michael O'Connor who realised the uniform – but I'm very proud to have been around in those early stages of production.

I still get such enthusiastic responses from people about the film so it's very gratifying to see my work now compiled in this book. I hope you enjoy what I think is a pretty unique insight into the realisation of DREDD – from script to screen.

Jock

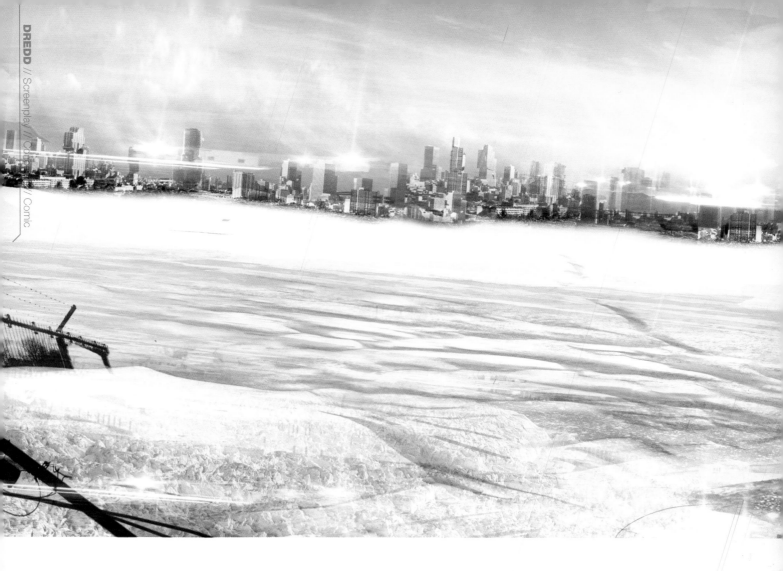

PEACH TREES

V.08

OPEN ON:

Desert.

EXT. CURSED EARTH - DAY

Blasted rock and dust, as far as the eye can see.

> **VOICE OVER**
>
> America is an irradiated wasteland. A Cursed Earth, in which a single outpost of civilisation remains. Stretching from Boston to Washington ...

EXT. CURSED EARTH/MEGA-CITY ONE - CONTINUOUS

A vast walled city appears on the horizon.

> **VOICE OVER**
>
> ... Mega-City One.

EXT. MEGA-CITY ONE - CONTINUOUS

We fly over the city.

On first glance, it looks comparable to its early twenty first century counterpart. A sprawl of low-rise buildings, with clusters of tall skyscrapers.

But as we get closer, we realise that what looked like low-rise buildings are in fact skyscrapers, and what looked like high rise buildings are in fact the MEGA BLOCKS.

Brutal concrete monoliths, jutting up out of pollution haze. Each operates like a self-contained town. The higher levels are residential, housing tens of thousands. On the lower levels, there are schools, med centers, shops, restaurants, bars, and recreational facilities.

Over this view of MEGA-CITY ONE ...

FADE TO -

INT. HALL OF JUSTICE

In a darkened room, with single light source, a man is putting on a uniform.

In the darkness and artfully positioned lighting, his face is always hidden in total shadow.

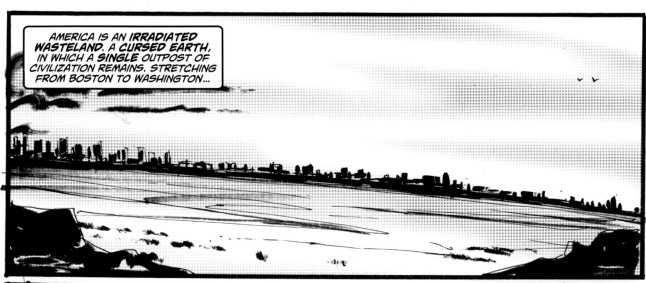

AMERICA IS AN *IRRADIATED WASTELAND*. A *CURSED EARTH*, IN WHICH A *SINGLE* OUTPOST OF CIVILIZATION REMAINS. STRETCHING FROM BOSTON TO WASHINGTON...

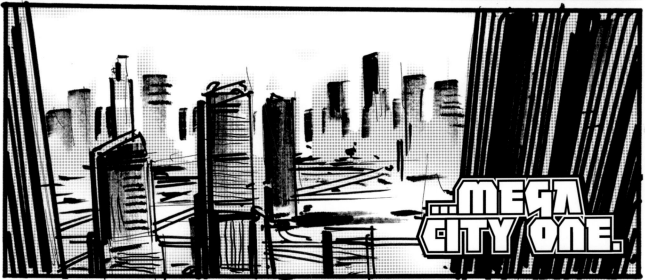

...MEGA CITY ONE.

SNAP

GICK

CHANK

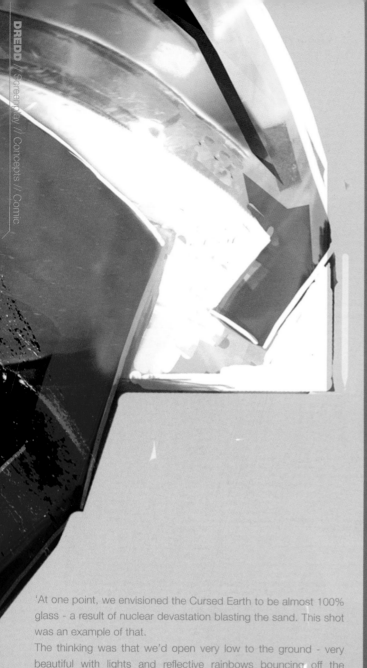

We see him -

- zipping up boots.

- clipping on utility belt.

- pulling on gloves.

- picking up his LAWGIVER GUN.

As DREDD'S fist closes around it, an LED light by a small digital display flashes red.

Then, on the digital display, a message appears:

ID OK

The LED turns green.

He holsters the weapon.

Finally, he pulls his helmet down over his head.

Now he moves in such a way that the light falls on his face.

The top half of his features are hidden below a visor. The lower half, his mouth and chin, look as if they have been carved from rock.

Title:

DREDD

'At one point, we envisioned the Cursed Earth to be almost 100% glass - a result of nuclear devastation blasting the sand. This shot was an example of that.
The thinking was that we'd open very low to the ground - very beautiful with lights and reflective rainbows bouncing off the surface. A slightly surreal start that would be in stark contrast to the harsh reality of Mega-City One.' - Jock

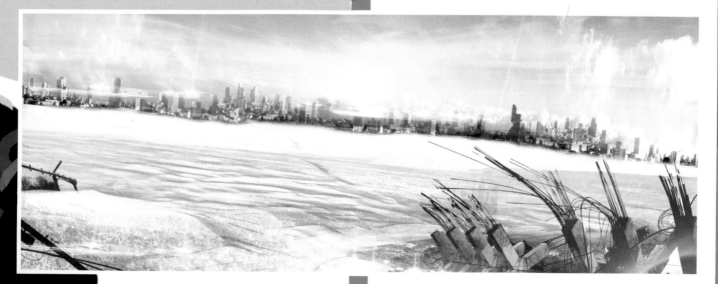

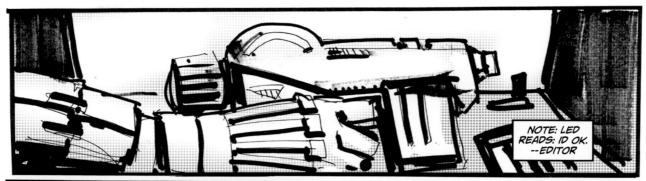

NOTE: LED READS: ID OK. --EDITOR

9

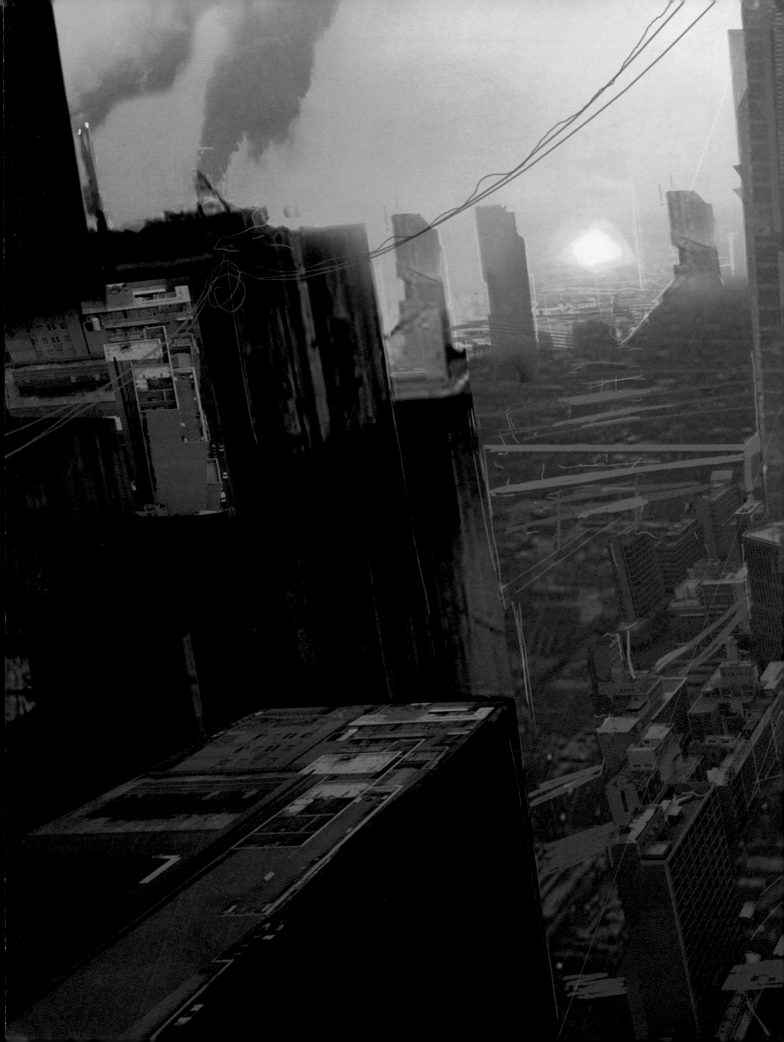

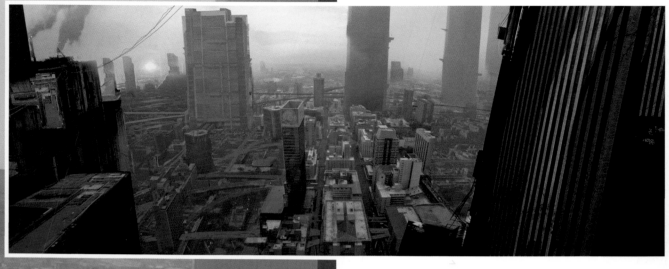

'One of many painted over location images. The producers scouted around South Africa, taking photos of possible destinations and I'd be sent the shots, to expand and develop as possible Mega-City vistas.

It was interesting building on what already existed, forcing the approach to be credible and grounded in reality.' - *Jock*

CUT TO -

EXT. MEGA-CITY ONE/ROAD - NIGHT

- a ribbon of road, through a canyon of mega blocks.

DREDD rides down it, on a huge, fat-wheeled motorbike.

His fist twists the throttle.

As he accelerates, we SWING AROUND to reveal -

- DREDD is in hot pursuit of a vehicle.

The pursuit takes place in the tunnels beneath and through the mega blocks, and the open stretches of road and fly-overs between.

DREDD

Dredd to Control. In pursuit of vehicle, sector thirteen, moving west up Wagner Drive. Driving erratic. Suspect driver is under influence of narcotics.

CONTROL

(over radio)

Copy, Dredd.

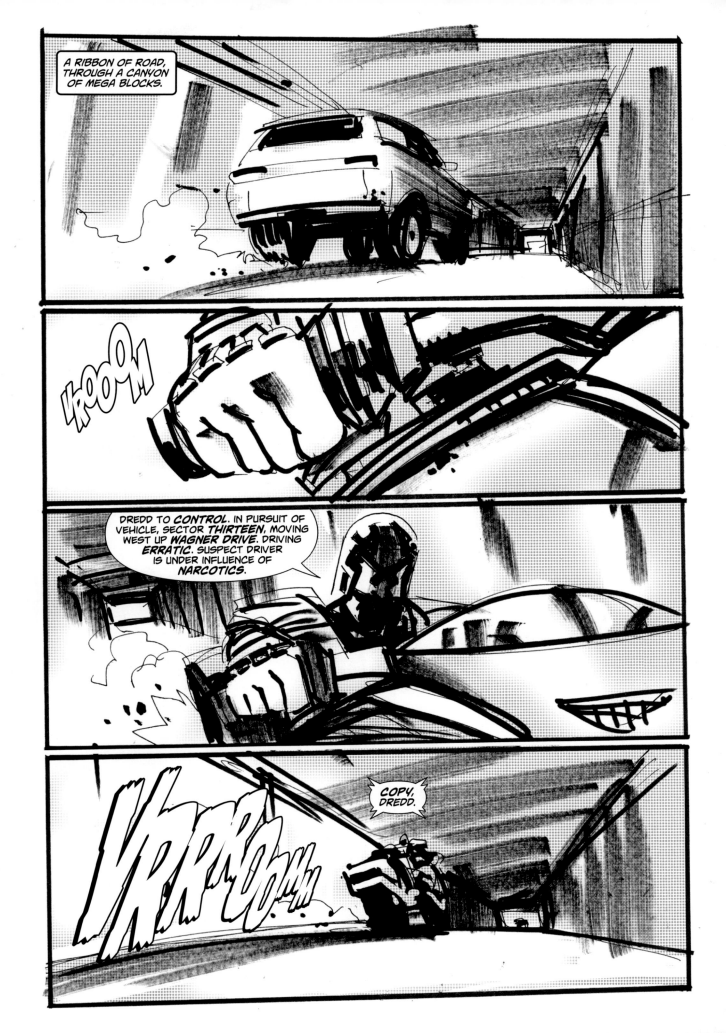

CUT TO -

INT. VEHICLE - CONTINUOUS

INSIDE THE VEHICLE -

- suddenly everything is in SLOW MOTION, and the colours are unnaturally IRIDESCENT and BRIGHT.

Inside, are three men. The DRIVER, the PASSENGER beside him, and a third man in the back seat -

- who is jamming a clip into a small MACHINE GUN.

The DRIVER turns in his seat, shouting something at the man behind -

- but the words are too slow and slurred for us to understand.

THEN the slow motion abruptly starts to speed up, and the colours start to lose their sparkle - returning to normal.

We can now understand what the DRIVER is shouting.

> **DRIVER**
>
> - *we've got* a *judge on our tail! Take him out* or *we're dead fucking meat!*

The SHOOTER takes a long hit on a small device like an asthma INHALER. On the side of the inhaler are the words SLO-MO.

As soon as *the SHOOTER takes the hit from the inhaler -*

- the slow motion and iridescent colours return.

CUT TO -

EXT. MEGA-CITY ONE/ROAD - CONTINUOUS

- outside the VEHICLE, as the SHOOTER leans out of the window of the vehicle ...

... and starts FIRING his machine-pistol at DREDD.

> **CONTROL** (over radio)
>
> Do you require back up?
>
> **DREDD** (into radio)
>
> No.

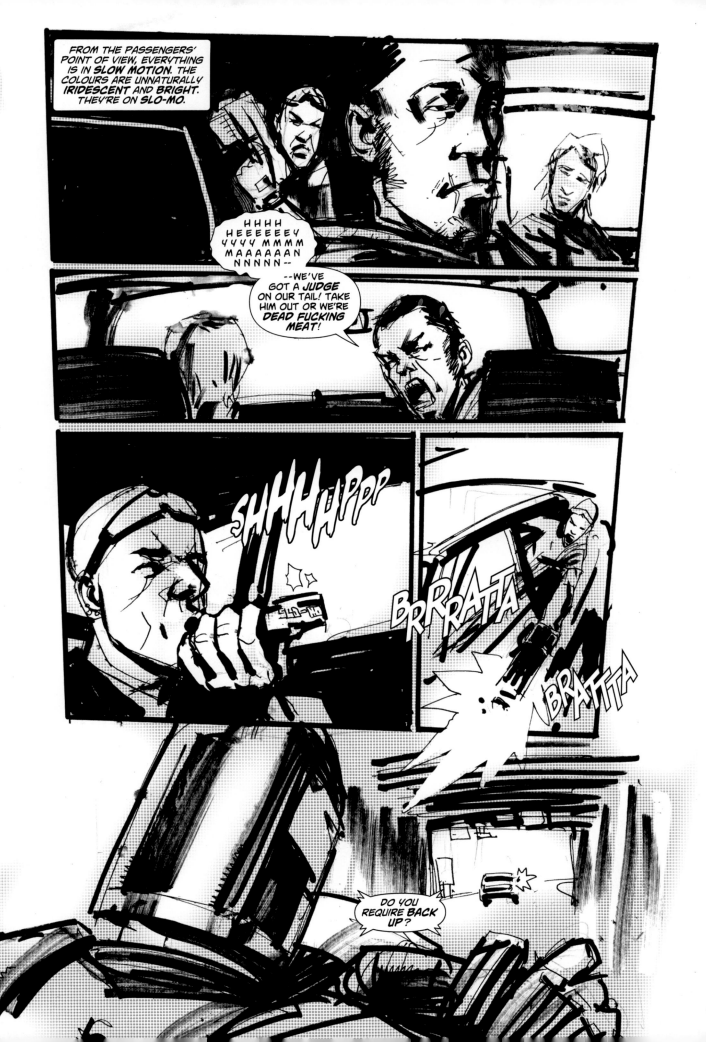

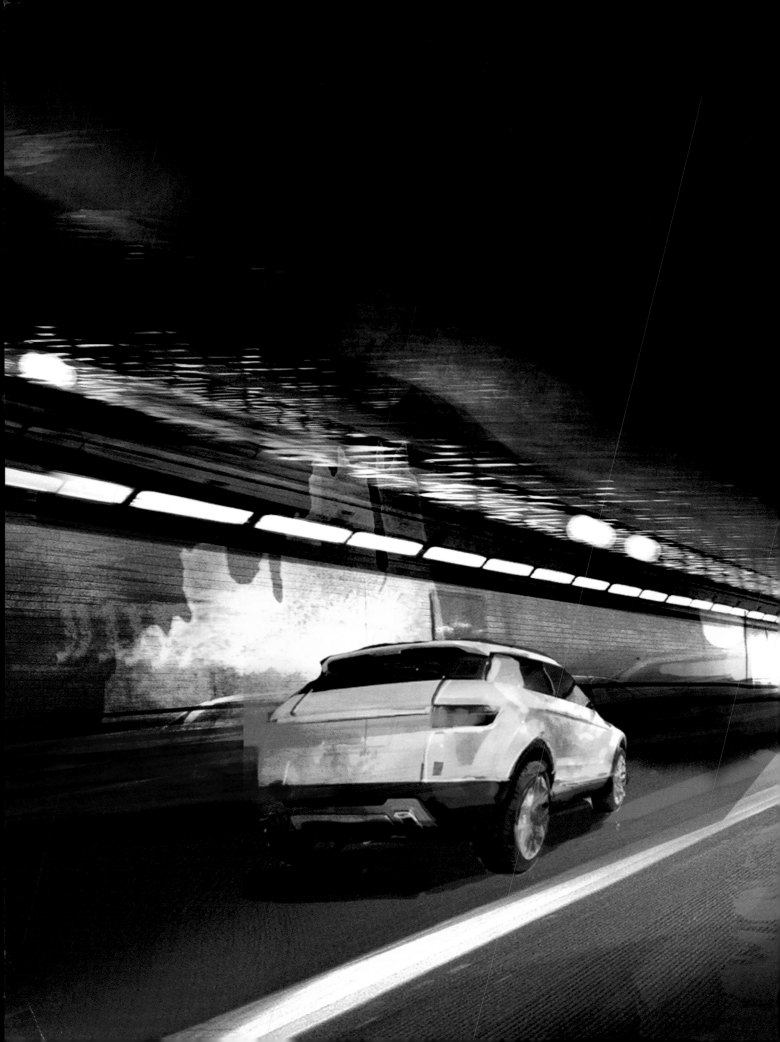

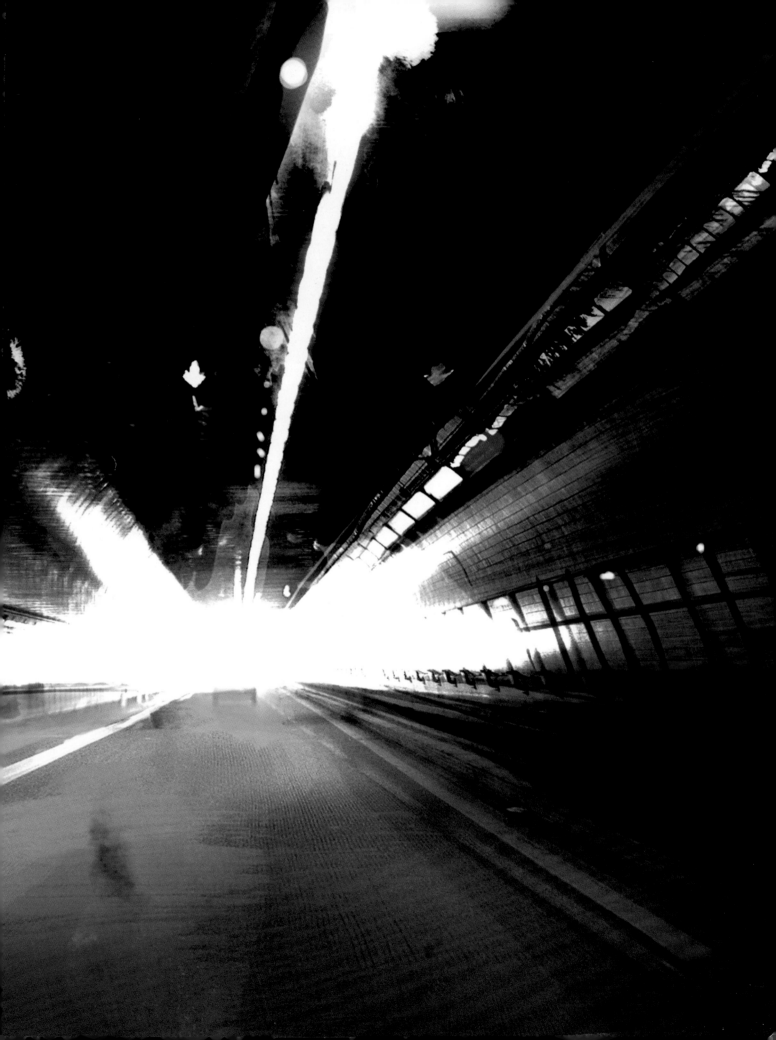

INT. VEHICLE - CONTINUOUS

Inside the vehicle, seen through the psychedelic filter of the narcotics, we see the driver swerve to avoid an oncoming vehicle.

In doing so, he mounts the pavement, and -

- a PEDESTRIAN slams against the front windscreen.

Then is sucked downwards, and dragged beneath the wheels.

'Concept car. This was based on a Range Rover that at the time wasn't available. Now you see them everywhere on the streets! Again, I tried to keep it feasible and real. Nothing too cliched sci-fi or fanciful.' - *Jock*

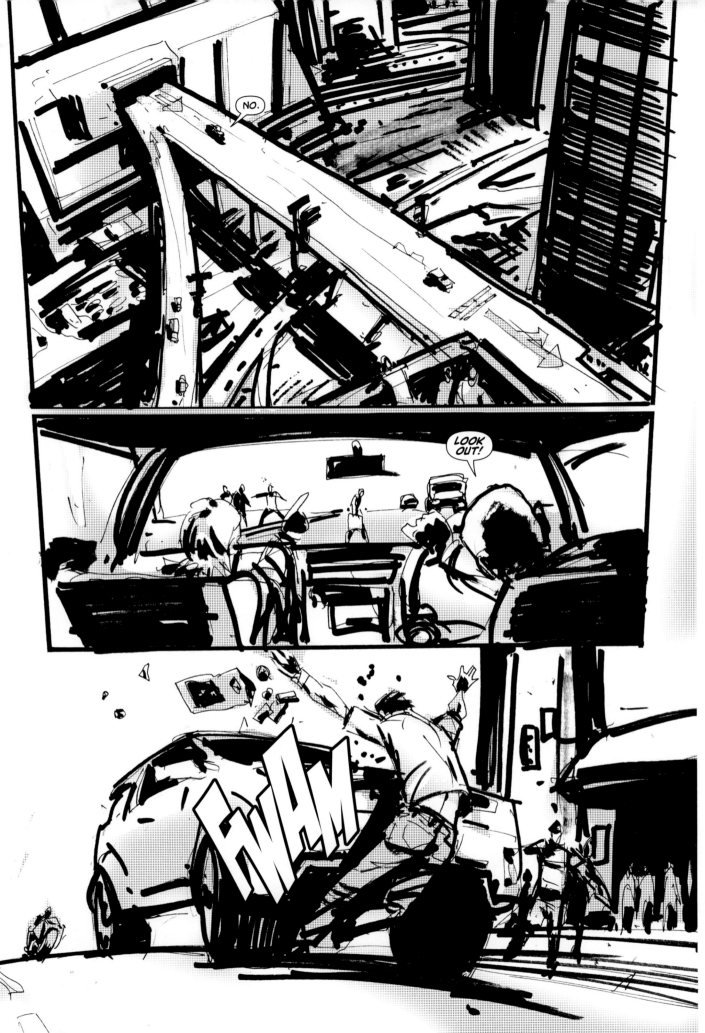

CUT TO -

EXT. MEGA-CITY ONE/ROAD - CONTINUOUS

- DREDD.

DREDD

Control. The perps just wiped out an innocent. I'm taking them out.

CONTROL

(over radio)

Copy.

FROM THE FRONT OF DREDD'S MOTORBIKE -

- twin canons either side of the front wheel suddenly blaze into life.

Bullets rip into the vehicle, blowing out its back tyres.

It is immediately thrown into a skid, slides sideways, then starts to roll.

CUT TO -

INT. VEHICLE - CONTINUOUS

- inside the vehicle, in BRIGHT COLOURS and SLOW MOTION, as it rolls.

LAWGIVER EVOLUTION

First pass at the Lawgiver. This is pretty close to the Mark II design from the comic, but the decision was made to lose the dial and lights. Moving forward I tried to keep the basic feel of this shape but augmented with different ideas.

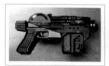 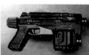 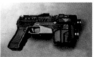

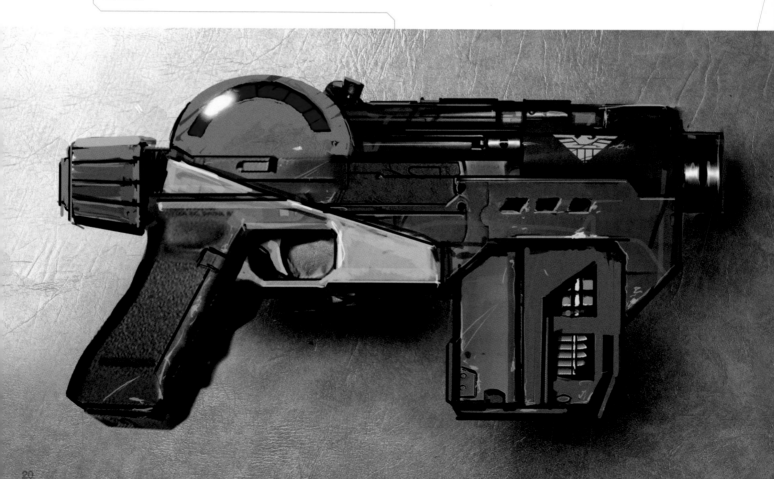

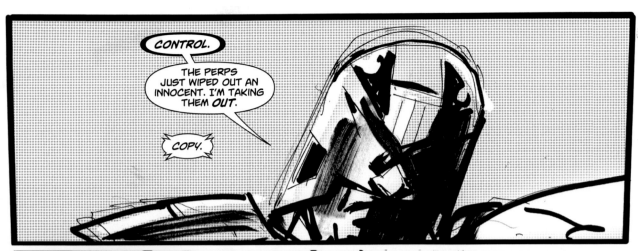

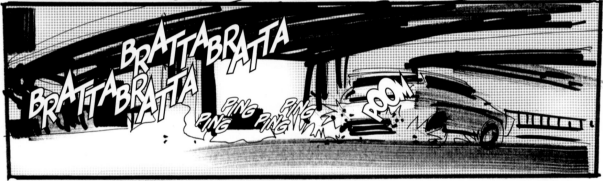

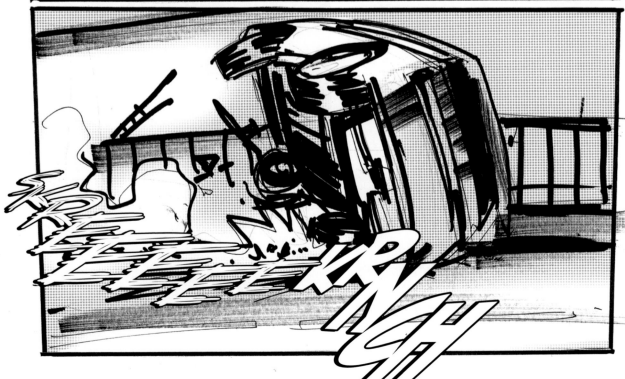

CUT TO BLACK.

Then FADE UP TO -

- inside the wreckage of the vehicle. Normal speed. Normal colours.

The vehicle is upside down.

The DRIVER is still strapped into his seat, impaled on the broken steering column, twitching.

Blood runs down from the DRIVER onto the corpse of his PASSENGER, who is crumpled up, limbs unnaturally folded like a child's doll.

The only living occupant is the SHOOTER.

He picks himself up and wipes blood from his eyes.

EXT. MEGA-CITY ONE/ROAD - CONTINUOUS

DREDD approaches the wreckage of the vehicle, handgun drawn.

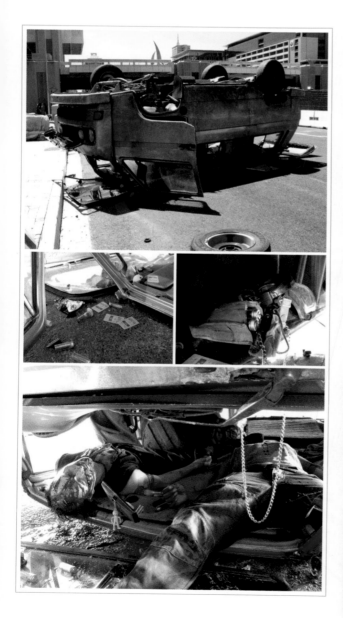

'You should be able to tell it's Dredd, just from his silhouette. Hard to pull off with a practical costume.' - Jock

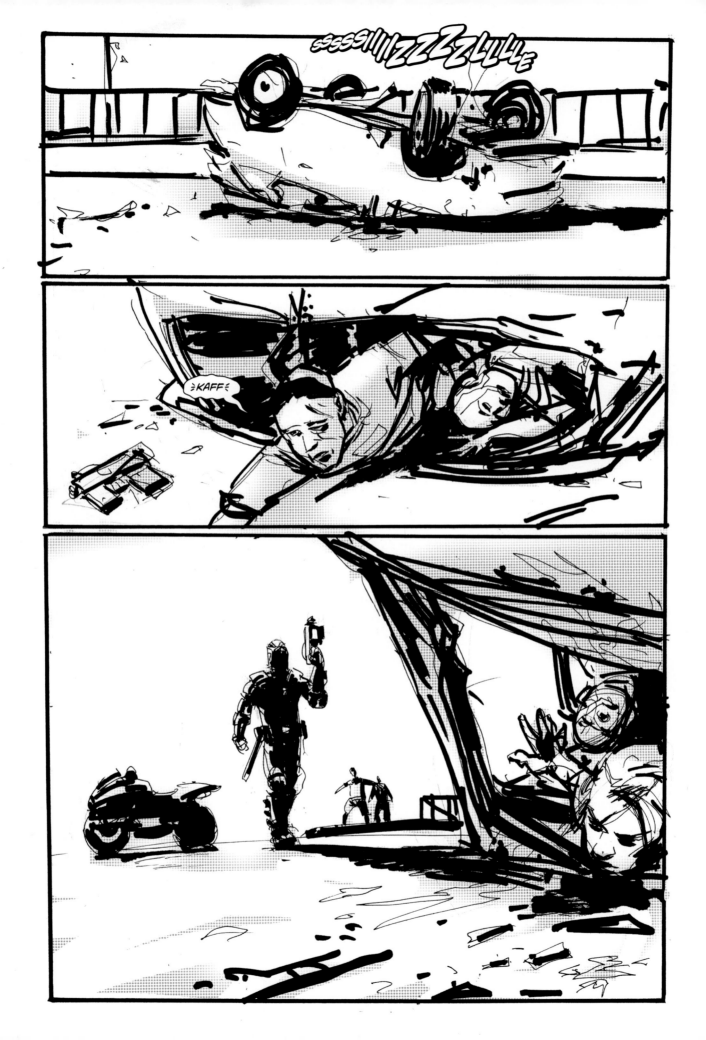

He pulls open the side door, and sees, past the bodies of the DRIVER and the PASSENGER, the opposite window.

Which has been kicked out.

And through the hole, DREDD spots the SHOOTER, sprinting towards the pedestrian entrance of a habitation block.

CITIZENS are thronged around the entrance, and the SHOOTER fires into them to clear a path.

DREDD steps around the side of the wrecked vehicle, talking into his radio:

> **DREDD**
>
> Paramedics to my GPS. We have citizens down.

DREDD lifts his gun.

We see what DREDD is aiming at.

The figure of the SHOOTER appears in glimpses through the crowd. Flashing in and out of view.

To pick him off from here, through the shifting layers of innocent people, would be an incredible shot.

But DREDD is clearly going to take it.

> **DREDD** (CONT'D)
>
> Armour piercing.

A setting on his firearm changes,

He holds the gun level, completely still, waiting for the right moment.

Then fires - just a single round.

A muzzle flash.

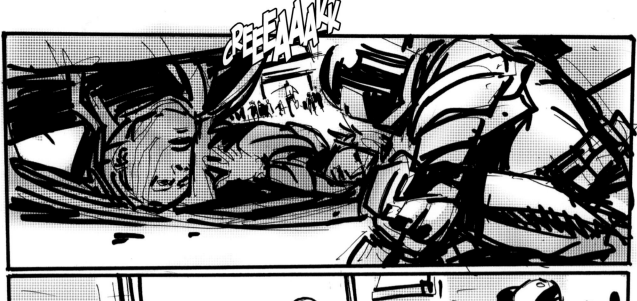

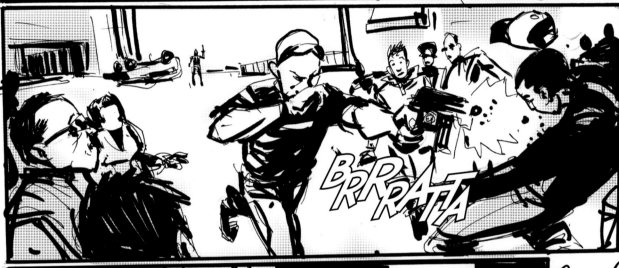

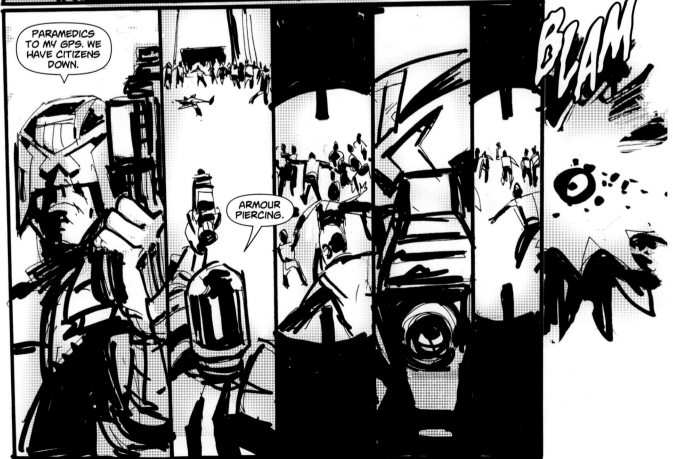

Halfway between DREDD and the SHOOTER, a WOMAN drops, with a puff of blood erupting from her shoulder.

And a split second later, the SHOOTER himself pitches forwards, hit in the back.

At the noise of the gunshot, the crowds scream and scatter.

DREDD moves forwards, gun still raised.

He passes the WOMAN who was hit, who is lying on the ground in a spreading pool of blood, flapping her arms weakly.

> **DREDD** (CONT'D)
>
> Remain calm. The bullet missed all major organs, and a paramedic team will be with you shortly.

He keeps moving.

To the SHOOTER.

EXT. OUTSIDE BLOCK - CONTINUOUS

The SHOOTER is alive, lying on his front, leaving a snail-trail of blood as he pulls himself forwards, still hopelessly trying to escape.

DREDD kicks the man's gun out of reach, then reaches down and flips him over on to his back.

The SHOOTER tries to speak, but his mouth is filled with blood, and no words come out.

DREDD uses his free hand to check the SHOOTER'S inside pockets.

Then finds what he is looking for. An ID card.

DREDD checks it.

> **DREDD**
>
> Citizen zwirner. Your crimes are homicide, unauthorised use of a firearm, attempted murder of a judge. Do you have anything to say in your defense?

More blood bubbles out of ZWIRNER'S mouth.

> **DREDD** (CONT'D)
>
> Defense noted.

DREDD levels his gun at ZWIRNER'S head.

> **DREDD** (CONT'D)
>
> Sentence: death.

ZWIRNER gazes up at DREDD, and the gun barrel aiming down at him.

Then DREDD fires.

A single shot. Right between ZWIRNER'S eyes.

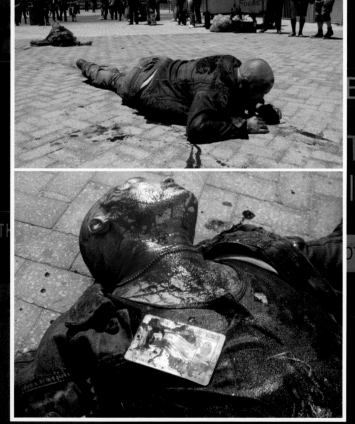

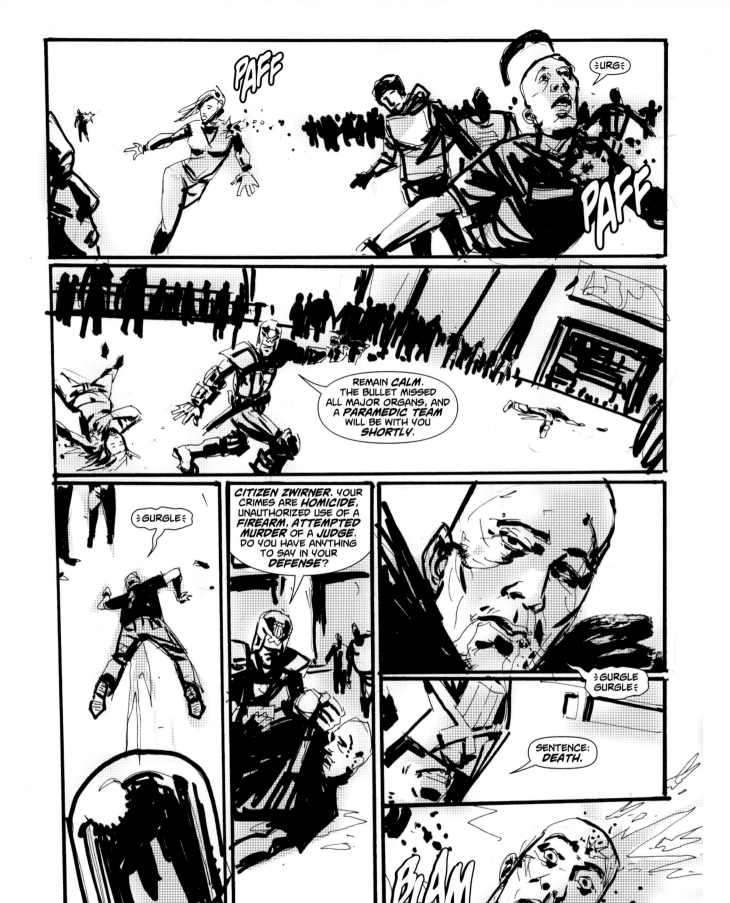

ANDERSON

MC01

3 in

Unused rookie badge design by
the Production Department

A beat. Then DREDD'S radio fuzzes back to life.

CONTROL

Control to Dredd. Come in.

DREDD

Dredd here.

CONTROL

Is your pursuit resolved?

ZWIRNER lies dead at DREDD'S feet.

Behind him, the wounded WOMAN flaps around.

Behind her, the wrecked vehicle smoulders.

DREDD

Yes.

CONTROL

Report back to the Hall Of Justice. The Chief Judge wants to
see you.

CUT TO -

**INT. HALL OF JUSTICE/OBSERVATION ROOM -
CONTINUOUS**

- a girl in her early twenties, in judge's uniform, minus helmet.

She is an immediate contrast with everything we have so far
seen of the grim world of Mega-City One.

Beautiful, blonde, and slightly vulnerable. Biting her lip as she
sits on a chair in a featureless room.

Opposite her is a mirror.

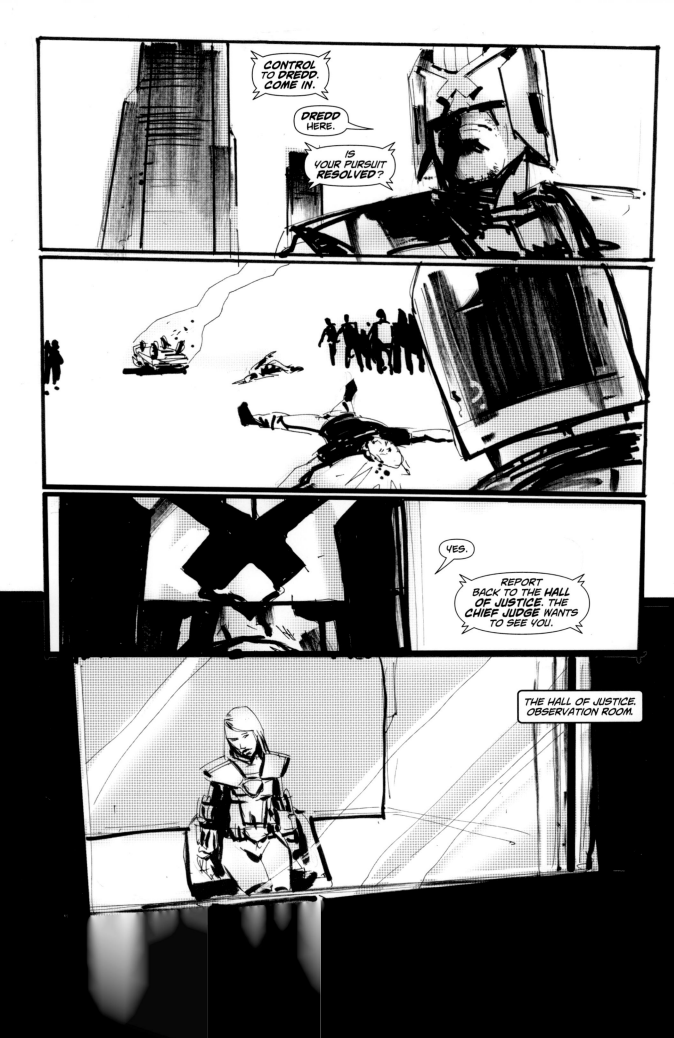

INT. HALL OF JUSTICE/OBSERVATION ROOM - CONTINUOUS

On the other side of the two-way mirror, DREDD and the CHIEF JUDGE, a woman in her fifties, look back at the girl.

CHIEF JUDGE

Cassandra Anderson. Twenty one. Born in a block one hundred metres from the radiation boundary wall. At seven years old, she lost both parents to residual-fallout cancer. As is standard with orphans, she was given a judge aptitude test at age nine. It classified her as unsuitable, but she was entered into the Academy on special instruction. In the Academy, her record was never better than borderline. The final Academy score put her three percentile points below a pass.

DREDD

So what's she doing in a uniform?

The CHIEF JUDGE doesn't answer.

Instead, she reaches out, and presses the INTERCOM button.

CHIEF JUDGE

Rookie Anderson.

ANDERSON

Sir.

CHIEF JUDGE

How many people are observing you?

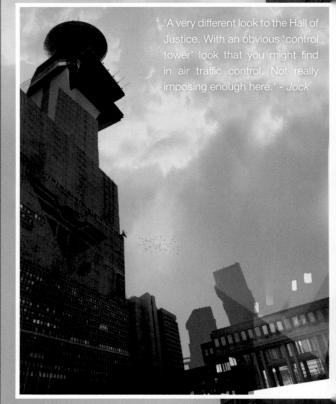

'A very different look to the Hall of Justice. With an obvious 'control tower' look that you might find in air traffic control. Not really imposing enough here.' - *Jock*

Justice Department vehicles and locations

MEGA-CITY ONE JUSTICE DEPARTMENT

JUSTICE
MC01

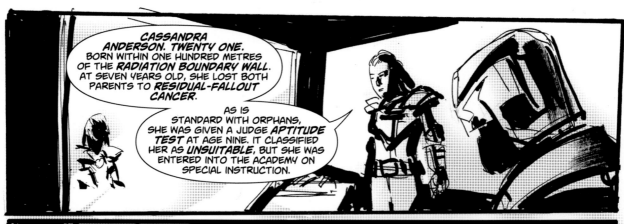

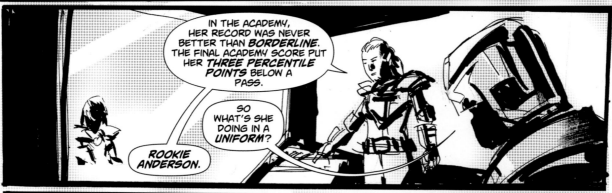

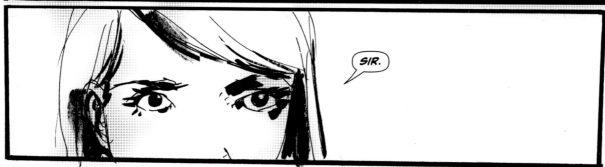

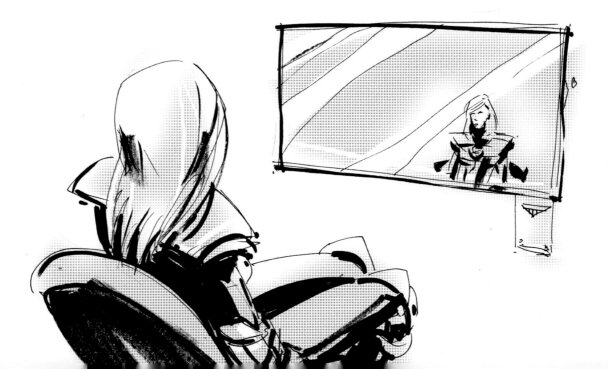

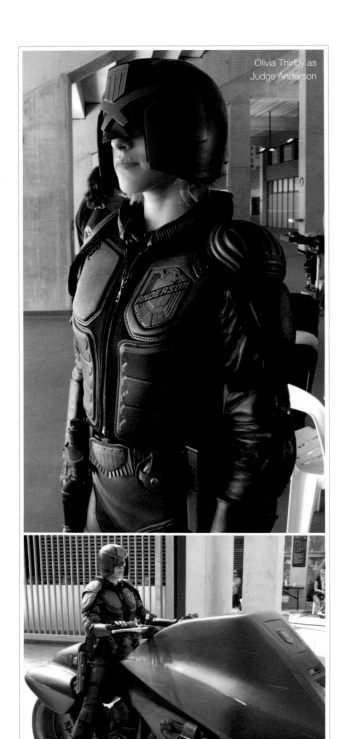

Olivia Thirlby as Judge Anderson

INT. HALL OF JUSTICE/OBSERVATION ROOM - CONTINUOUS

ANDERSON continues looking at her reflection, frowning slightly. Biting her lip a little harder.

ANDERSON

Two.

INT. HALL OF JUSTICE/OBSERVATION ROOM - CONTINUOUS

DREDD reacts.

CHIEF JUDGE

(into intercom)

What can you tell me about the person I am with?

ANDERSON

(through intercom)

Male.

CHIEF JUDGE

(into intercom)

Good.

ANDERSON

(through intercom)

Another judge.

(concentrating harder)

I can feel anger. And control. But there's something else. Behind the control. Something almost .. ~

CHIEF JUDGE

(cuts in)

Okay, Anderson. That'll do.

The CHIEF JUDGE switches the intercom off.

DREDD

A mutant.

CHIEF JUDGE

The most powerful psychic we've ever come across - by a huge margin. We believe she could be a major asset.

Beat.

CHIEF JUDGE (CONT'D)

As I said. Her final score was only three points below a pass. It's marginal.

DREDD

It's not marginal. She failed.

CHIEF JUDGE

The girl's getting one more chance. I want you to take her out and give her one day in the field. Supervised. To see if she makes the grade.

The CHIEF JUDGE turns to DREDD.

CHIEF JUDGE (CONT'D)

Sink or swim. Chuck her in the deep end.

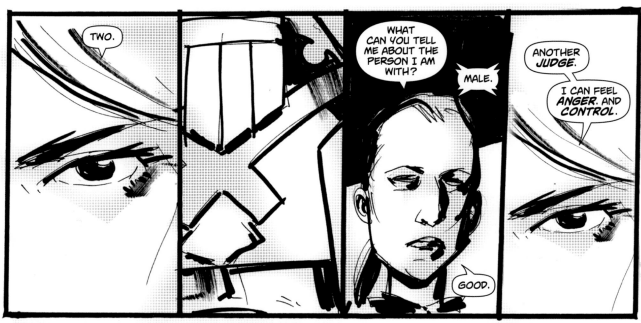

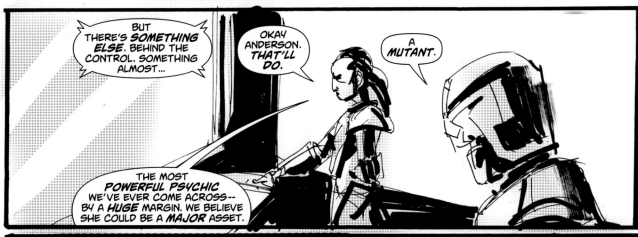

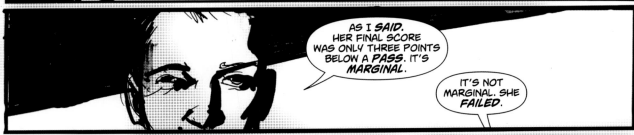

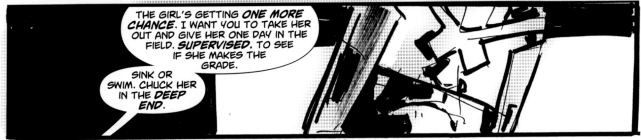

On DREDD, unreadable:

DREDD

It's all the deep end.

Then CUT TO -

INT. HALL OF JUSTICE/OBSERVATION ROOM - CONTINUOUS

- ANDERSON.

She sits quietly. Gazing at something in her hands.

It's a photo. Slightly battered. It shows a little blonde girl, seven years old, smiling, between both her parents. All are smiling at the camera.

Abruptly, she folds the PHOTO and tucks it into her utility belt.

Then turns to look at the door.

A second later, it opens, revealing DREDD.

ANDERSON stands immediately, and salutes.

DREDD enters, and closes the door behind him.

A beat.

Then:

DREDD

A rookie judge on assessment is likely to be involved in armed combat. They may be required to carry out on the spot executions of convicted felons.

ANDERSON

Yes, sir.

DREDD

Incorrect sentencing is an automatic fail. Not obeying a direct order from your assessment officer is an automatic fail. Losing your primary weapon or having it taken from you is an automatic fail.

ANDERSON

Yes, sir.

DREDD

You ready for this.

ANDERSON

I am.

A beat.

Then DREDD nods.

DREDD

Your assessment starts now.

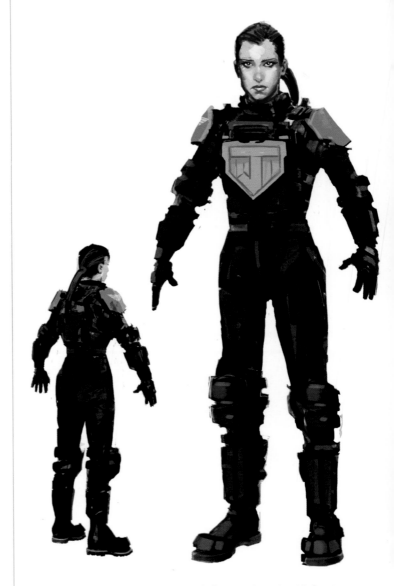

'An early Chief Judge idea - an obvious nod to the McGruder character from the comics. Alex was very happy about that at the time, but ultimately casting went in a different direction.' - *Jock*

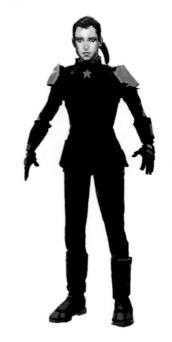

Rakie Ayola as the Chief Judge

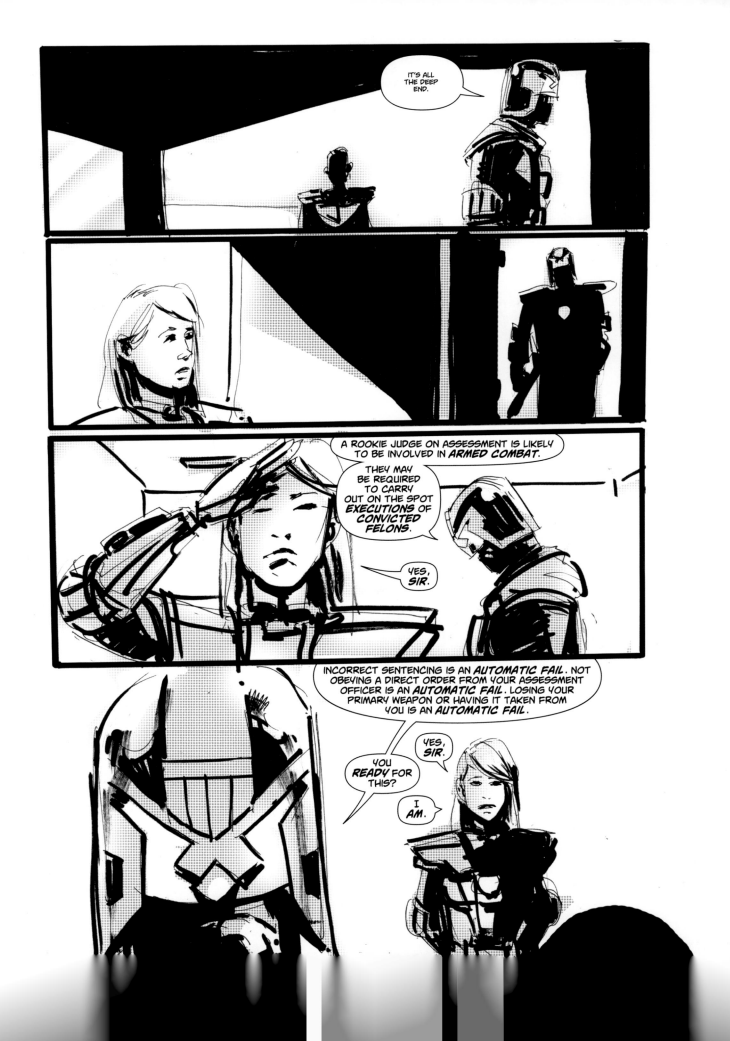

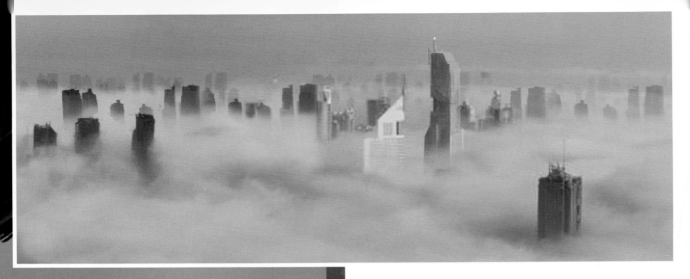

'I really liked this "city in the clouds" look, but it was immediately shot down as being too fairy tale. Mega-City couldn't be a fantasy city. It had to be brutal and real.'
- *Jock*

EXT. MEGA-CITY ONE - DAY

An airborne view of the city.

EXT. PEACH TREE BLOCK - CONTINUOUS

CLOSE UP on a SKATEPARK, concrete, surrounded by a high wire mesh fence, half-pipes and rails, where six SKATERS are pulling off some impressive arial moves.

As one of the SKATERS soars, and revolves a neat 720 spin -

- we reveal the vertiginous drop on the other side of the wire fence.

The SKATE PARK is bolted on the side of a mega block, hundreds of feet in the air.

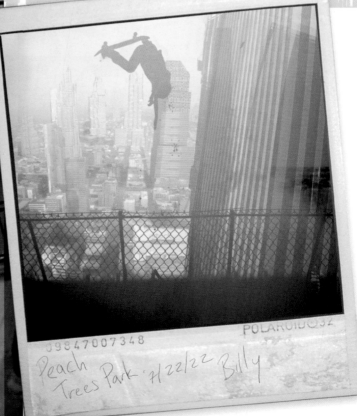

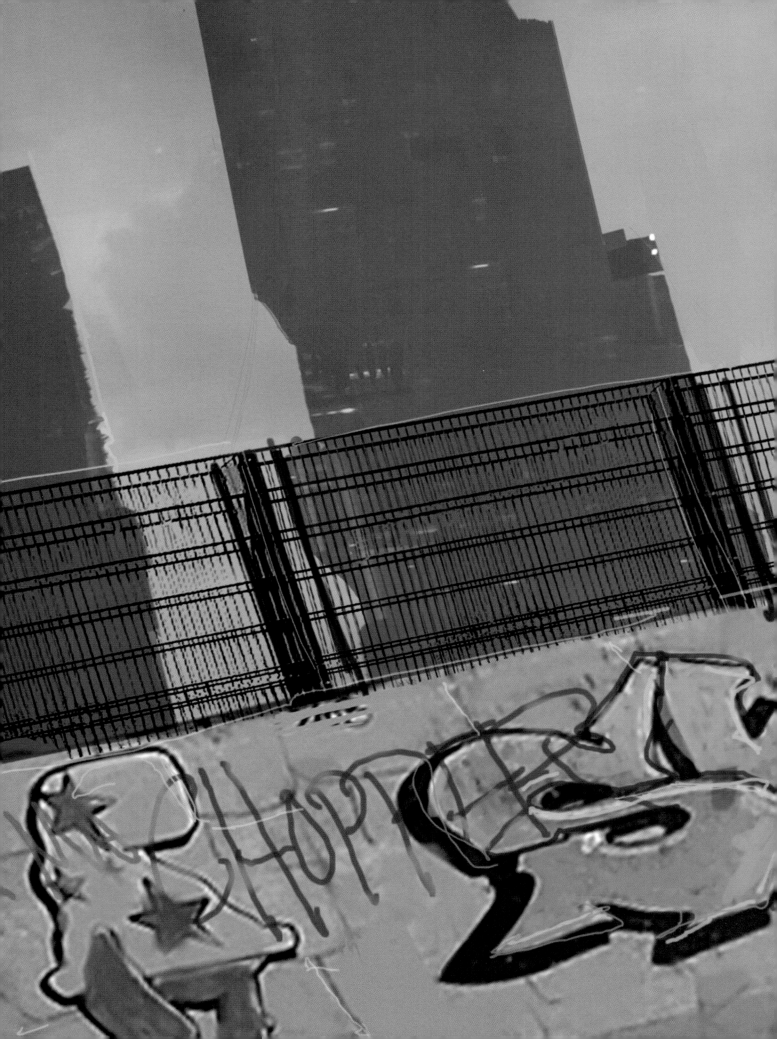

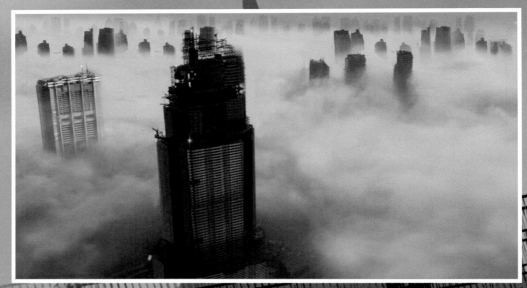

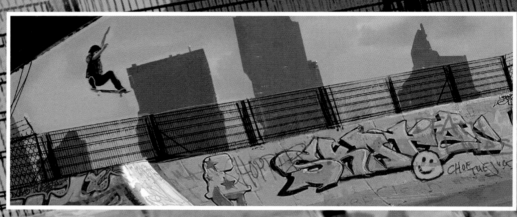

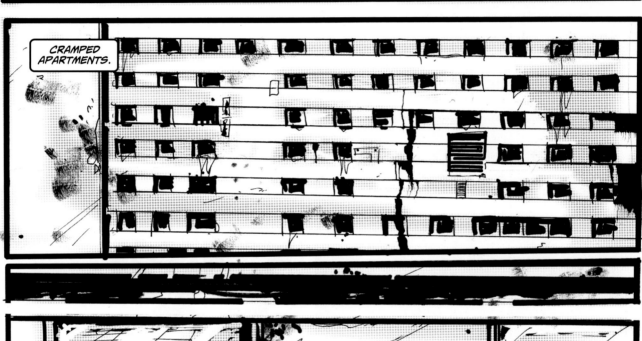

CRAMPED APARTMENTS.

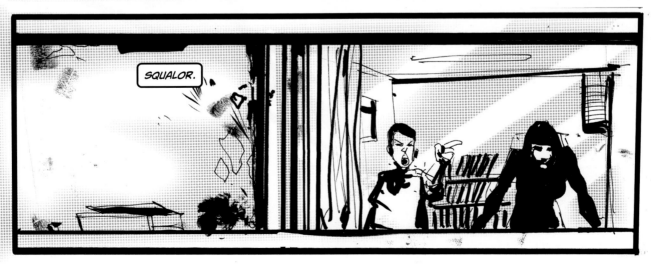

SQUALOR.

This particular block is called PEACH TREES. Named in luminous peach lettering, etched into the acid-rain and fume-stained concrete flanks.

The scale of the construction is colossal. Leaving the park behind, we start moving past windows, we glimpse the lives inside. Cramped apartments. People watching television. Sleeping. Eating. Having sex. Or simply absent.

The only common factor between the lives we see is squalor, and poverty.

Peach Trees is a slum.

EXT. PEACH TREE BLOCK/WINDOW - CONTINUOUS

We eventually settle on a single window, at the top level of the block.

Looking out of the window is a woman. She could be in her late fifties or early sixties, but a diagonal stripe scar that disfigures her cheek and top lip, and heavy make-up, make her precise age hard to place.

This is MA-MA.

'One idea for Ma-Ma was that she could be played by a man, dressed as a woman. Actors' names were even mentioned, but in the end it went to Lena Headey, who did a great job. It would have been an interesting choice, though, adding an extra unhinged element to the character.' - Jock

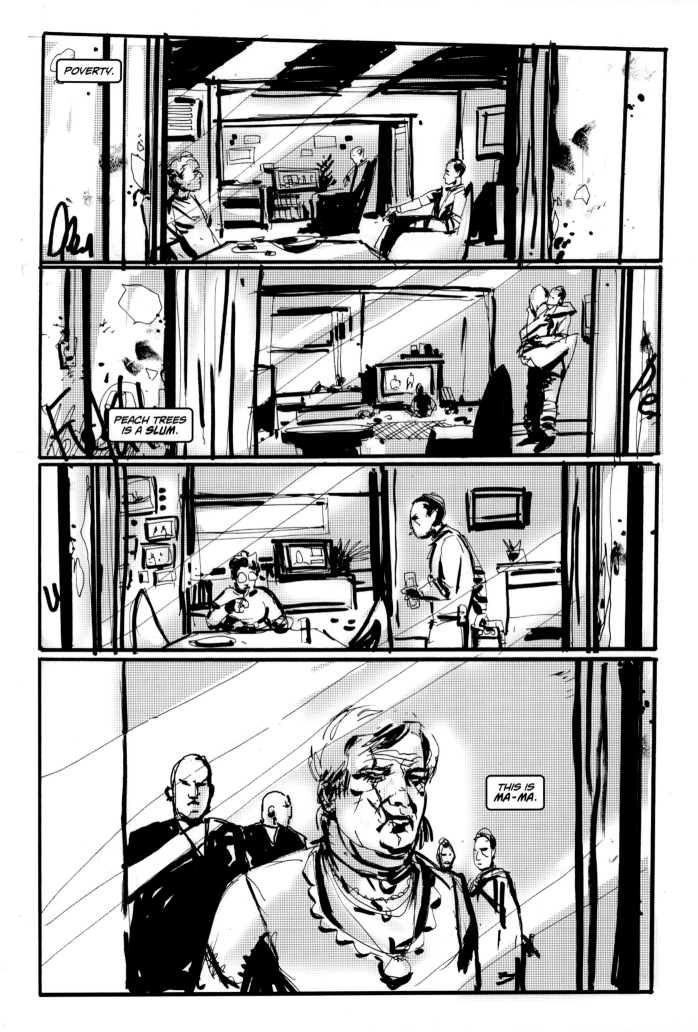

INT. MA-MA'S BASE - CONTINUOUS

Behind MA-MA are five men.

The first of these men is CALEB. Late thirties. Physically powerful. Intelligent and violent. MA-MA's right hand man.

The next two are KAY and SY. Junior to CALEB. Soldiers. Lieutenants.

And finally there are MA-MA'S two BODYGUARDS. They never leave her side, and never speak.

All are inked with dense black tattoos - but share one particular tattoo on the side of their necks: a pierced heart and scroll - with the word Ma-Ma written inside.

> **CALEB**
>
> The only danger is we expand too fast. In the last few days we've added distribution to three new blocks. Pretty soon we'll be looking at making inroads into sectors nine and fifteen.

> **MA-MA**
>
> Fifteen is still Red territory. Why make waves?

> **CALEB**
>
> I've been talking to my contacts there. They want a sit-down, but from what I hear, it's already squared. Fact is, they want what we've got. Just business.

MA-MA nods.

> **MA-MA**
>
> Good.

Then she turns, and gestures to the corner of the room.

> **MA-MA** (CONT'D)
>
> And what about them?

REVEAL that throughout the previous conversation, there were actually three other men in the room.

Sat in a row, on chairs. Beneath the chairs are plastic sheets. Their arms are tied behind them. They are all gagged. Wide-eyed. Bruised and blood-stained. Unable to do anything but listen.

KAY speaks up.

> **KAY**
>
> They were selling Sternhammer product on my level. Warned them off with a beating a couple of weeks ago. Guess it didn't work.

> **MA-MA**
>
> And you can't deal with it yourself?

> **KAY**
>
> I can deal with it.

> **CALEB**
>
> The question is whether you want to make an example of them.

Lena Headey as villain Ma-Ma

MA-MA thinks a couple of moments.

Then turns away.

> **MA-MA**
>
> Skin them and toss them over the balcony.

On their seats, the GAGGED MEN freak out, eyes bugging, struggling against their restraints.

SY pulls a knife.

> **KAY**
>
> Hit 'em with a little slo-mo first?

> **MA-MA**
>
> Sure.

KAY walks up to the first GAGGED MAN. He is also inked - with a crude JUDGE DEATH TATTOO on his chest.

KAY yanks the MAN'S head back and pulls out the gag.

As the gag is released, the MAN starts to scream.

Which is stifled as KAY jams a SLO-MO inhaler into his mouth, and depresses the button.

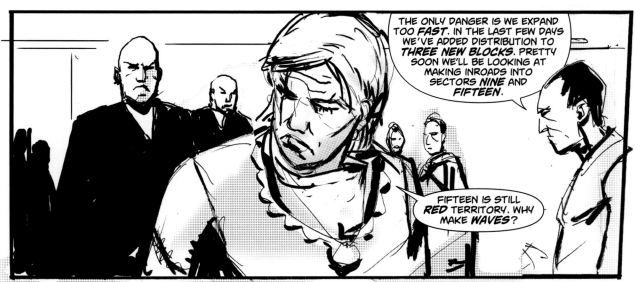

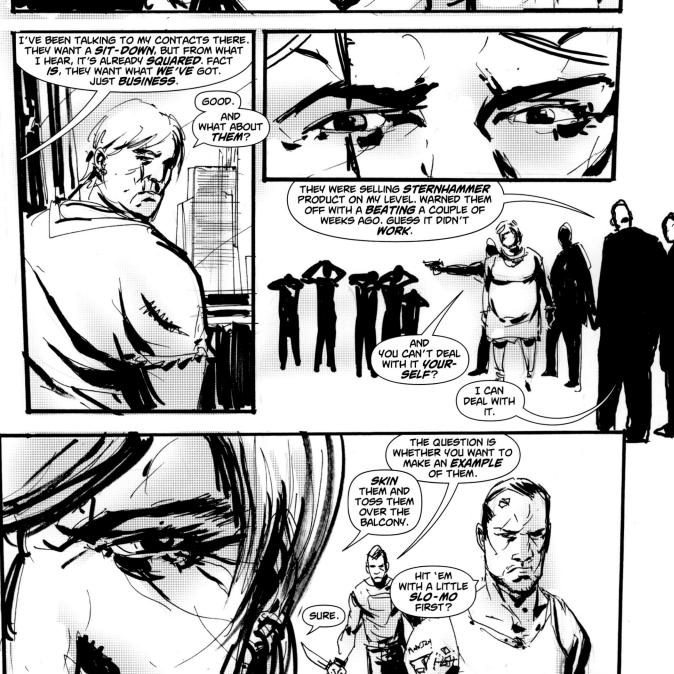

CUT TO -

INT. PEACH TREE BLOCK/ATRIUM - DAY

- the interior of Peach Trees, which contains an atrium of dizzying scale. It spans the entire height of the construction. Effectively, the block is hollowed out, two hundred stories high, ringed with balconies.

The lower levels are a shopping and recreation zone. Above the shopping and recreation zone are medical centers and educational facilities. Everything above is residential.

At the base of the atrium is an area like a massive, busy Third-World train station, with people crisscrossing the area, milling about, exiting out of tunnels and escalators.

We track a WOMAN with a CHILD in a pushchair as she makes her way through.

Suddenly, out of nowhere, a body falls out of the sky, and lands with a sickening impact.

THWACK. Right in front of the pushchair.

The WOMAN pulls back.

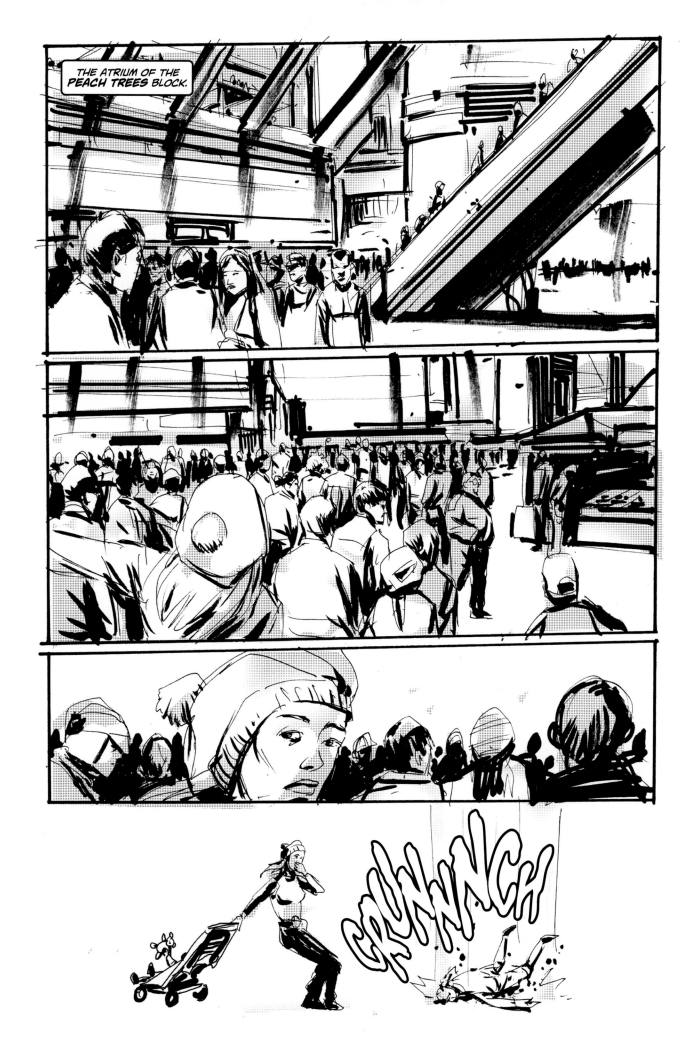

THE ATRIUM OF THE PEACH TREES BLOCK.

CRUNNNCH

And a second body lands directly behind her.

THWACK.

She looks up, as the crowd around her starts to scatter ...

... and is stunned to see that another body is tumbling down towards her.

She just manages to jam the pushchair forwards before the body lands.

THWACK.

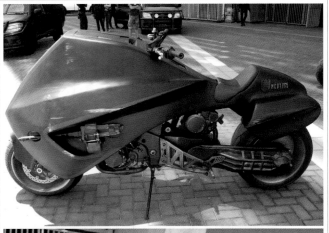

EXT. MEGA-CITY ONE - DAY

DREDD and ANDERSON stand by their fat-wheeled motorbikes, on a ribbon of flyover, in a canyon of Mega Blocks.

Vehicles flash past them.

Over the roar of the traffic, their radios fuzz into life.

We tap into the endless streams of radio calls that are constantly being transmitted from CONTROL.

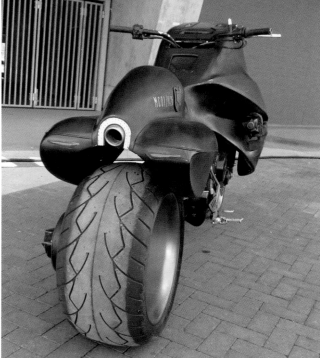

> **CONTROL**
>
> (over radio)
>
> Responders in vicinity of Peach Tree block. We have a report of a multiple homicide.
>
> **CONTROL** (CONT'D)
>
> (over radio)
>
> Responders in Sector 13 North, we have armed robbery in progress. Four suspects on foot. Gunshot victims at scene of crime.
>
> **CONTROL** (CONT'D)
>
> (over radio)
>
> Responders on Highway Alpha Five. We have ambulance crew under fire, requesting assistance.
>
> **DREDD** (to Anderson)
>
> Twelve serious crimes reported every minute. Seventeen thousand per day. We respond to around six percent.
>
> **ANDERSON**
>
> Which six percent?
>
> **DREDD**
>
> Your assessment. You tell me.

ANDERSON glances down at her bike-nav screen. Waypoint markers are flashing all across the sector map.

> **ANDERSON**
>
> Peach Trees, multiple homicide.

DREDD lifts his left hand - which has his radio integrated into the glove.

> **DREDD**
>
> (into radio)
>
> Dredd responding to Peach Tree homicides. On our way.

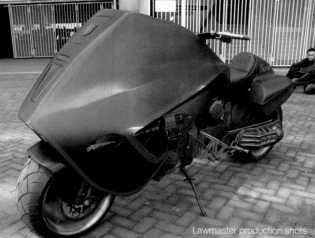

Lawmaster production shots

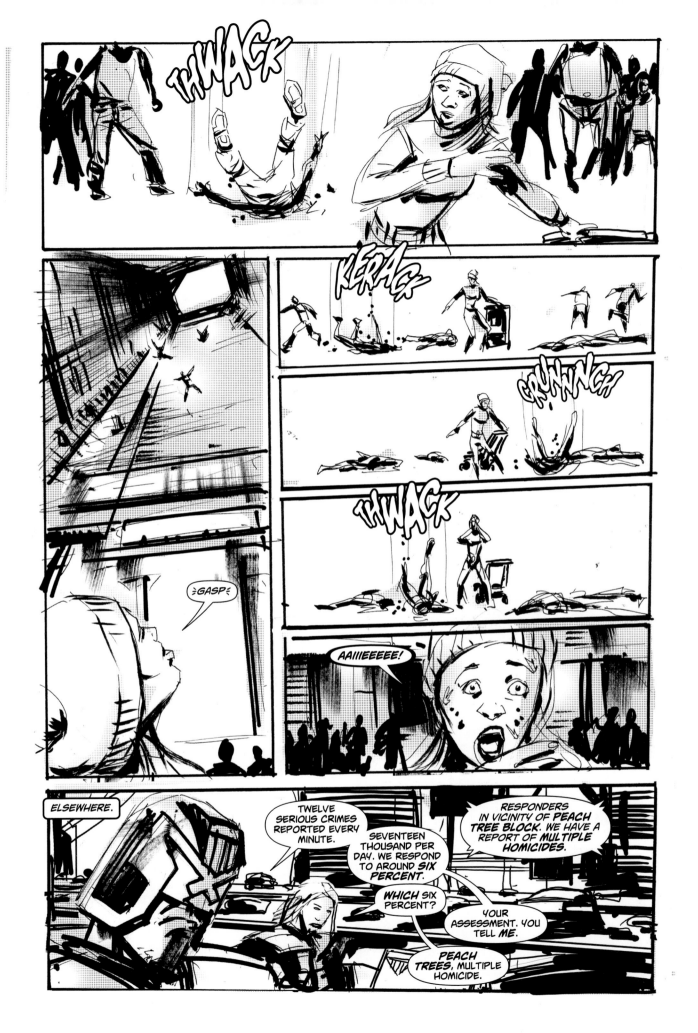

EXT. MEGA-CITY ONE/ROAD - DAY

DREDD and ANDERSON ride their bikes towards Peach Trees.

EXT. PEACH TREE BLOCK - DAY

DREDD and ANDERSON walk into the south entrance of Peach Trees.

Above them, against the background of grey and black concrete slab, a bright hologram of a cartoonish peach tree flickers like a neon strip-light with a bad connection.

Sat against one side of the entrance is a HOMELESS MAN.

In front of him is a handwritten sign on cardboard.

It reads:

> HOMELESS JUNKIE.
>
> WILL DEBASE SELF FOR CREDITS.

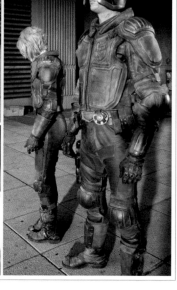

As DREDD and ANDERSON pass him:

DREDD

Anderson.

ANDERSON

Vagrancy, three weeks, iso cubes. But prioritise murders.

DREDD

Correct.

(to the Homeless Man)

Don't be here when we come back.

INT. PEACH TREE ATRIUM - DAY

DREDD and ANDERSON enter the busy atrium.

DREDD

Tell me about Peach Trees.

ANDERSON

Sir. Houses seventy five thousand registered citizens. Actual population rate probably closer to one hundred thousand. Highest crime rate in Sector Thirteen. Unemployment rate at ninety six percent. More than half of the residential levels are classed as slums.

DREDD

Why do you want to be a judge, Anderson?

ANDERSON is thrown momentarily by the non-sequitur.

ANDERSON

... Sir. I want to serve the city. Make a difference.

DREDD

Make a difference to a block like this?

ANDERSON

I was born and raised in a block like this. until the Justice Department took me. I know there are good people inside. Good families. Just trying to get by.

Beat.

ANDERSON (CONT'D)

Yes. I think I can make a difference.

DREDD glances upwards.

Above the bustle of the atrium floor, the ringed balconies of the atrium stretch up into shade and darkness. At the very top is a small circle of reddish sky.

It's like looking into a pit, with a pool of blood at the bottom.

DREDD

(flat)

Admirable.

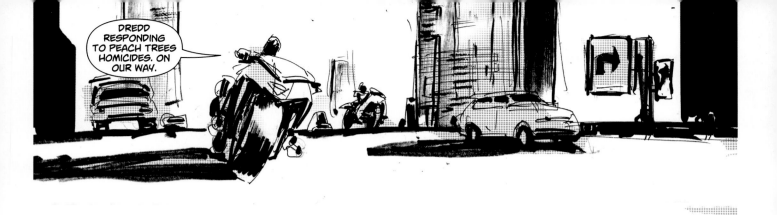

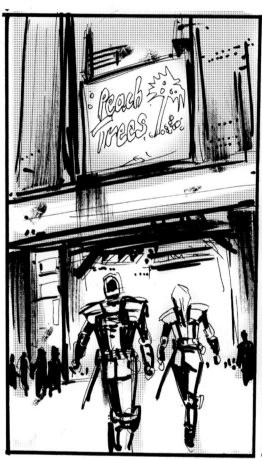

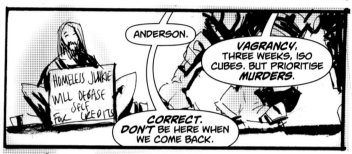

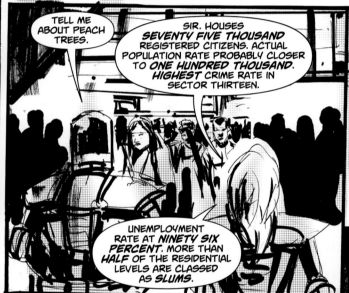

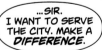

51

INT. PEACH TREE ATRIUM/CRIME SCENE - CONTINUOUS

DREDD and ANDERSON push past a taped cordon.

Behind the cordon, a PARAMEDIC is erecting a tent screen to shield the sight of the bodies from the gathering crowd, and the onlookers who are looking down from the ringed balconies.

> **DREDD**
>
> (to Paramedic)
>
> What have you got?

> **PARAMEDIC**
>
> Three stiffs in a somewhat fucked-up condition.

The PARAMEDIC pulls open the tent screen to allow DREDD and ANDERSON through.

The bodies are the three men we saw with KAY.

They have fallen from a great enough height to crack the tiles on which they landed.

From the neck down and waist up, they have been skinned.

> **DREDD**
>
> You're based in Peach Trees?

> **PARAMEDIC**
>
> Med center on level twenty five.

> **DREDD**
>
> Have you ID'd them?

> **PARAMEDIC**
>
> Mostly. That one is registered to this block. And that one is registered to Block Sternhammer.

> **DREDD**
>
> (gesturing to the last)
>
> And him?

The PARAMEDIC shrugs.

CLOSE UP on the man's severely crushed head.

> **PARAMEDIC**
>
> I'll have to run his blood through the DNA profiler. If I can figure out which blood is his.

DREDD kneels down to take a closer look at the nearest body.

Inside the man's open mouth is a white, dust-like marking.

> **DREDD**
>
> Anderson. What do you make of this?

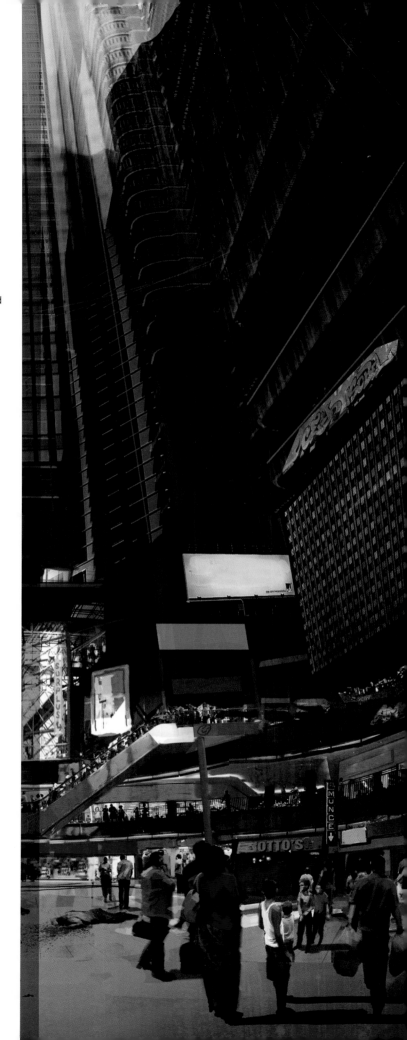

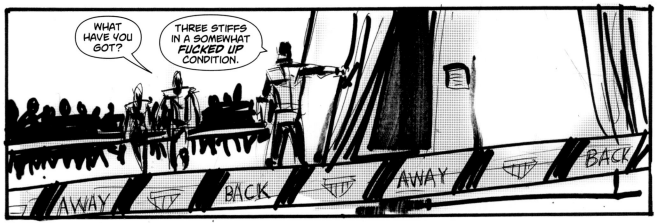

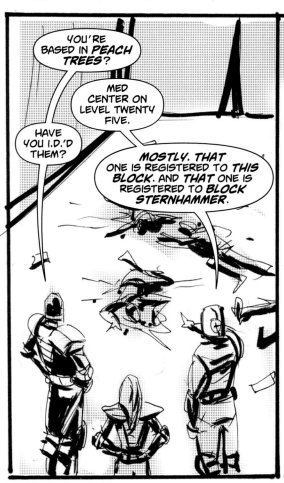

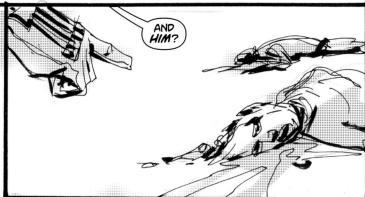

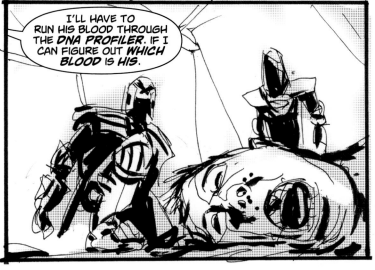

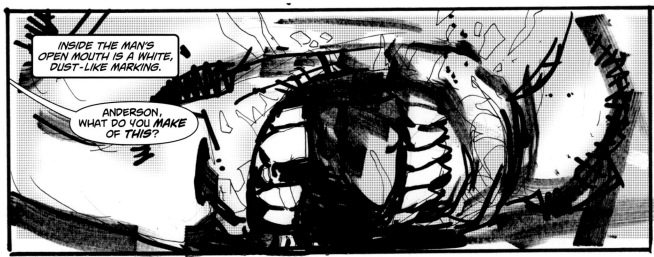

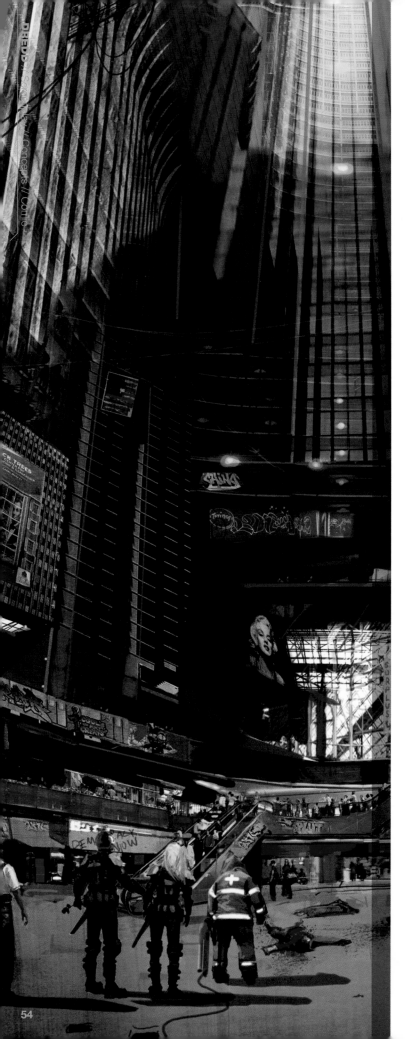

ANDERSON

... I don't know, sir.

DREDD

It's a cold-burn from a slo-mo inhaler.

ANDERSON

Slo-mo?

PARAMEDIC

A new narcotic. Only just hit the grid, but it's making big waves. Makes the brain feel as if time is passing at one percent its normal speed.

ANDERSON looks up to the height from which the men dropped.

FLASH CUT TO -

- a image of one of the men falling, screaming, in extreme slow motion, leaving a trail of suspended blood droplets from his flayed torso.

CUT BACK TO -

- ANDERSON, shuddering.

The PARAMEDIC is also gazing upwards, obviously having much the same thought.

PARAMEDIC (CONT'D)

Must have felt like a long way down.

INT. CONTROL - DAY

In CONTROL, where rows of men and women sit in front of banks of monitors, operating the huge communication center within the Hall Of Justice ...

... we find a screen, on which the faces of the murdered men are appearing.

The CONTROL OPERATOR manning this monitor speaks into his mike.

CONTROL OPERATOR

Positive on your IDs. All show convictions for possession of narcotics.

CLOSE ON MONITOR SCREEN.

CONTROL OPERATOR (CONT'D)

Transmitting data now.

'The Atrium was a vital environment and it went through many location ideas. It was finally shot outside, simply so that the footprint of the floor could be large enough to do justice to the huge Peach Trees block structure, and augmented with CGI to keep the interior feel.' - *Jock*

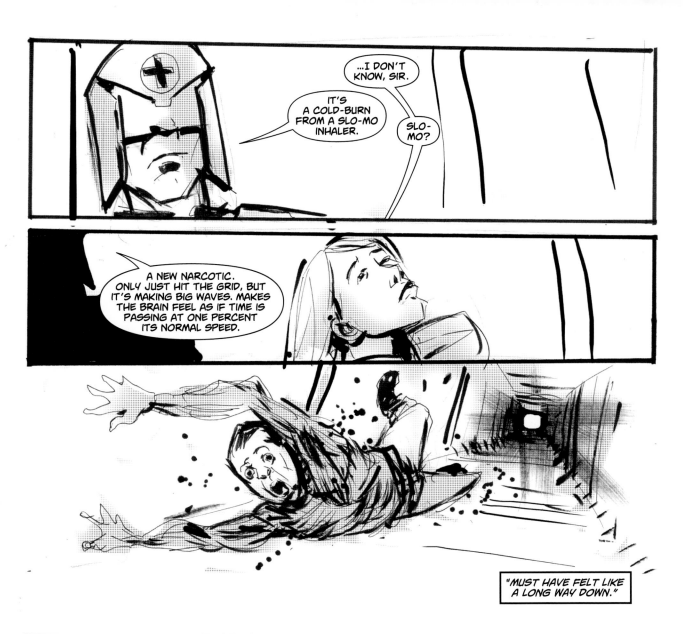

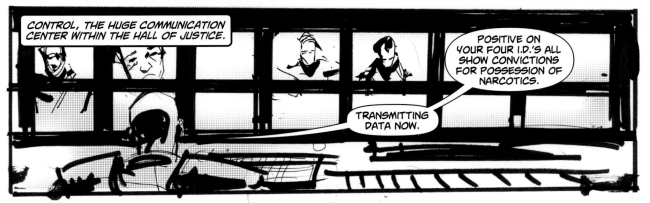

INT. PEACH TREE ATRIUM/CRIME SCENE - CONTINUOUS

PULL BACK from the image on the monitor screen, to reveal we are now seeing it on DREDD'S PDA.

DREDD

Small-time perps. Junkies. No known gang affiliation. What's your assessment, Anderson?

ANDERSON

Drugged. Skinned. Dumped in the most public place you could find. It has to be a punishment killing. A message.

Above them, the balconies of the atrium are ringed with people looking down.

PARAMEDIC

Yeah. Don't fuck with the Ma-Ma Clan.

ON DREDD. Turning.

DREDD

Who?

INT. MEDICAL CENTER - DAY

In the twenty fifth floor medical center, DREDD and ANDERSON are looking at a holographic display, on which we can see a rotating 3D MUGSHOT of MA-MA, and her medical records.

In the background, the PARAMEDIC closes the medical center's heavy security door, while he provides a brief bio of MA-MA.

PARAMEDIC

We have her on record from her whoring days. The picture's pretty old, but yeah. That's her. Madeline Madrigal, AKA Ma-Ma. Ex-hooker from the S-Nine pleasure district. Quit working after she got sliced up by a pimp. But she got her own back. Block legend says she feminized the guy with her teeth. Then took over his business interests, and never looked back.

The PARAMEDIC sucks his teeth.

PARAMEDIC (CONT'D)

Anyone else, you'd say it was bullshit. But not with Ma-Ma. Her trademark is violence. Takes it further and harder than anyone else. I've been in Peach Trees fifteen years. Used to be there were nine or ten different gangs, hustling for control. Now there's just one.

ANDERSON

How did she get away with it?

PARAMEDIC

You know how often we get a Judge in Peach Trees?

DREDD

You've got one now.

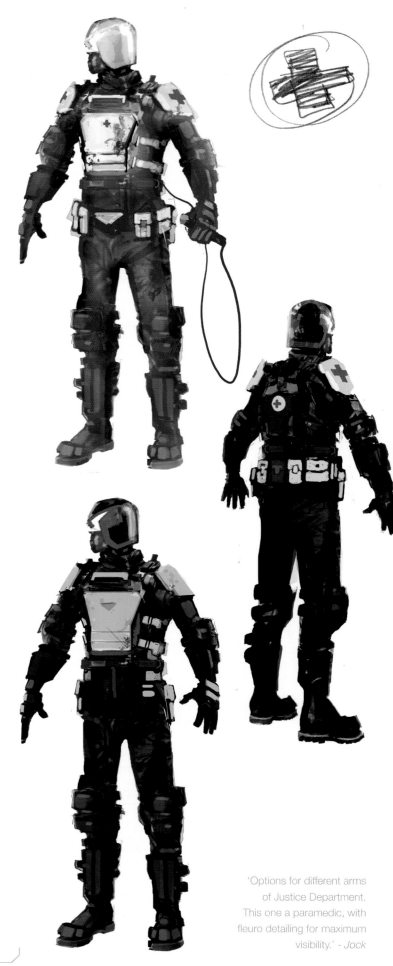

'Options for different arms of Justice Department. This one a paramedic, with fleuro detailing for maximum visibility.' - *Jock*

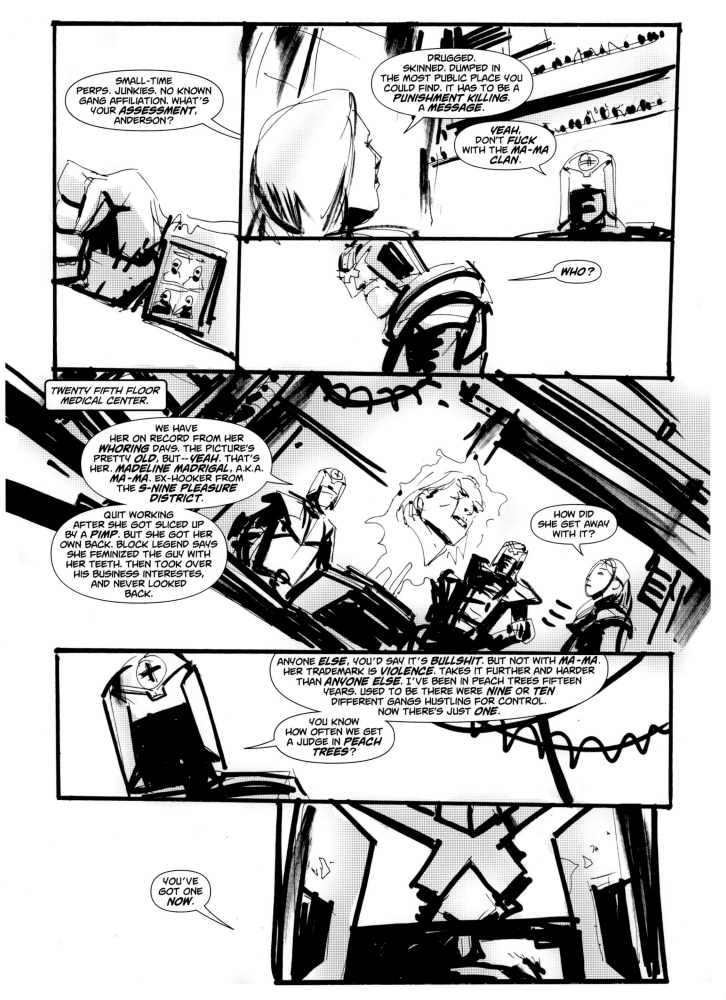

DREDD hits a console button, and the holographic display changes to a map of Peach Trees.

DREDD (CONT'D)

The victims were registered to apartments on level thirty nine. Likely killed over a turf issue, so we'll find their killers in the same vicinity.

(to Anderson)

Anderson. Next move.

ANDERSON

Locate where the Clan work out of on this level, and hit it hard.

The PARAMEDIC lights up an area of the map.

PARAMEDIC

That would be here.

CUT TO -

INT. METAL DOOR - DAY

- a viewing hatch sliding open, in a metal door.

Crowded into the other side of the viewing hatch, we see the faces of the two JUNKIES.

One of them holds up credits.

The door is opened.

INT. SLO-MO DEN - CONTINUOUS

The JUNKIES enter an apartment.

A squalid shit-hole. In our day and age, it would be a crystal meth or crack-den, with piss-stained mattresses, schizoid graffiti on the walls, and crushed glass pipes on the floor.

But this is a slo-mo den. Much the same, but instead of crushed crack pipes on the floor, it's empty inhalers.

The man by the door is SY, holding a shotgun.

Sat on an armchair, with a pistol on his lap, is KAY.

Our two JUNKIES score off KAY, swapping credits for inhalers.

LAWGIVER EVOLUTION
The lawgiver minus the dial. With added small grenade launcher below the regular barrel.

 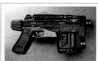 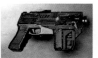 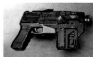 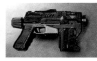

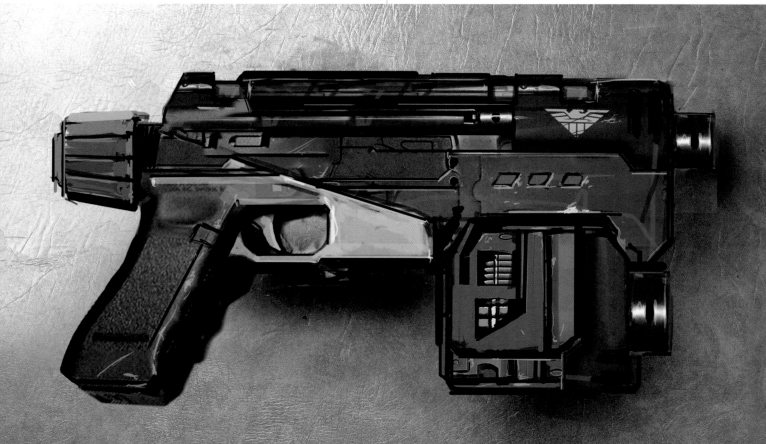

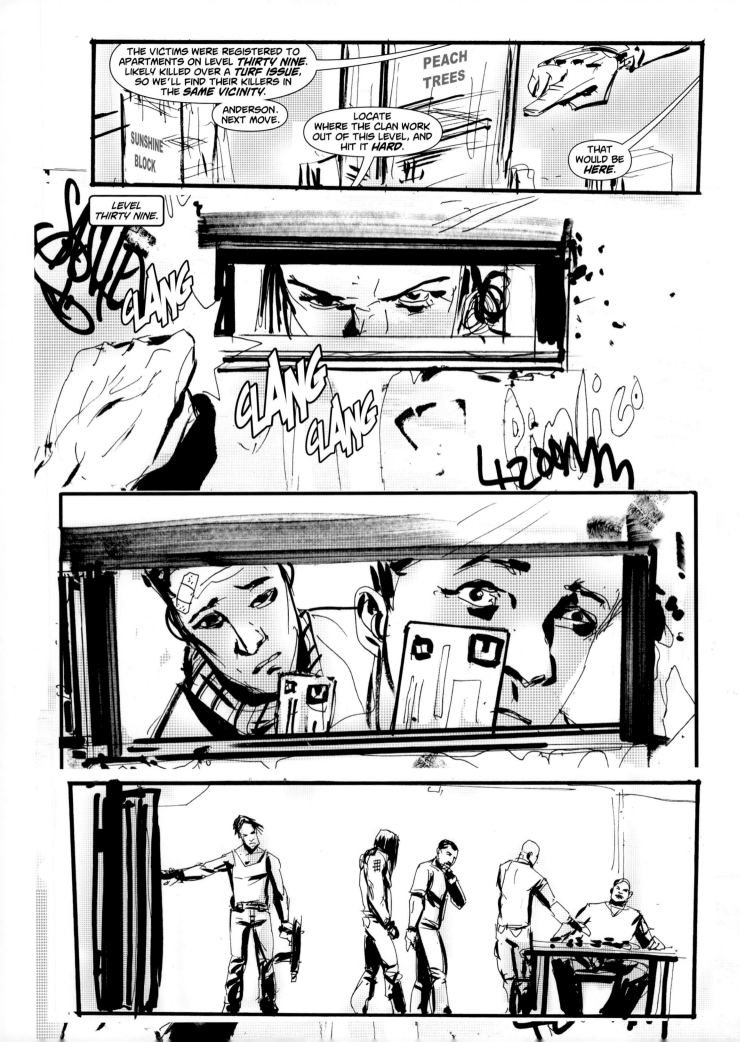

CUT TO -

INT. LEVEL THIRTY NINE/CORRIDOR - CONTINUOUS

- outside the apartment.

DREDD and ANDERSON, taking position either side of the metal door.

Weapons drawn.

We can see ANDERSON'S nerves.

The door opposite them opens - and a KID peers out of the crack. ANDERSON gestures for the kid to go back inside. The door closes.

> **DREDD**
>
> Take it this is your first time in non-simulator combat.
>
> **ANDERSON**
>
> Yes sir.
>
> **DREDD**
>
> Been wondering when you'd remember you left your helmet at base.
>
> **ANDERSON**
>
> Sir - a helmet interferes with my psychic abilities.
>
> **DREDD**
>
> Think a bullet might interfere with them more.

CUT BACK TO -

INT. SLO-MO DEN - CONTINUOUS

- the JUNKIES.

They find a space in a corner of the room, beside two people who are mechanically screwing on a filthy mattress.

Then put the inhalers in their mouths. Take a long hit.

CUT TO -

INT. LEVEL THIRTY NINE/CORRIDOR - CONTINUOUS

- DREDD, pulling a plasti-charge out of his utility belt.

He fixes the plasti-charge to the door.

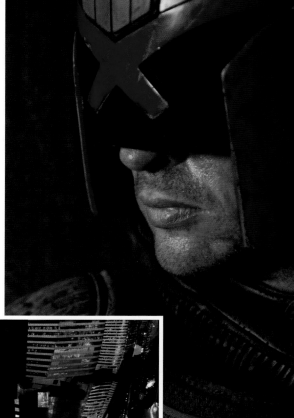

Karl Urban *is* Judge Dredd

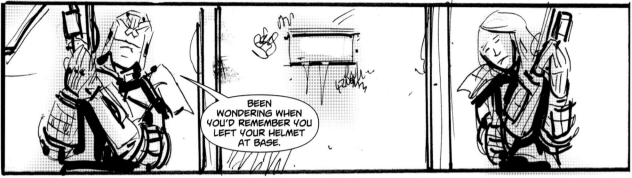

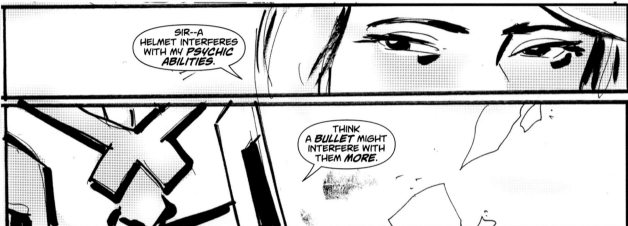

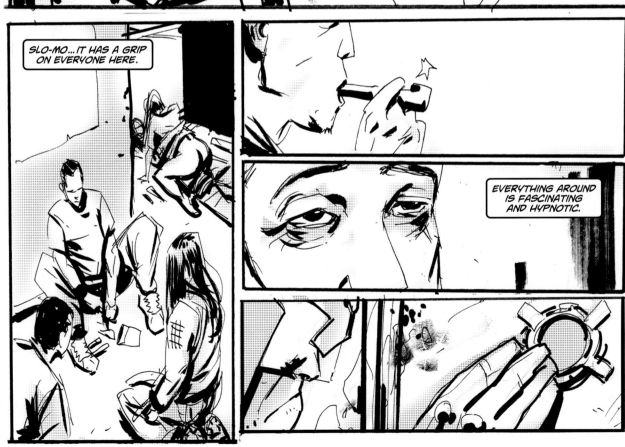

DREDD

Ready?

ANDERSON nods.

DREDD notices -

- glitter of sweat on ANDERSON'S face. The slight tremble in her hands.

DREDD (CONT'D)

You don't look ready.

ANDERSON tightens her grip around her gun to stop the shake.

ANDERSON

Just adrenaline, sir.

CUT BACK TO -

INT. SLO-MO DEN - CONTINUOUS

- our JUNKIES. In the grip of the drug.

And we're with it too.

Everything slow.

Not just slow - ultra slow.

All movements. Facial expressions. Blinking eyes.

And we discover why people take the SLO-MO - as grim reality is transformed into something lyrical.

From sordid to oddly beautiful. Fascinating and hypnotic.

Even the couple screwing on the floor.

Then -

- what was fascinating and hypnotic -

- becomes slightly confusing.

Because the heavy door of the slo-mo den is very gradually starting to expand.

To bulge.

And in front of the bulge, a shock wave of air is starting to form.

And contacting the guard, SY, who stands just behind it.

Lifting him delicately off his feet.

And now around the edges of the door, we can see a white and yellow brightness.

Which becomes a blossoming explosion of flame.

Until the door, and SY, are flying backwards across the room.

SLOW CUTS BETWEEN -

JUNKIES hunching.

Faces morphing into expressions of fear and surprise.

Hands reaching for guns.

DREDD coming through the door.

Followed by ANDERSON.

Now gunplay, gracefully erupting.

'Early idea for the look of the slo-mo drug. Alex was very keen to get this right and worked on it with the FX team right up until the picture was locked. I think the results speak for themselves.' - *Jock*

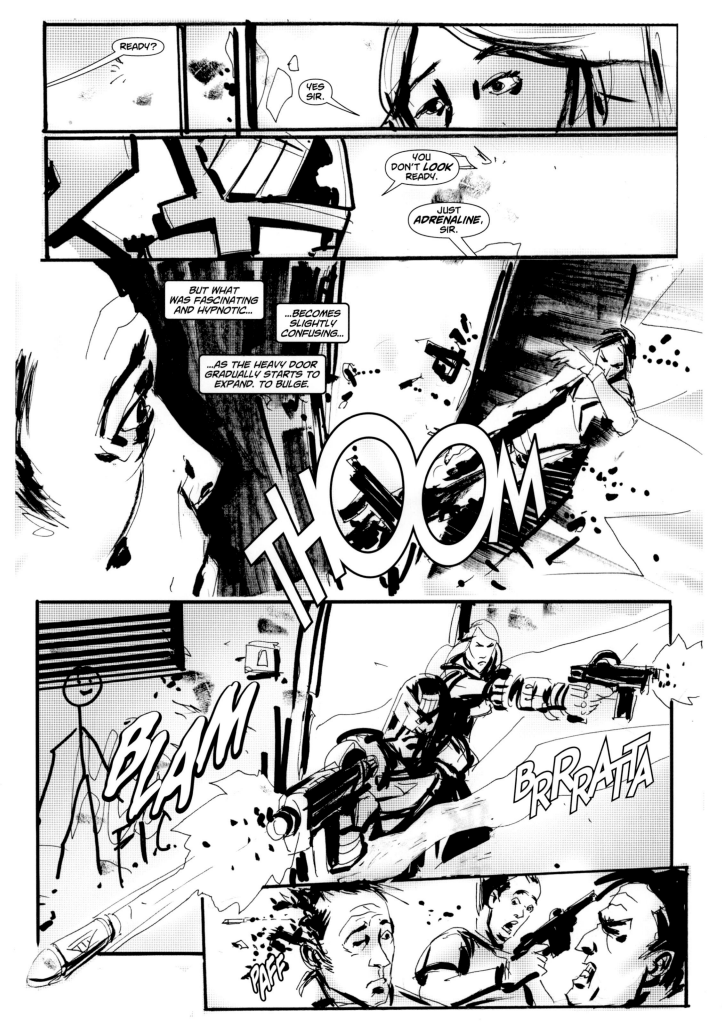

Bullets rifling through the air.

Punching through plaster work.

Drilling through chests, leaving trails of hanging blood.

Drilling into the head of a clan member, creating a spiral of flesh as it enters.

Smoke and dust unfurls.

Until it blinds us.

'First shot of the slo-mo den. Run down and ugly. You can see this colour scheme in one of the corridors in the final movie.' - *Jock*

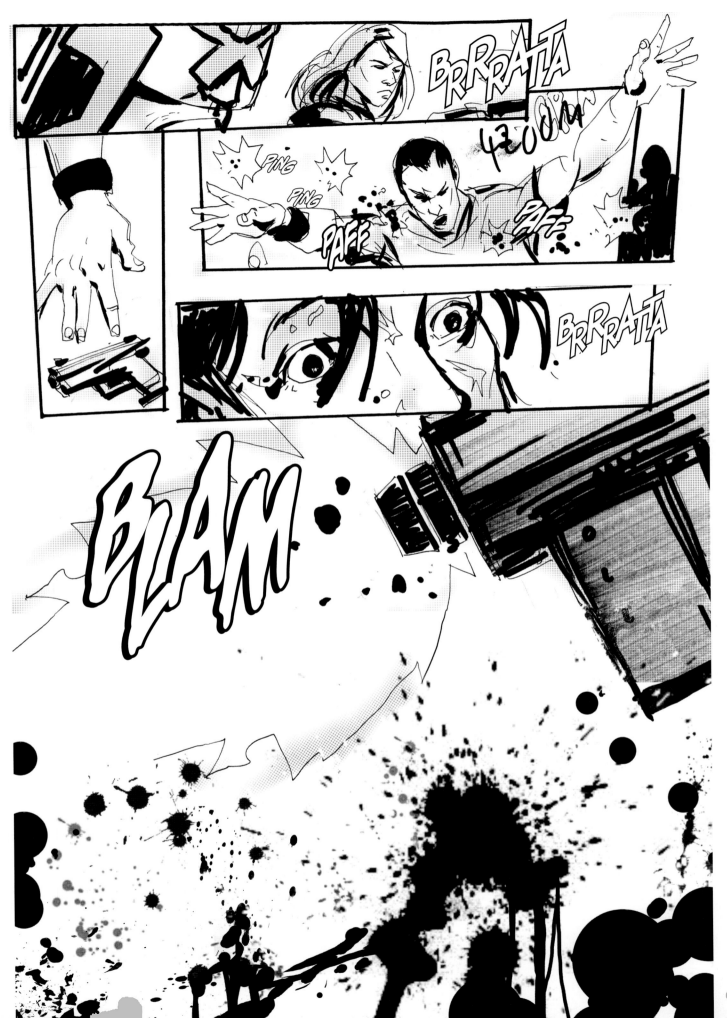

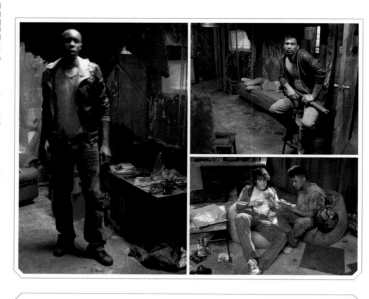

INT. SLO-MO DEN - CONTINUOUS

As the smoke and dust clears, it allows us to return seamlessly to normal speed.

DREDD and ANDERSON stand surrounded by the corpses of gang members and those junkies who were foolish enough to reach for their guns.

The survivors crouch or stand with arms raised, dazed with narcotics and fear, with the guns of the two judges trained on them.

ANDERSON is breathing fast. Still charged with adrenaline.

DREDD

Anderson. Judgement.

ANDERSON gathers her wits.

ANDERSON

Crime: possession and use of controlled substances. Sentence: two years in the iso-cubes.

DREDD

Don't tell me. Tell Control.

ANDERSON

Sir.

(into radio)

Anderson to Control. Requesting meat wagon to Peach Trees. We've got six bodies for Resyk and seven live for the iso-cubes.

CONTROL

(over radio)

Copy that. Meat Wagon inbound.

DREDD nods.

DREDD

Let's get them cuffed.

INT. SLO-MO DEN - CONTINUOUS

The perps are lined up and being cuffed.

One of them winces as DREDD pulls the plasti-cuffs mercilessly tight around his wrists.

ANDERSON is cuffing another man -

- but hesitates as she sees the distinctive Ma-Ma tattoo on the side of his neck.

ANDERSON

Sir, this one is a gang member. He-

ANDERSON breaks off. Frowning.

Then she turns the man round, revealing -

- KAY.

They gaze at each other for a couple of beats.

Then:

ANDERSON (CONT'D)

Sir. It's him.

DREDD

It's who?

ANDERSON

The man who murdered the people in the atrium.

KAY'S eyes narrow fractionally. Internally, he's wondering how she could know this information, but he's far too practised with being on the wrong side of the law to give anything away.

DREDD

You're sure.

ANDERSON

Ninety nine percent.

DREDD

Can't execute a perp on ninety nine percent.

DREDD steps over to KAY. Stares him down.

DREDD (CONT'D)

Save a lot of paperwork if you confessed right now.

KAY says nothing. And clearly isn't going to.

DREDD nods.

DREDD (CONT'D)

(to Anderson)

Finish securing him. We'll take him in. See how he holds up after a few hours of interrogation.

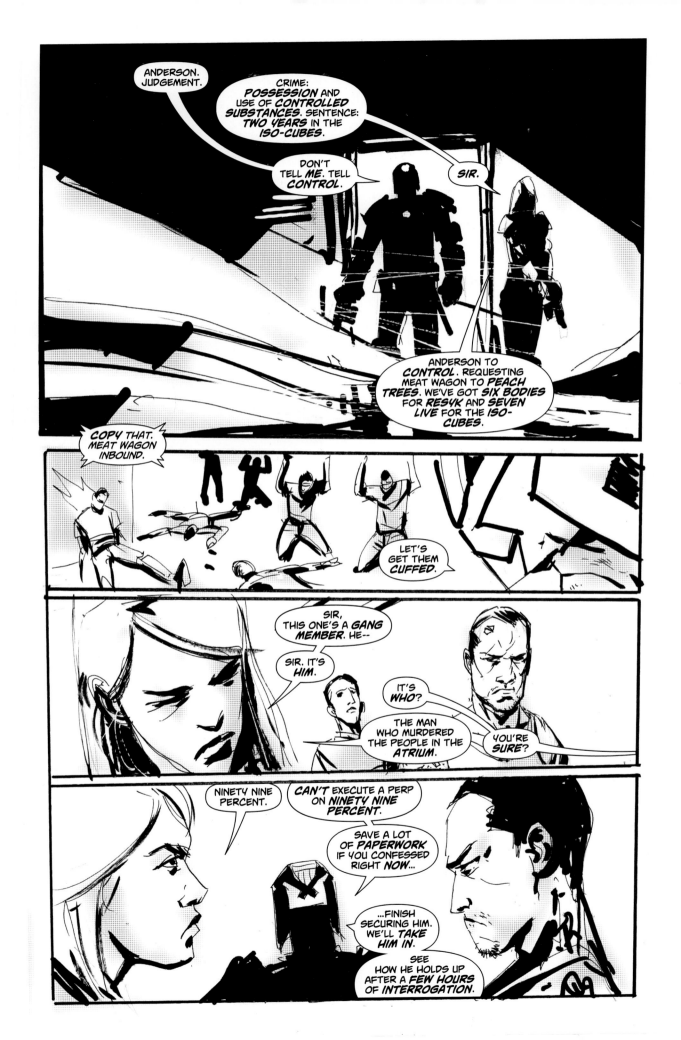

As ANDERSON turns to KAY again, KAY'S eyes look up to the corner of the room.

We ZOOM ON the place where KAY is looking, and find -

- a PINHOLE.

And through the pinhole, the glint of a lens.

CUT TO -

This scene, viewed from the hidden CCTV camera in the corner of the room.

PULL BACK TO REVEAL -

INT. MA-MA'S BASE/CCTV ROOM - CONTINUOUS

- a monitor, showing the image of KAY'S arrest by DREDD and ANDERSON.

Next to the monitor, a red alarm light is blinking.

PULL BACK to reveal more monitors, showing various views around Peach Trees.

This is the CCTV ROOM: the technological hub of MA-MA'S operation, at the heart of her base, overlooking the atrium from the top floor.

Supervising the monitors is the CLAN TECHIE.

Twenty years old.

Hunted, undernourished, nervy: a dog who's been kicked too many times. And he's got no eyes. Instead, attached and implanted to his face are large, bulbous robotic eye implants. Like a chameleon lizard, each eye implant can move independently of the other.

And what these robotic eyes are focused on is making him worried.

> **CLAN TECHIE**
>
> Oh shit.

He reaches for a radio.

> **CLAN TECHIE** (CONT'D)
>
> (into radio)
>
> Uh, Caleb? I'm sorry to - no, I know. Yes, but - I think there's a problem on level thirty nine.

CUT TO -

INT. MA-MA'S PENTHOUSE/ENTRANCE HALL - DAY

- an extreme CLOSE UP on MA-MA'S FACE.

Her cheeks are rippling weirdly, and slowly.

REVEAL -

- compressed gas from a SLO-MO INHALER is jetting into her mouth.

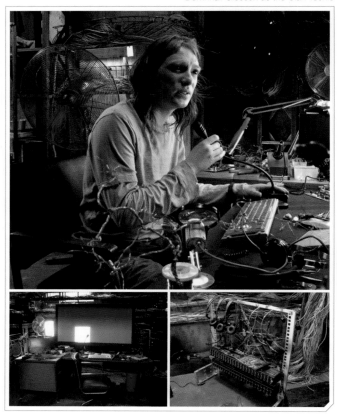

Domhnall Gleeson as the Clan Techie

CUT TO -

- NORMAL TIME.

CALEB enters the room.

Reveal MA-MA'S penthouse surroundings. It's a weird mix of squalor and crass luxury. A Dolce and Gabbana crack den. Gold fittings, rococo design, holes in walls, wires trailing from empty light fittings. The artwork on the walls is softcore porn, in florid frames, much of it featuring MA-MA herself.

Sees MA-MA, sprawled on day-bed, inhaler in mouth.

Behind her, her two BODYGUARDS, like statues.

> **CALEB**
>
> Ma.

Long beat.

Vapour curling out of MA-MA'S mouth.

The beat continues.

MA-MA frozen.

Then the drug rush fades.

MA-MA focuses. Turns to CALEB.

> **MA-MA**
>
> What?
>
> **CALEB**
>
> We've got trouble.

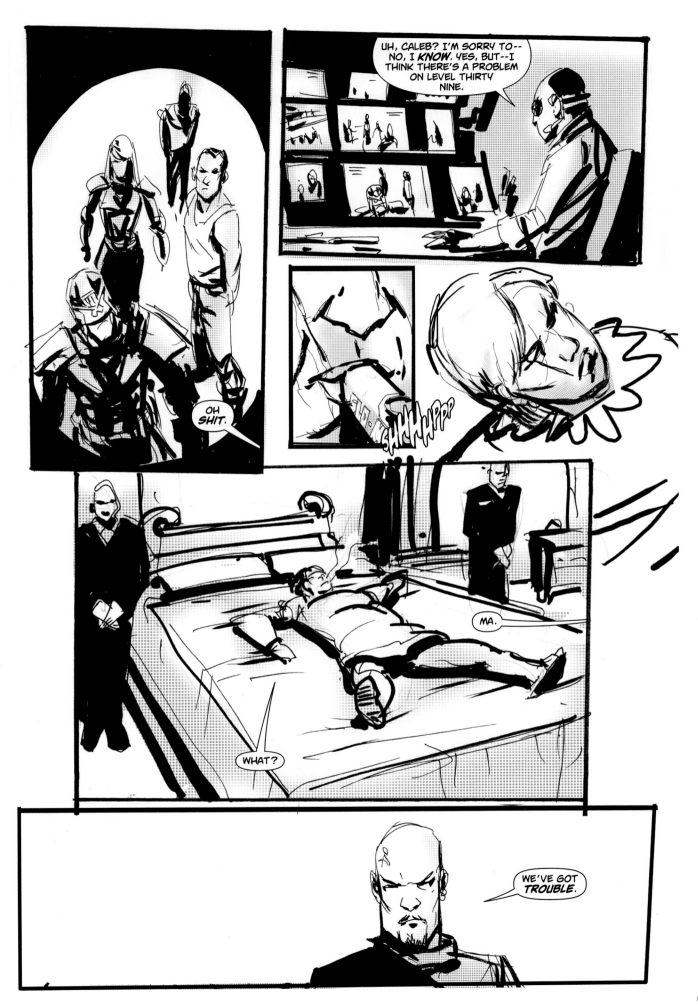

INT. MA-MA'S BASE/CORRIDOR - CONTINUOUS

MA-MA and CALEB walk and talk, en route to the CCTV room, followed by the BODYGUARDS.

> **CALEB**
>
> The judges hit the distribution point on level thirty nine. Shot the place up. Took out a few of the boys.

> **MA-MA**
>
> (unfazed)
>
> So what? We're overdue a bust. The law's just showing their faces. Reminding the citizens they exist.

> **CALEB**
>
> No. Ma - they picked up Kay.

MA-MA reacts.

> **MA-MA**
>
> Executed?

> **CALEB**
>
> Interrogation.

This stops MA-MA in her tracks.

> **MA-MA**
>
> What?

> **CALEB**
>
> He's cuffed and they're taking him in. Right now.

Beat.

> **MA-MA**
>
> Fuck.

> **CALEB**
>
> If Kay talks -

> **MA-MA**
>
> If they're taking him in, he'll talk.

Beat.

> **CALEB**
>
> What are we going to do?

MA-MA glazes a moment.

Thinking.

CUT TO -

INT. LIFT - DAY

- DREDD, ANDERSON and KAY, riding the lift to the ground floor in silence.

As the lift descends -

- KAY is looking straight ahead at the doors ...

... in which he can see himself, and DREDD and ANDERSON reflected.

KAY shifts his position very slightly.

DREDD'S head tilts fractionally.

> **ANDERSON**
>
> Sir - he's thinking about making a move for your gun.

> **DREDD**
>
> I know.

KAY shoots a glance back at ANDERSON.

> **ANDERSON**
>
> He just changed his mind.

> **DREDD**
>
> Yeah.

The lift continues descending in silence.

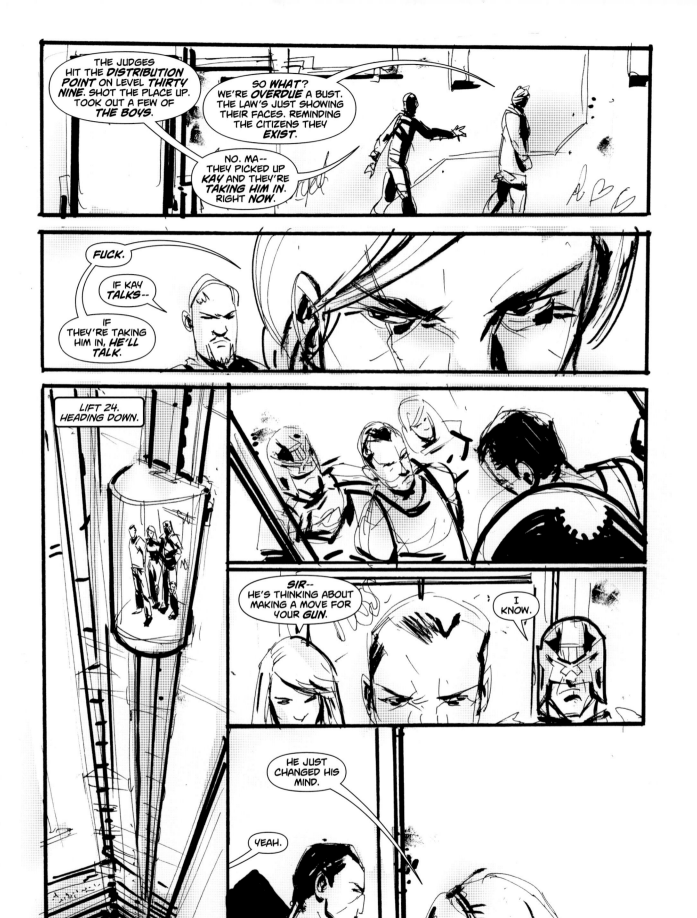

INT. PEACH TREE CONTROL ROOM - DAY

The control room of Peach Trees.

Banks of screens.

Many of them down, broadcasting static or blacked out.

Others showing water and electricity levels.

Power levels.

Refuse collection times.

Engineering schematics.

Manning the control room, four TECHNICIANS, playing cards.

Looking round in surprise as the door to the control room is kicked open -

- and CALEB, plus four other clan members pile in.

A vicious burst of gunfire, and the TECHNICIANS in the control room are cut down.

CALEB lifts a two-way.

> **CALEB**
>
> (into two-way)
>
> Control room is secure.

CALEB walks over to the central console, and pulls out a small router, and plugs it in.

> **CALEB** (CONT'D)
>
> (into two-way)
>
> Router's in. You're good to go.

CUT TO -

INT. MA-MA'S BASE/CCTV ROOM - CONTINUOUS

- the CLAN TECHIE, sitting in front of the bank of monitors and assorted hardware.

MA-MA and her BODYGUARDS stand behind him.

MA-MA leans down to the CLAN TECHIE. Puts a slab hand on his shoulder. Makes him hunch instinctively.

> **MA-MA**
>
> What am I going to do to you if you don't pull this off?

The TECHIE swallows.

> **CLAN TECHIE**
>
> Don't know.
>
> (beat)
>
> Shoot me?

> **MA-MA**
>
> Worse.

> **CLAN TECHIE**
>
> (small voice)
>
> Probably cut out my insides or something.

> **MA-MA**
>
> Yeah. That.

The CLAN TECHIE takes a moment.

Then starts tapping commands into his keyboard.

We hear a phone ring over speaker phone.

Then a voice picks up.

> **SECTOR CONTROL**
>
> (over speaker)
>
> Sector Control.

The CLAN TECHIE forces his voice to sound casual.

> **CLAN TECHIE**
>
> Sector Control, this is Peach Trees Control. Just want to check you were notified about the def-con systems test today.

> **SECTOR CONTROL**
>
> (over speaker)
>
> Copy that. Uh ...
>
> (beat)
>
> Peach Trees, we don't have you down for a def-con test.

> **CLAN TECHIE**
>
> We must be. Check the...

> **SECTOR CONTROL**
>
> (over speaker)
>
> Nope. I've got nothing.

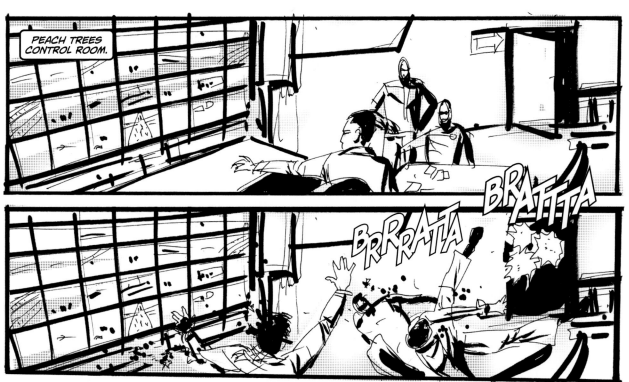

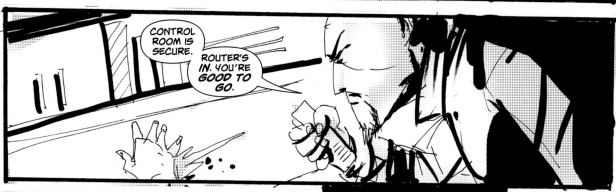

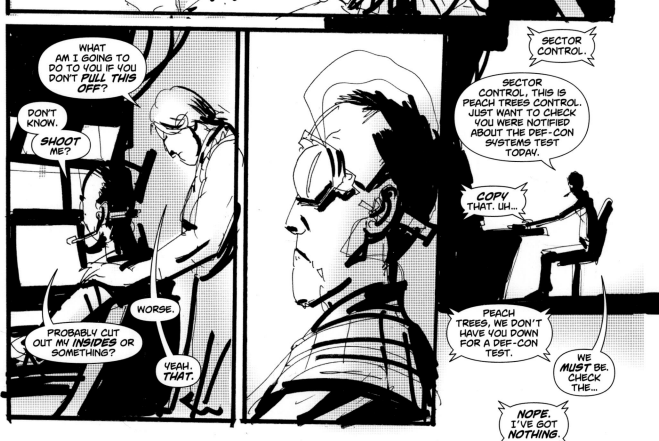

The CLAN TECHIE injects heat into his voice.

CLAN TECHIE

God-fucking-dammit, Sector! I put in the notification myself, three fucking times! We're set to go *right now!* I've got my supervisor breathing down my neck and -

SECTOR CONTROL

(cuts in, over speaker)

Hold fire, Peach Trees. Let me get on this.

(beat)

Okay. I put you on the system. Hall of Justice and all emergency services are notified to ignore your status. Run the test any time you like.

The CLAN TECHIE'S relief is genuine.

CLAN TECHIE

Appreciate that, Sector. You just saved my ass over here.

SECTOR CONTROL

(over speaker)

You're welcome, Peach Trees.

MA-MA nods her approval.

On his console, the CLAN TECHIE hits the RETURN KEY.

CUT TO -

INT. PEACH TREE CONTROL ROOM - CONTINUOUS

- a blood-sprayed monitor in the control room, with the body of a TECHNICIAN sprawled in front of it.

CALEB hauls the body of the man off.

On the bloody monitor, a command screen appears, headed:

DEF CON EMERGENCY PROTOCOLS

The command prompt moves down the screen.

Highlighting, in turn -

FIRE

BOMB

RIOT

CHEMICAL

And finally ending on -

NUCLEAR WAR

On NUCLEAR WAR, the command prompt stops.

Off camera, we hear a tap.

And a moment later, a message box appears on the screen.

PROTOCOL INITIATED

INT. PEACH TREE BLOCK/ENTRANCE - CONTINUOUS

DREDD and ANDERSON walk KAY towards the South entrance.

The HOMELESS MAN is still there, sat in the doorway.

DREDD

Warned you. Get up. You're headed for the cubes.

DREDD is interrupted by a SIREN, which abruptly starts sounding.

As DREDD looks round, **CUT TO -**

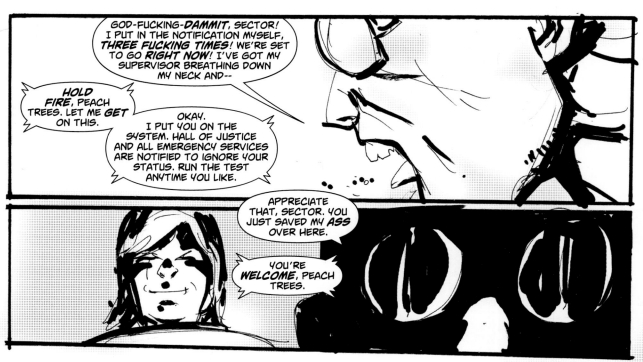

FIRE

BOMB

RIOT

CHEMICAL

▷ NUCLEAR WAR

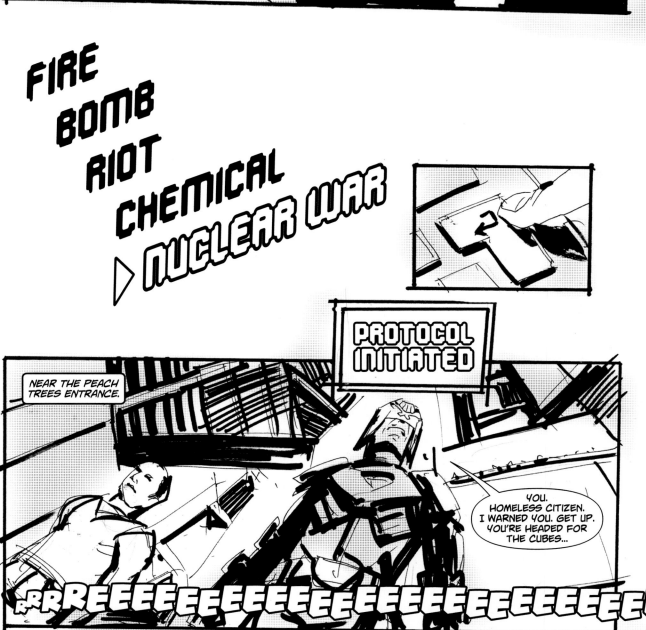

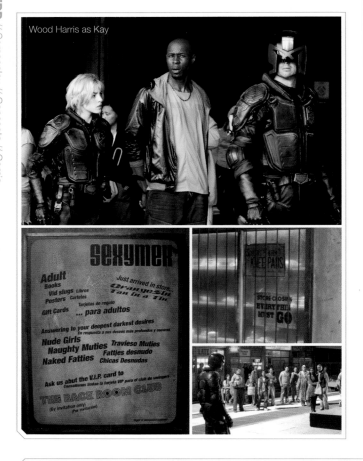

Wood Harris as Kay

'My very first crack at a judge, complete with the bulky, cumbersome pads from the comic.' - *Jock*

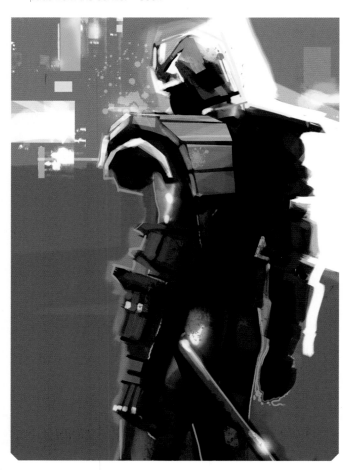

EXT. PEACH TREE BLOCK - CONTINUOUS

- the outside of the block.

Moving down as, over every window we pass ...

... a LEAD-LINED SHUTTER suddenly slams down.

EXT. PEACH TREE BLOCK/SKATEPARK - CONTINUOUS

In the SKATEPARK bolted on to the side of Peach Trees, the shutter comes down, trapping the SKATERS outside.

> ### SKATER 1
>
> What the fuck?

SKATER 2 pointlessly bangs his fist against the slab of metal.

> ### SKATER 2
>
> Hey! What's going on? Open up!

INT. PEACH TREE BLOCK/ENTRANCE - CONTINUOUS

At the south entrance, just ahead of where DREDD, ANDERSON and KAY are standing, a two-metre thick blast door slams down with incredible speed.

The HOMELESS MAN, unlucky enough to be directly beneath it, is crushed as it drops.

One half of his bisected body remains on the inside.

EXT. PEACH TREE BLOCK/ATRIUM ROOF - CONTINUOUS

At the top of the atrium, two massive metal shutters are closing, blocking out the light from the sky above.

INT. MA-MA'S BASE/CCTV ROOM - CONTINUOUS

The CLAN TECHIE hands MA-MA a handset.

> ### CLAN TECHIE
>
> You're patched in.

INT. PEACH TREE ATRIUM - CONTINUOUS

DREDD, ANDERSON and KAY have returned to the atrium.

Across the atrium floor, as the roof shutters close, twin shadows are moving across the floor.

DREDD, ANDERSON and KAY stand in the middle of the narrowing band of light.

All around them, people react with confusion and panic.

> ### ANDERSON
>
> What's going on?

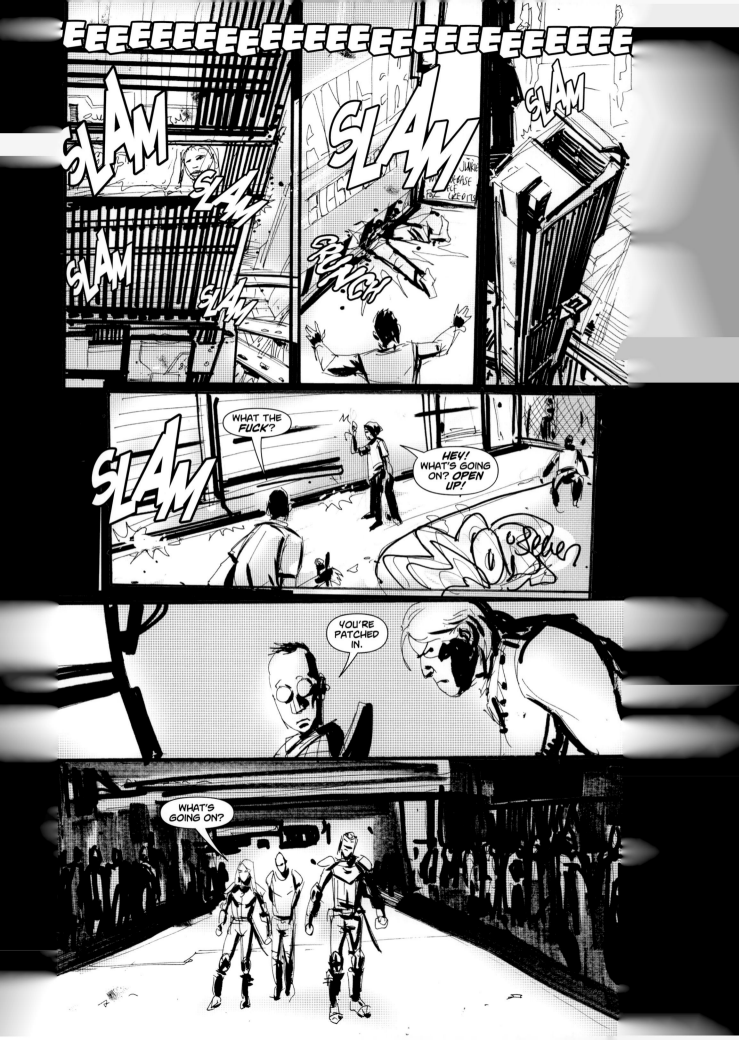

DREDD

 I don't know.

But KAY seems to have an idea.

He says nothing, but the barest smile appears on the corner of his lips ...

... as the roof shutters finally connect, and slam shut.

And the narrowing band of light winks out.

And the siren suddenly stops.

A moment of silence.

The whole building is now in a twilight of emergency lighting.

Then a sudden FEEDBACK WHINE comes over the block-wide TANOY.

Piercing. Rising fast to a deafening level, which echoes around the atrium, making people jam their hands over their ears...

until it abruptly cuts out.

And MA-MA'S voice comes in.

MA-MA

 Peach Trees. This is Ma-Ma.

The statement hangs a moment. Everywhere, everyone is frozen.

MA-MA (CONT'D)

 Somewhere in this block are two judges. I want them dead. And until I get what I want, the block is locked down.

As she talks, we move around the atrium. Seeing the confusion and fear on people's faces.

MA-MA (CONT'D)

 All Clan, every level, hunt the judges down. Everyone else, clear the corridors and stay the fuck out of our way until the shooting stops. If I hear about anyone helping the judges, I'll kill them and the next generation of their family.

She pauses a moment, to make sure the point is rammed home. Then:

MA-MA (CONT'D)

 As for the judges, sit tight, or run. Makes no difference. You're mine.

The Tanoy cuts out.

Now, all across the balconies, above and below, and from the atrium floor, every single person is looking at DREDD and ANDERSON.

A beat.

Then:

DREDD

 ... We'd better move.

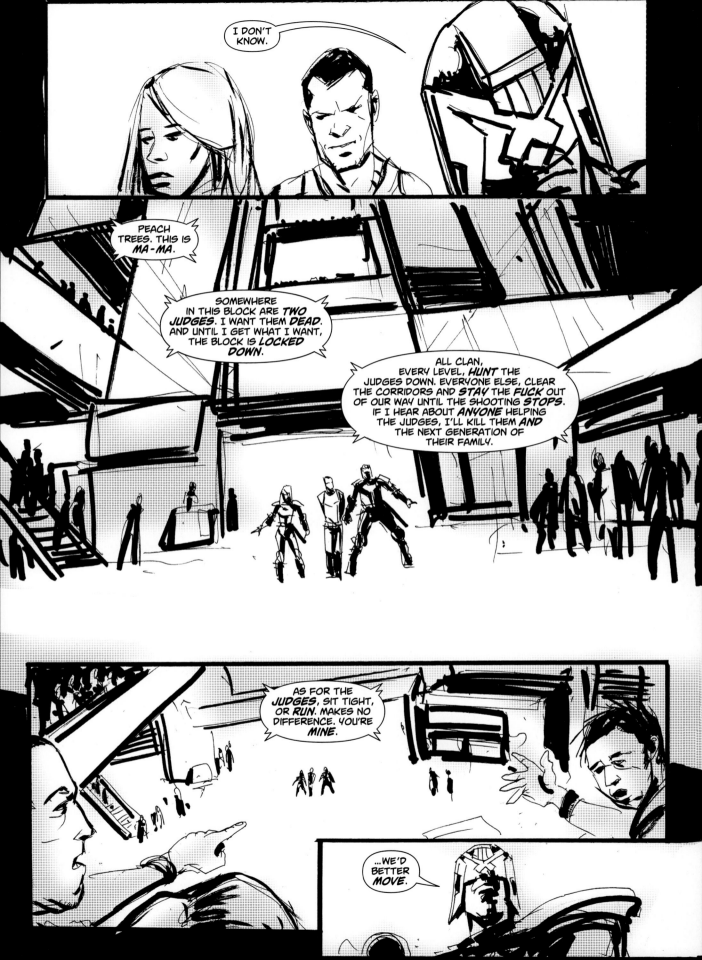

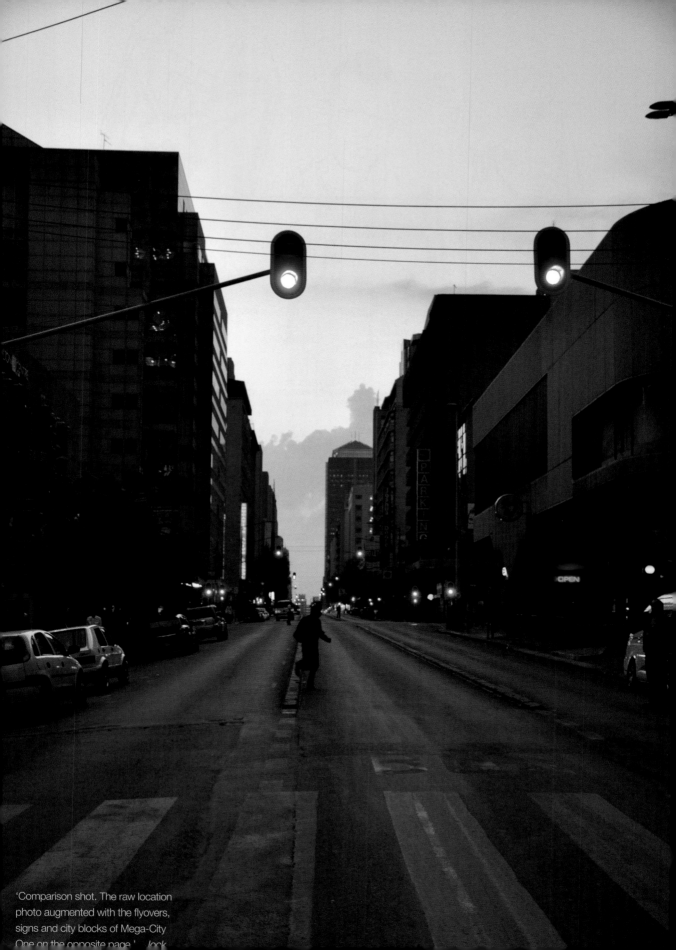

'Comparison shot. The raw location
photo augmented with the flyovers,
signs and city blocks of Mega-City
One on the opposite page.' *lock*

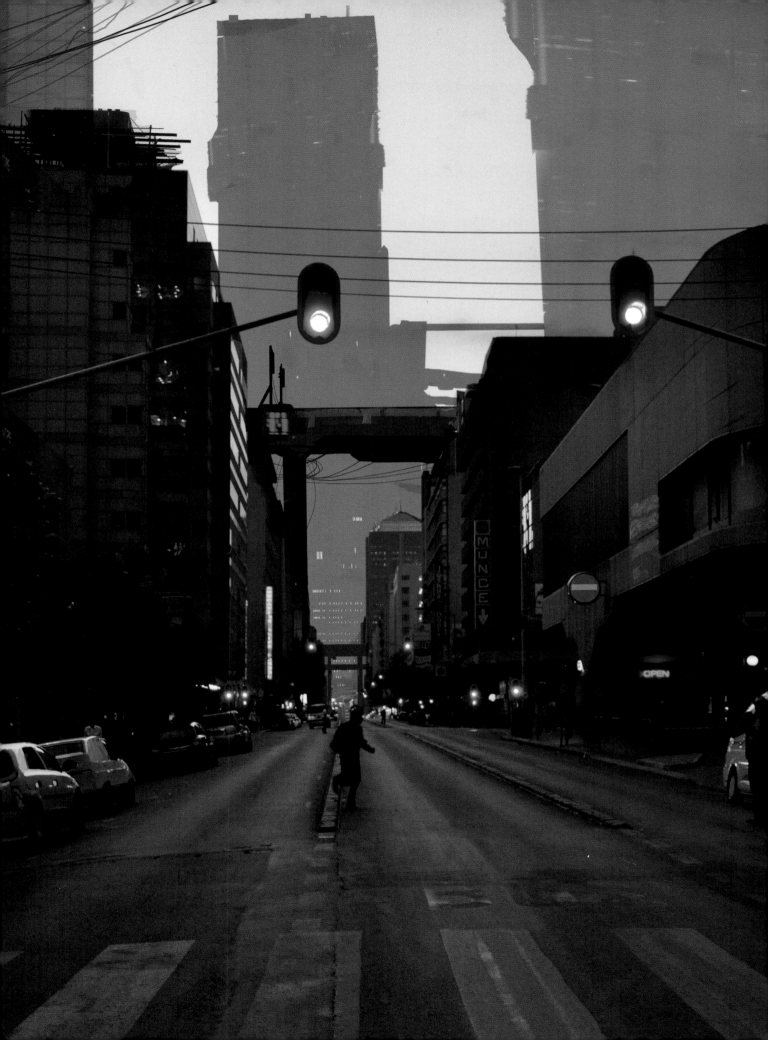

INT. CORRIDOR - CONTINUOUS

DREDD and ANDERSON move down a corridor, dragging KAY behind.

DREDD is talking into his radio.

DREDD

Control, we have a situation developing in Peach Trees. Request immediate back-up.

He gets only static back.

DREDD (CONT'D)

Control. Do you copy?

Static.

ANDERSON

(nervous)

My comms are down too.

DREDD

The shielding must be blocking our transmissions.

As he says this, they turn a corner.

Directly ahead is a posse of four CLAN, all armed.

CLAN MEMBER

(shouts)

THEY'RE HERE!

'Various early armour ideas.' - Jock

As DREDD, ANDERSON and KAY duck back behind the corridor, the CLAN open fire.

As the plasterwork around the corner erupts -

DREDD

Anderson. Call it.

ANDERSON

... Sir?

DREDD

You forgotten you're on assessment?

A volley of shots almost destroys the corner they are hiding behind.

ANDERSON

(flustered)

Sir - multiple armed targets. Minimal risk of collateral Rapid fire.

DREDD

Rapid fire.

On Dredd's command, a setting on DREDD'S gun changes.

He spins back around the corner, and opens up.

Rapid fire rounds rip through the air and punch into the CLAN, mowing them down.

DREDD (CONT'D)

We'll head back for the med center. This way.

They take a side door into a stairwell.

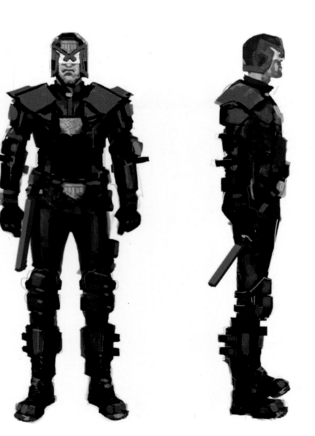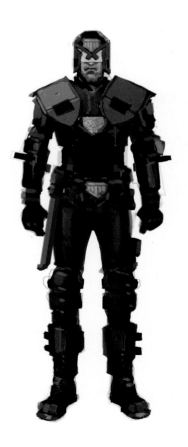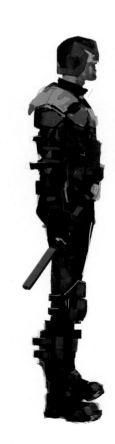

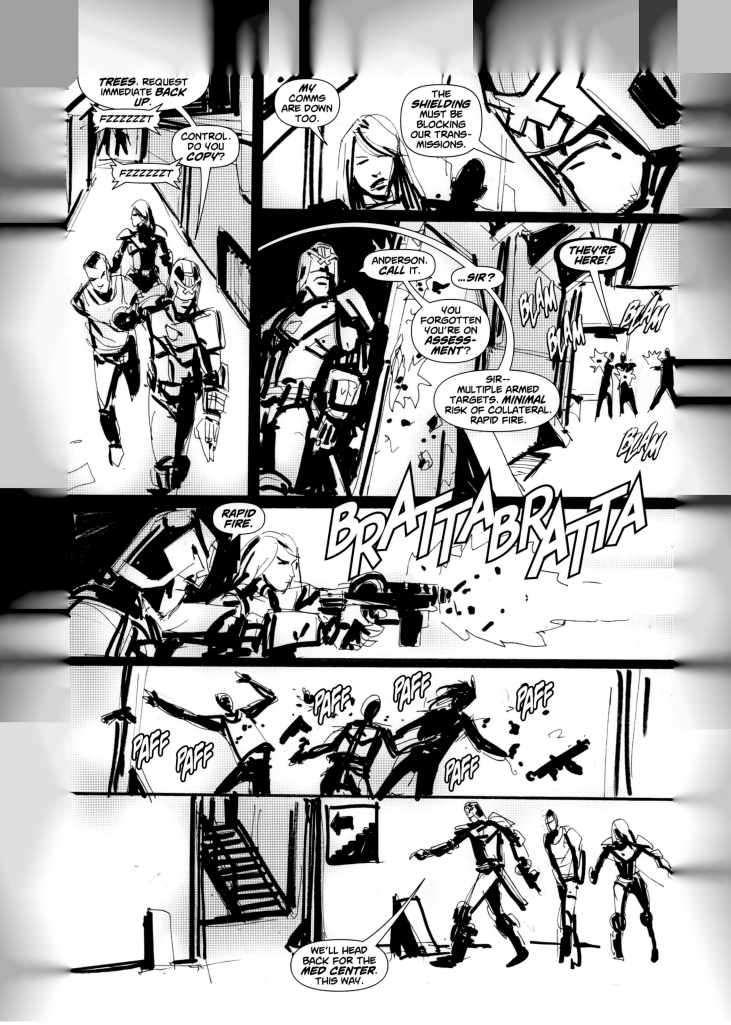

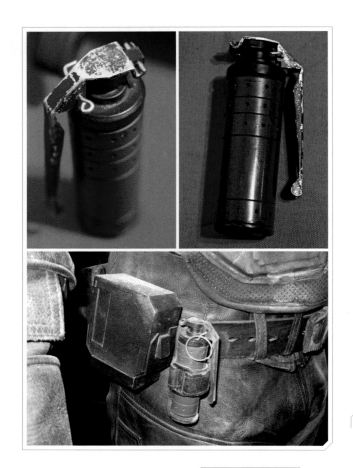

INT. STAIRWELL - CONTINUOUS

In the stairwell, DREDD looks up.

CLAN are coming from above.

DREDD looks down.

CLAN are coming from below.

> **DREDD**
>
> Respirators.

DREDD and ANDERSON pull respirators from their belts.

> **DREDD** (CONT'D)
>
> (to Kay)
>
> Advise you hold your breath.

From his utility belt, DREDD pulls out two grenades.

He primes them and throws them. One up. One down.

Gas plumes behind them as they arc through the air.

LAWGIVER EVOLUTION

This one was minus the rear scope. Getting closer to the final look.

 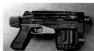 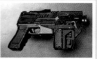 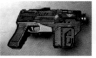 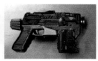

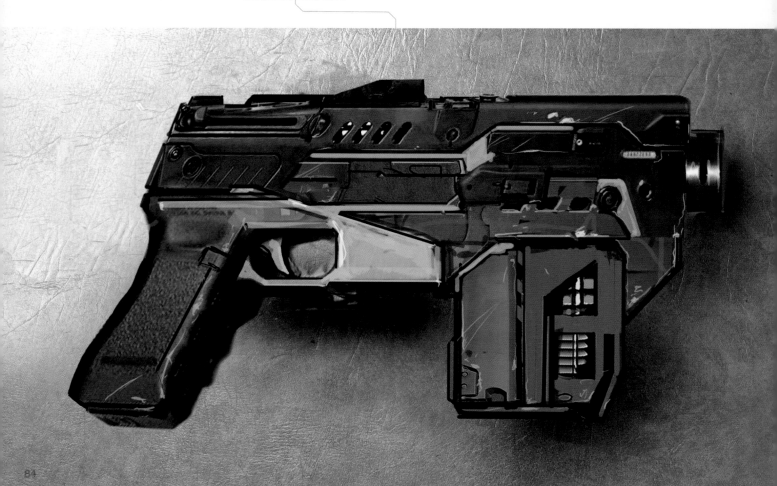

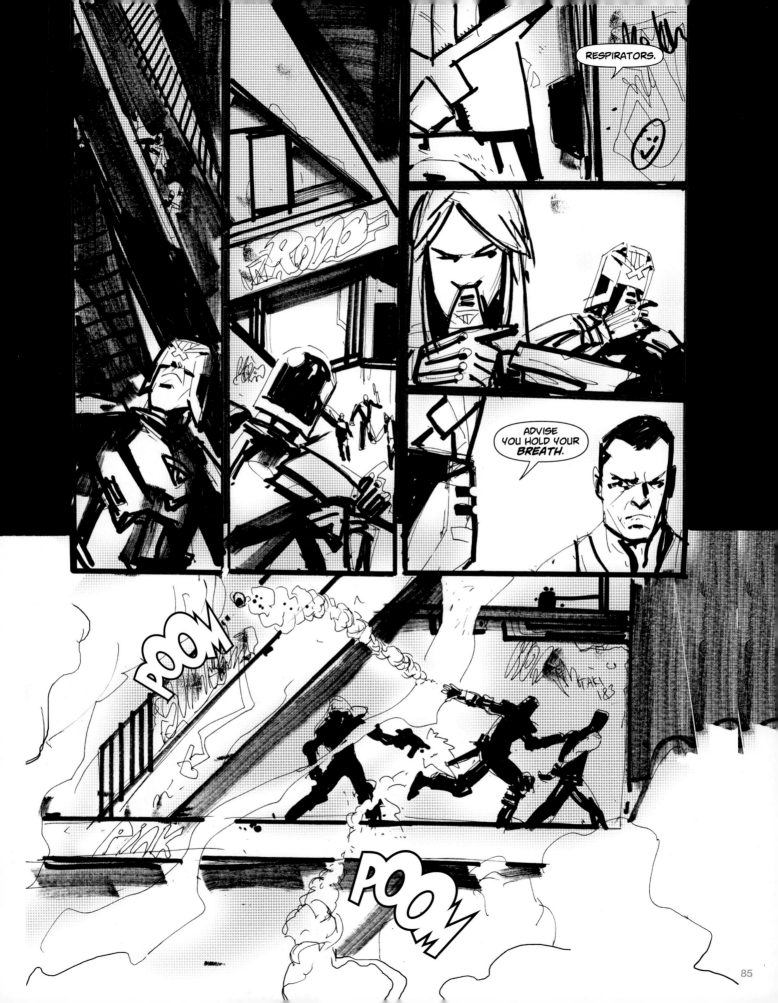

INT. STAIRWELL - CONTINUOUS

As DREDD and ANDERSON fight their way through the gas cloud, and the choking, vomiting CLAN ...

... CUT TO -

INT. JAPHET'S APARTMENT - CONTINUOUS

A man, JAPHET, with CLAN tattoos, is pulling apart his kitchen.

He has a BERETTA 9mm stuffed into the back of his trousers.

> **JAPHET**
>
> *Shit, shit, shit.*

He finds a box of bullets in the back of a drawer.

Checks it. There are three rounds inside.

> **JAPHET** (CONT'D)
>
> Three fucking rounds! Is that all we've got?

JAPHET takes out the clip and starts sliding in the rounds.

His fingers are shaking.

His WIFE, watching from the kitchen doorway, holding a young baby, is watching, horrified.

> **JAPHET'S WIFE**
>
> You're going to take on two judges with an antique gun and three bullets?

> **JAPHET**
>
> They probably aren't even on our level.

> **JAPHET'S WIFE**
>
> Then just stay in here! Let the others get them!

JAPHET slides the clip home.

> **JAPHET'S WIFE** (CONT'D)
>
> *Please,* Japhet!

> **JAPHET**
>
> What the fuck do you want me to do? Call Ma-Ma and ask if I can sit this one out? I'd be better off fighting the judges.

JAPHET pushes past his wife.

Then turns.

Looks at her.

> **JAPHET** (CONT'D)
>
> Lock the door. Don't open it, whatever happens.

He's gone.

> **JAPHET'S WIFE**
>
> (quiet)
>
> Oh God.

EXT. CORRIDOR - CONTINUOUS

We track JAPHET as he runs down the corridor.

As he runs, other CLAN are exiting from apartments, carrying firearms of various types.

> **MAN**
>
> (exiting apartment)
>
> Japhet!

> **JAPHET**
>
> Where we headed?

> **MAN**
>
> Big Joe said the med center!

INT. OUTSIDE MEDICAL CENTER - CONTINUOUS

JAPHET and the others join up with the crowd gathering outside the closed security doors of the MED CENTER.

In the middle of the crowd is BIG JOE.

BIG JOE is huge. He has a SAW machine gun in one hand and an ammo box in the other.

> **BIG JOE**
>
> I want the North and East corridors totally covered! Sal is covering West and South! Spread out the hardware!

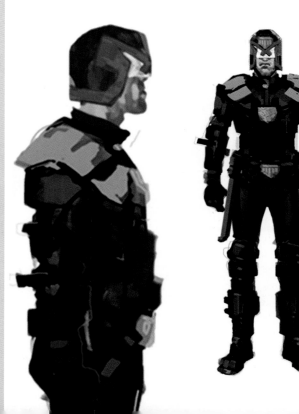

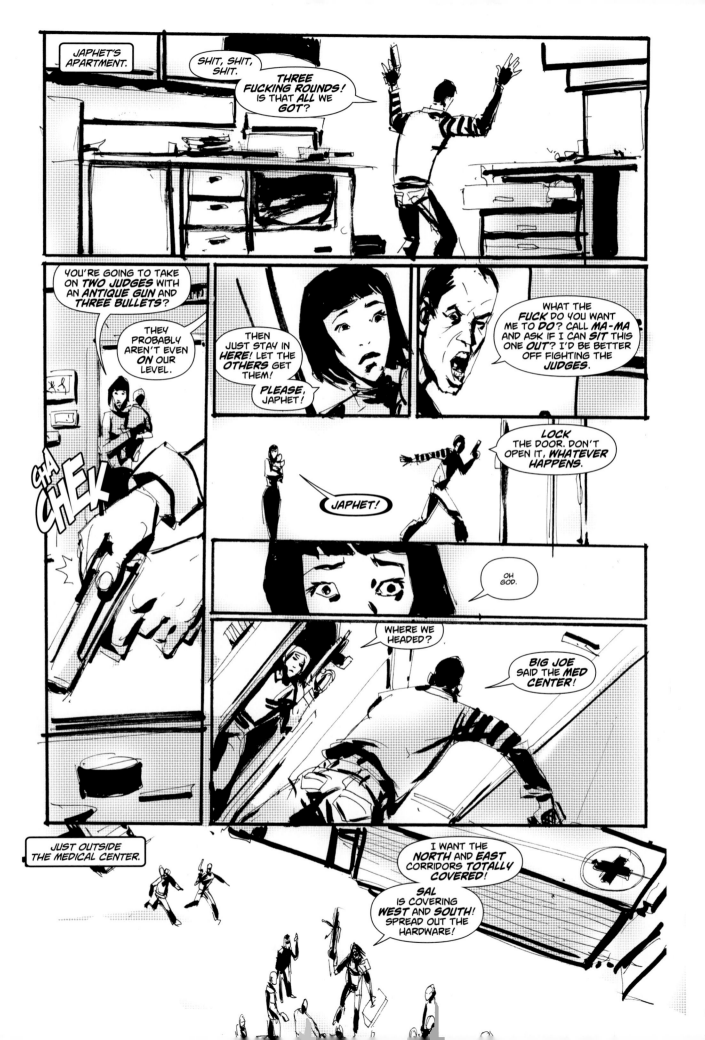

BIG JOE lifts his SAW, and fires a burst into the ceiling.

BIG JOE (CONT'D)

We're going to shoot these judges into hamburger and hand them to Ma-Ma on a plate.

CUT TO -

INT. DOORWAY - CONTINUOUS

On the other side of the area outside the MED CENTER, there is a door.

Slightly ajar.

Through it, a sliver of JUDGE'S helmet.

DREDD, observing the scene.

INT. ACCESS CORRIDOR - CONTINUOUS

DREDD and ANDERSON are hidden in an access corridor.

Low lit.

Utility pipework and wiring.

KAY is behind them. Gagged and cuffed to a pipe.

DREDD

We're going to have to go through them.

DREDD pulls back from the slightly open doorway.

Checks his utility belt.

DREDD (CONT'D)

No gas grenades. Got any flashbangs?

ANDERSON

One.

He looks back through the doorway.

DREDD

Let's give them the bad news.

INT. OUTSIDE MEDICAL CENTER - CONTINUOUS

TRACKING a small cylindrical object.

Rolling along the floor.

Under the legs of the citizen vigilantes.

Until it comes to a stop -

- under JAPHET.

He doesn't see it, because his attention - and the attention of all the vigilantes, is distracted by the sound of DREDD'S voice.

His words are amplified, as if through a loud hailer.

DREDD'S VOICE

Citizens of Peach Trees. This is the law.

The vigilantes look around, trying to see where the noise is coming from.

DREDD'S VOICE (CONT'D)

Disperse immediately, or we will use lethal force to clear the area.

CITIZEN

Where's that coming from?

CITIZEN (CONT'D)

Over there! The access corridor!

ALL WEAPONS swing to the doorway behind which DREDD and ANDERSON are hidden.

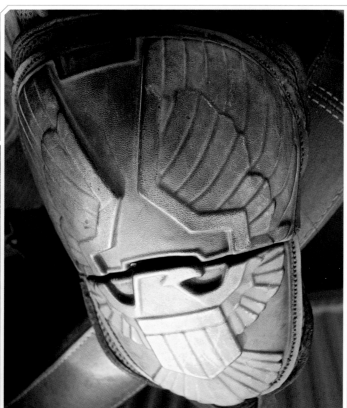

INT. ACCESS CORRIDOR - CONTINUOUS

DREDD and ANDERSON are pressed to the wall either side of the doorway.

DREDD is speaking into a mike, swung out of the inside curve of his helmet.

> **DREDD**
>
> You have been warned. You now have twenty seconds to comply.

INT. OUTSIDE MEDICAL CENTER - CONTINUOUS

BIG JOE, SAW trained on the doorway, shouts back.

> **BIG JOE**
>
> It's you doing the complying, judge. Twenty of us, two of you. Come out from that doorway, or we're blowing the shit out of you.
>
> **DREDD**
>
> Ten seconds to comply.

BIG JOE flips the safety.

> **BIG JOE**
>
> You got five.

INT. ACCESS CORRIDOR - CONTINUOUS

> **DREDD**
>
> Thanks for the heads-up.

In his hand, he depresses a small button on a hand held device.

INT. OUTSIDE MEDICAL CENTER - CONTINUOUS

At JAPHET'S feet -

- the FLASHBANG detonates.

A blinding flash of light fills the space.

As our vision returns, bleaching back from white-out brightness, deafening tinnitus ringing in our ears ...

...we can see DREDD and ANDERSON are already out of the doorway.

Guns blazing.

'The simple remit for Dredd was that he had to look functional. Any element that would be a hindrance was out. No chain... No bulky, over-the-top shoulder pads... This is a guy in hand-to-hand combat every day, so we set about streamlining Dredd's look to a hard-wearing, practical uniform.' - *Jock*

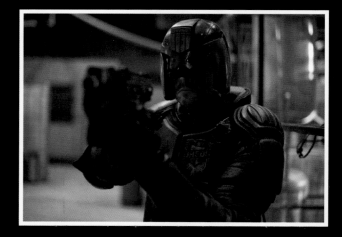

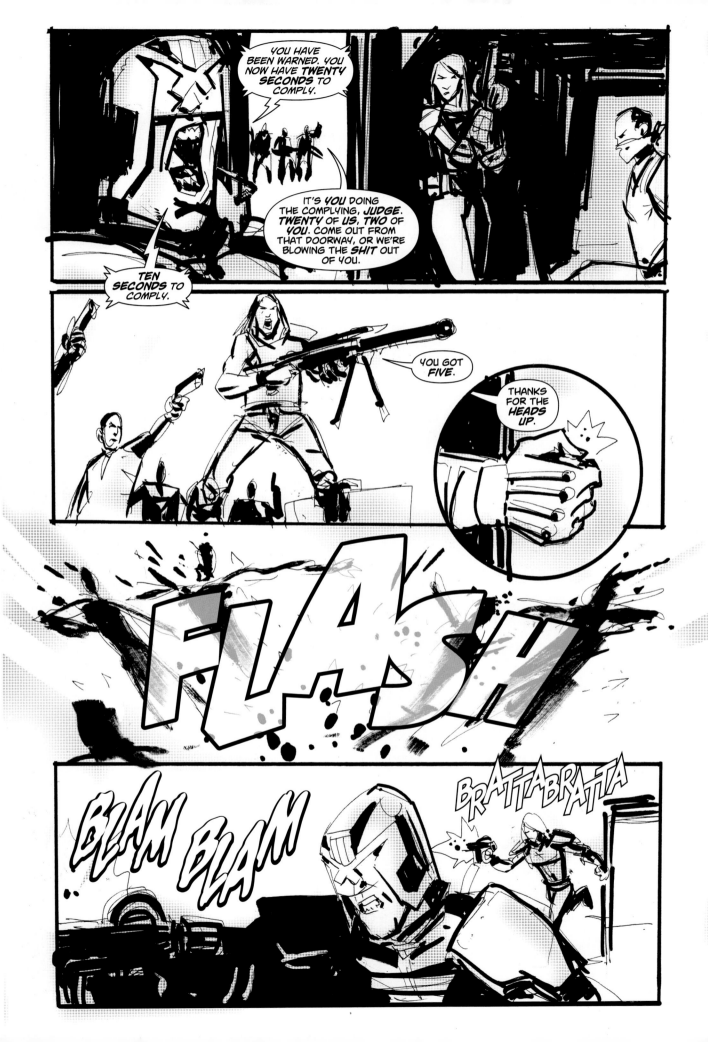

91

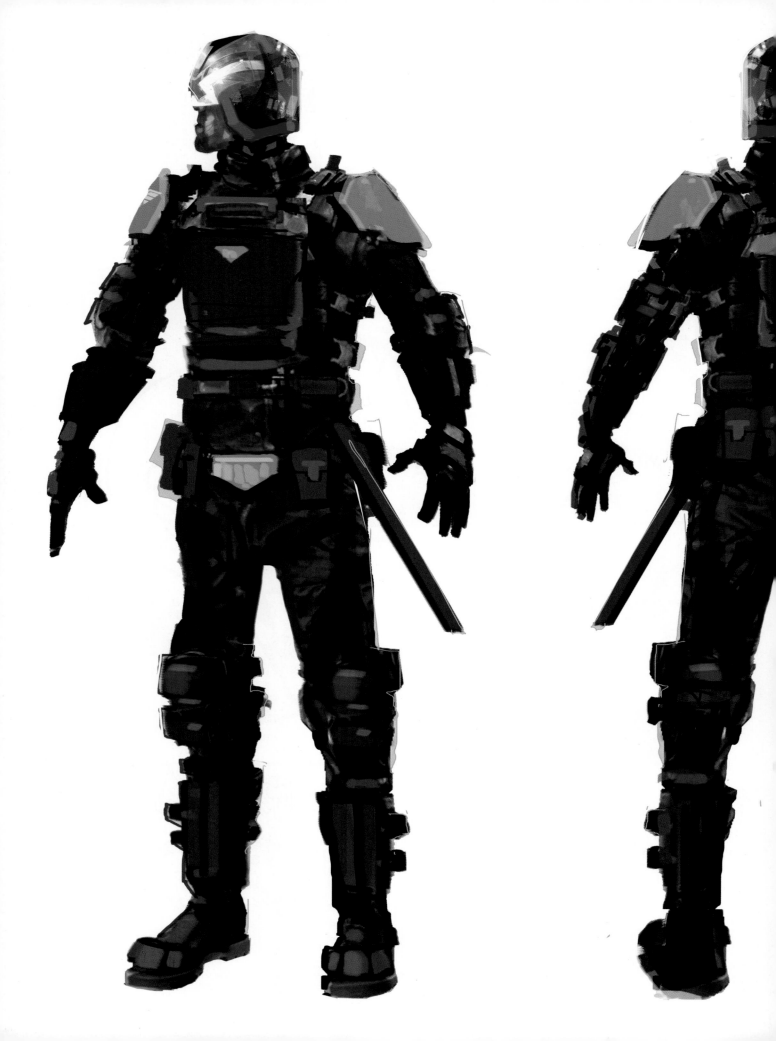

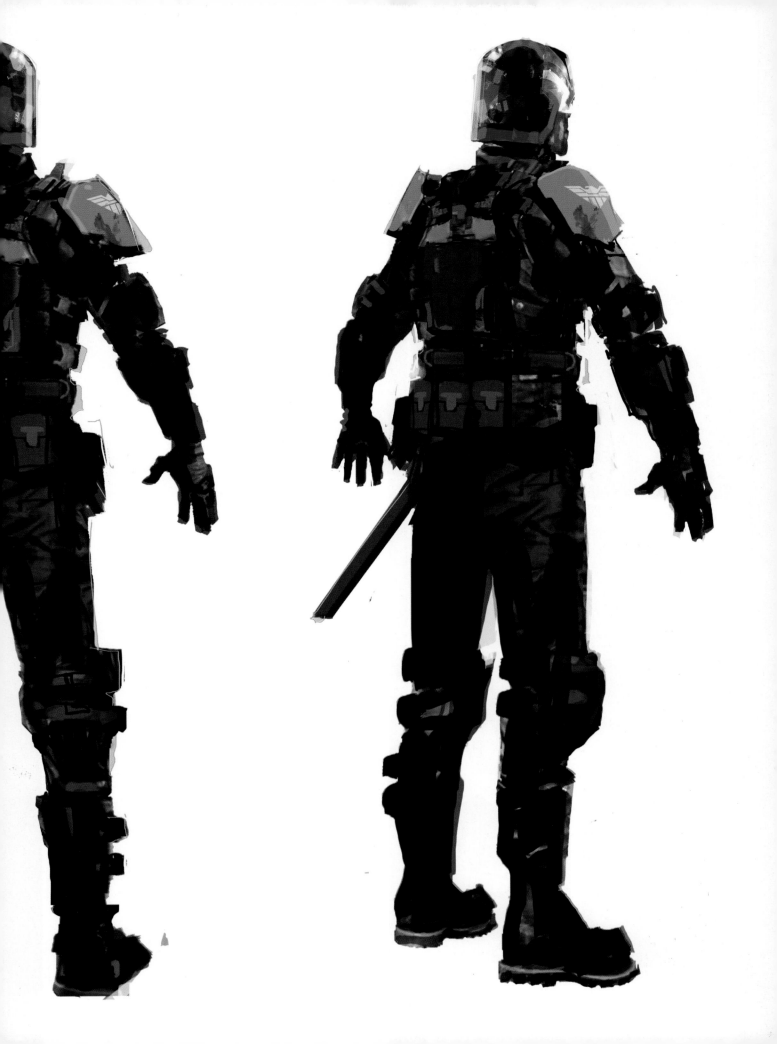

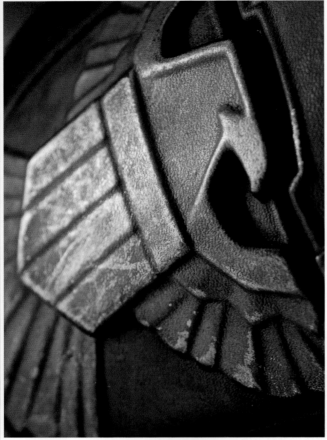

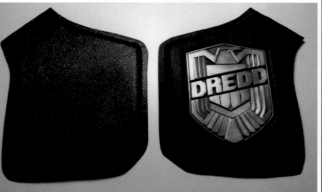

And the CLAN MEMBERS are being shredded by the rain of rapid fire.

Before the effects of the flashbang have cleared, the CLAN have been shot to the ground.

CUT TO -

ANDERSON.

She seems dazed by the sight of the carnage.

The shattered bodies. The sprays of blood and bullet holes.

She's looking at the one vigilante who is still alive.

JAPHET.

Bloon pouring from the wounds in his stomach. Doubled up on the floor. Kneeling. Still dazed.

Seeing his BERETTA beside him.

With slow, drunken coordination, reaching for it.

Trying to bring it to bear on ANDERSON.

ANDERSON keeps her gun levelled at JAPHET.

But she doesn't fire.

Instead, frozen, watches as JAPHET'S arm fails him.

The gun remains only half-raised. Swaying. As if it is heavy for him to lift.

DREDD'S voice cuts in to ANDERSON'S reverie.

> **DREDD**
>
> Anderson - what are you waiting for?

ANDERSON doesn't answer.

> **DREDD** (CONT'D)
>
> His crime is attempted murder of a judge. His sentence is death.

Beat.

> **ANDERSON**
>
> (distant)
>
> Sir.

ANDERSON fires.

JAPHET is hit in the head.

He drops forward, and lands face down.

HOLD on DREDD a moment. Watching ANDERSON. His face is expressionless, but we can tell: as far as ANDERSON'S assessment goes, the balance just tipped against her.

'Early on we weren't going to use the eagle motif on the shoulder, but I love how costume designer Michael O'Connor made use of it, in a practical way.' - *Jock*

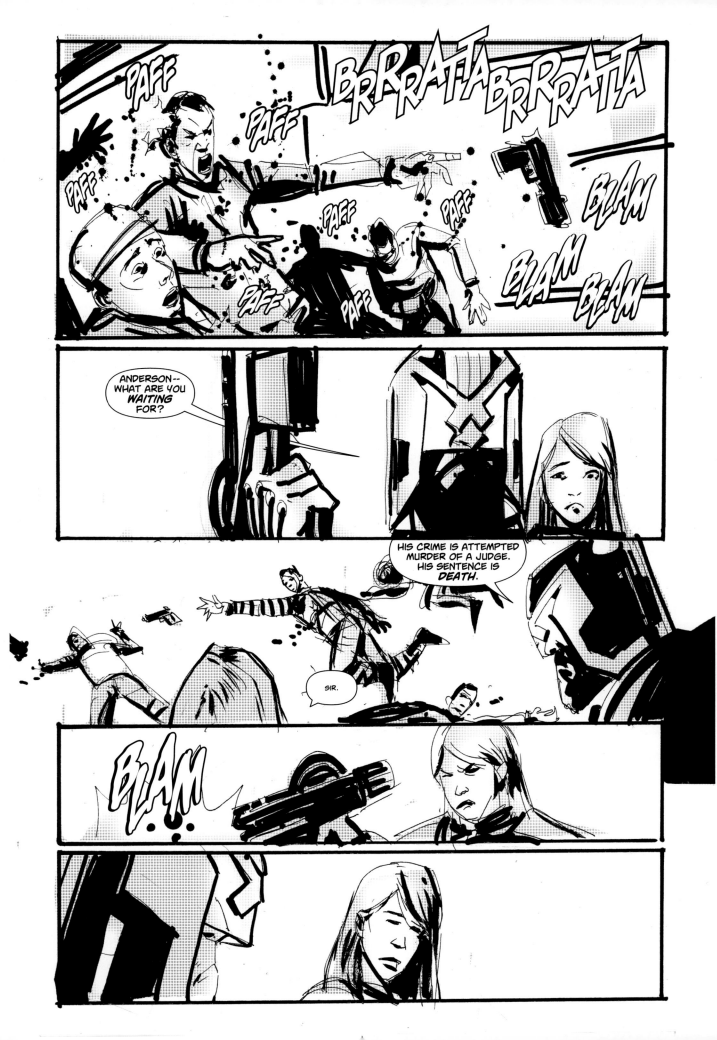

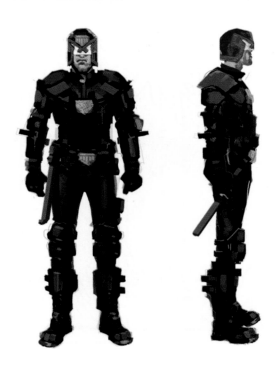

INT. MEDICAL CENTER - CONTINUOUS

The PARAMEDIC is watching a monitor from behind his security doors.

On the monitor:

ANDERSON is pulling KAY out of the access corridor.

DREDD is walking over the bodies of the dead vigilantes, to the video intercom.

> **DREDD**
>
> Open up.

In front of the PARAMEDIC is the door release mechanism. But he makes no move for it.

> **DREDD** (CONT'D)
>
> (leaning into the camera)
>
> Open *up!*

> **PARAMEDIC**
>
> Negative, judge.

> **DREDD**
>
> You know what's going on. We need a place we can defend.

> **PARAMEDIC**
>
> Then you'd better find somewhere else. This is a medical facility. Neutral ground.

> **DREDD**
>
> You're not neutral. You're choosing sides.

> **PARAMEDIC**
>
> Peach Trees has been sealed by blast doors designed to withstand nuclear attack. No one is getting out.
>
> (MORE)

> **PARAMEDIC** (CONT'D)
>
> No one is getting in. And you have every Clan affiliate in the block after your blood.
>
> (shrugs)
>
> You're already dead. There are no sides.

INT. OUTSIDE MEDICAL CENTER - CONTINUOUS

DREDD walks to ANDERSON.

KAY kneels a few feet away.

> **DREDD**
>
> We're going to keep moving.

They are out of KAY'S earshot, but he seems to know what's happening.

He smiles.

> **ANDERSON**
>
> What about the perp? Are we keeping him with us?

> **DREDD**
>
> Explain.

> **ANDERSON**
>
> ... Just that under the circumstances, he's a liability.

> **DREDD**
>
> Also a prime suspect in five homicides. What do you say, rookie? Want to cut him loose?

> **ANDERSON**
>
> (chastened)
>
> No, sir.

INT. LEVEL TWENTY FIVE/CORRIDOR - DAY

KAY, with DREDD and ANDERSON either side of him, move down a corridor.

Echoing down the corridors, we can hear the voices and shouts of CLAN, searching for the judges.

> **DREDD**
>
> (quiet)
>
> Switch weapon to silencer mode. Minimum profile. Conserve ammunition. Don't shoot unless you're going to hit.

They hit a button on their handguns, and a suppressor slides out over the barrel.

Almost as soon as they have done so, at the far end of the corridor, at a T-junction, we see three armed CLAN appear.

They are not facing the judges. They appear to be talking to someone out of sight around the junction corner.

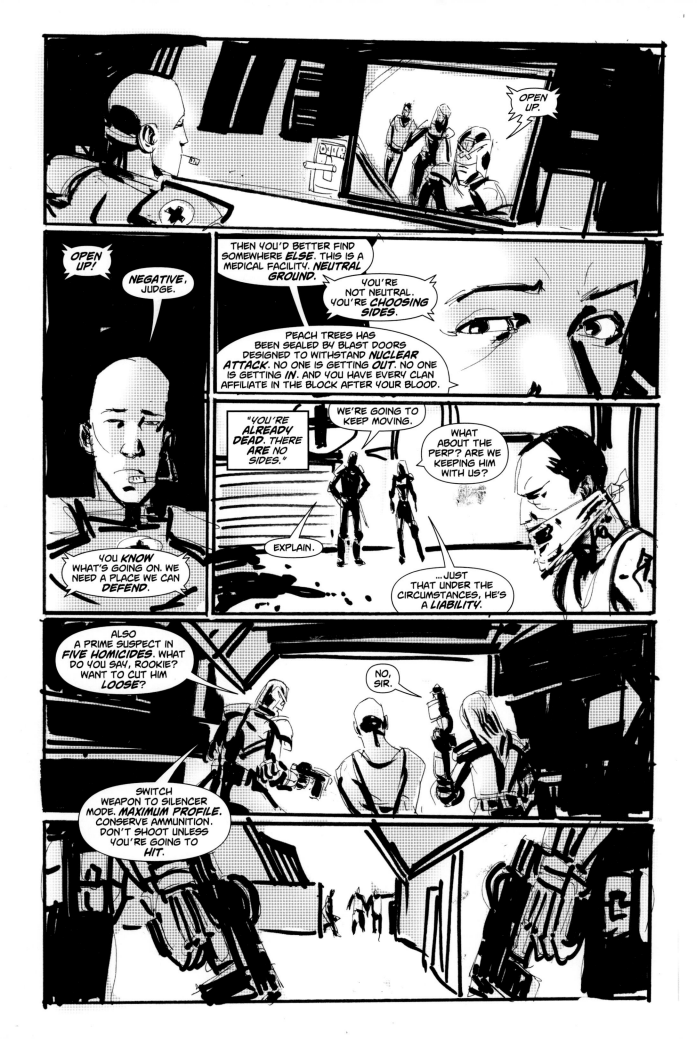

ANDERSON'S gun raises immediately

- but DREDD pushes her hand down.

He pulls her into the recess of one of the apartment doorways.

DOWN THE CORRIDOR -

- the three CLAN start to walk towards us.

IN THE RECESS -

DREDD pushes himself flat, gun raised, waiting for the men to draw parallel.

We can hear their footsteps.

Getting closer.

But ANDERSON is doing something else.

Her head suddenly tilts to the side -

- as if she is listening. Hearing something through the apartment doorway.

Then stays motionless like that for a moment.

Then - surprisingly, ANDERSON pushes the intercom buzzer.

DREDD (CONT'D)

(whispers)

What are you -

She motions for him to be silent.

Then whispers into the intercom.

ANDERSON

Cathy?

Beat. Then:

WOMAN'S VOICE

(through intercom)

Who's that?

The ARMED CITIZENS are now only a few feet away.

ANDERSON

Cathy, open the door.

Another beat.

Then the door unlatches.

Immediately, ANDERSON jams it open.

LAWGIVER EVOLUTION
Another variation.

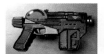 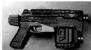 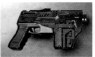 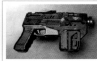 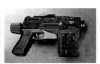 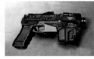

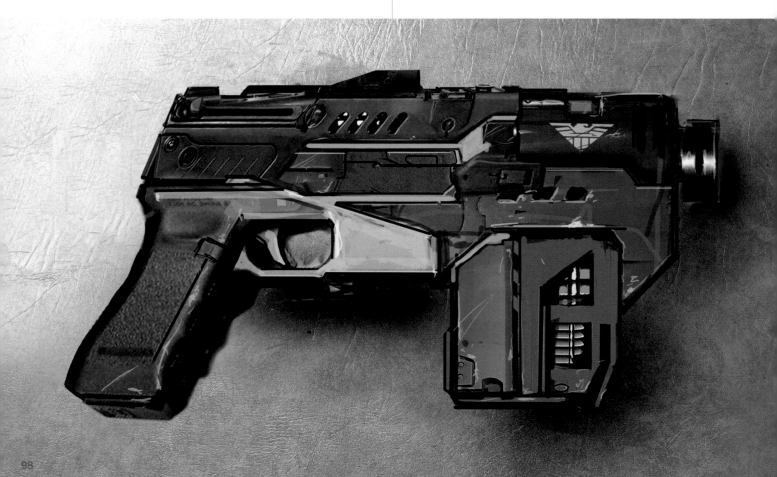

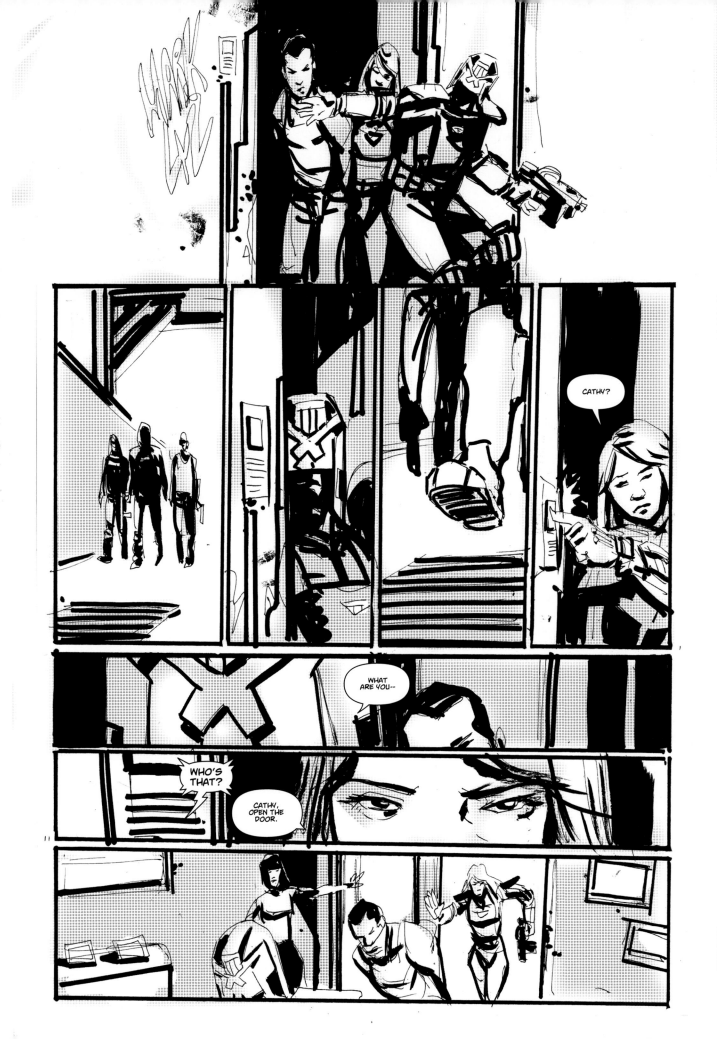

INT. JAPHET'S APARTMENT - CONTINUOUS

DREDD and ANDERSON push inside with KAY, throwing CATHY back, and close the door behind them.

As soon as we see CATHY, we recognise her as JAPHET'S wife.

ANDERSON stops CATHY from screaming with her hand.

> **ANDERSON**
>
> (quiet)
>
> It's okay. We aren't going to hurt you.

DREDD watches through the spyhole as the ARMED CITIZENS pass.

A silent beat.

> **DREDD**
>
> They're gone.

He turns, looking at ANDERSON. She obviously just went up in his esteem.

> **DREDD** (CONT'D)
>
> Secure the woman, somewhere where she can't raise any alarms, and we'll move on.

> **ANDERSON**
>
> Sir - I don't think we can. She has a baby. Joey. Asleep next door. He's three weeks old.

CATHY, wide-eyed with confusion and fear, nods.

> **ANDERSON** (CONT'D)
>
> We can't secure her if we don't know when she'll get freed.

> **DREDD**
>
> Where's her husband?

ANDERSON gazes into CATHY'S eyes. Not looking into them. Through them.

> **ANDERSON**
>
> Out there. Looking for us.

CATHY'S eyes open even wider. Awed and bewildered by ANDERSON'S abilities.

> **ANDERSON** (CONT'D)
>
> She has something to say.

ANDERSON removes her hand from CATHY'S mouth.

> **ANDERSON** (CONT'D)
>
> Go ahead, Cathy.

CATHY keeps looking at ANDERSON, hyperventilating.

> **CATHY**
>
> You. You're - How did you -

> **ANDERSON**
>
> (cuts in)
>
> Calm down. Just tell him what you were thinking.

CATHY takes a deep breath. Tries to control the tremor in her voice.

> **CATHY**
>
> I'm not raising any alarms. If the men out there don't know where you are, you won't be killing them.

> **DREDD**
>
> Go on.

> **CATHY**
>
> There's a service elevator near here. The sign says it's broken, but it works as long as you're hitting a button above level forty.

DREDD nods.

> **DREDD**
>
> You've done the right thing, citizen.

> **CATHY**
>
> I just want you off my level. Away from my family.

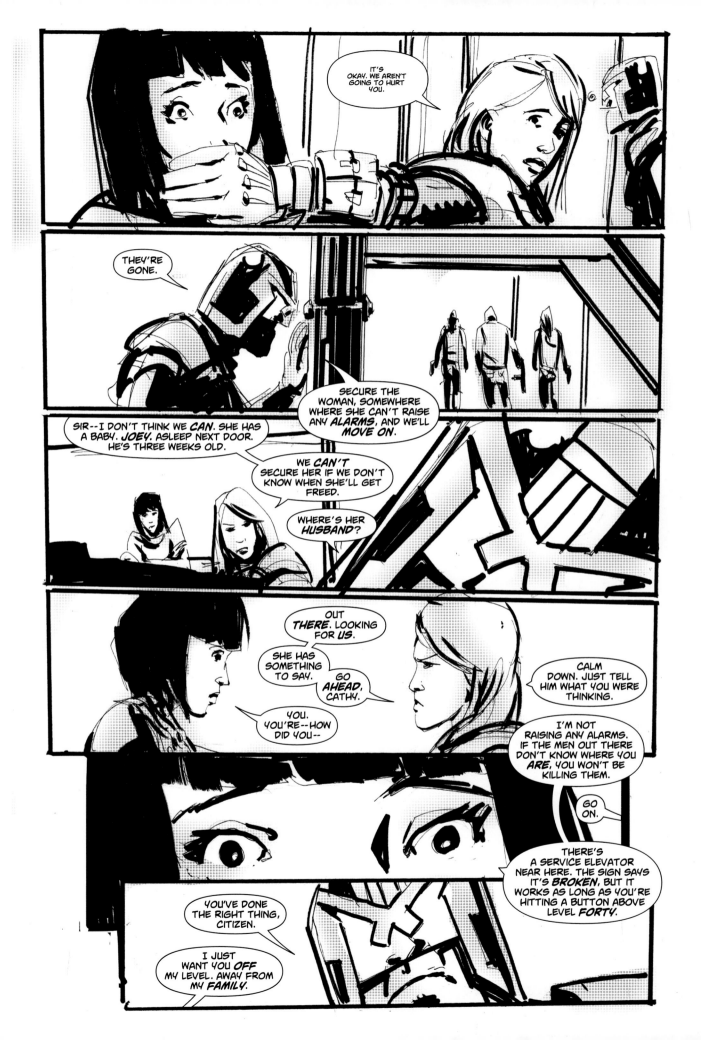

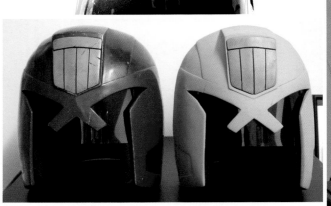
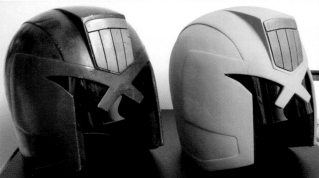
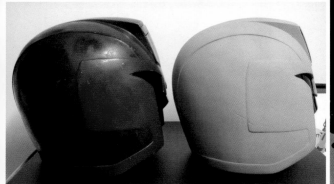
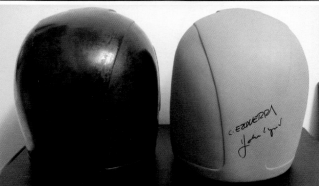
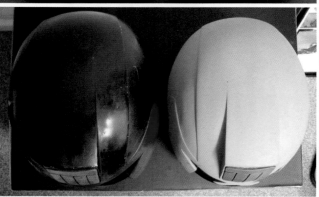

Various versions of Dredd's helmet were manufactured. The final movie version is on the left, and a smaller 'Urban Special' on the right. The smaller version was specially made for Karl Urban but was only used in early press shots.

INT. LEVEL TWENTY FIVE/DOORWAY - CONTINUOUS

DREDD eases the door open.

Checks each way down the corridor.

> **DREDD**
>
> It's clear. Let's move.

INT. JAPHET'S APARTMENT - CONTINUOUS

DREDD leads KAY through the door into the corridor.

ANDERSON is about to follow -

- then stops dead.

She's seen something.

On the wall - a framed photo.

CATHY, the BABY, and JAPHET.

A terrible, frozen beat, as ANDERSON realises that the man she executed was CATHY'S husband.

From the other room, the baby wakes, and starts to cry.

ANDERSON looks back to CATHY.

A moment between them.

> **ANDERSON**
>
> Cathy, I -
>
> **CATHY**
>
> (cuts in)
>
> Don't thank me. It's not for you. I just don't want to see you again.
>
> **ANDERSON**
>
> (quiet)
>
> You won't.

INT. LEVEL FIFTY/LOBBY - DAY

An armed CLAN MEMBER stands guard in a lobby.

The glowing wall stencil reads LEVEL 50.

Behind him is the service elevator. A sign in front of it reads: out of order.

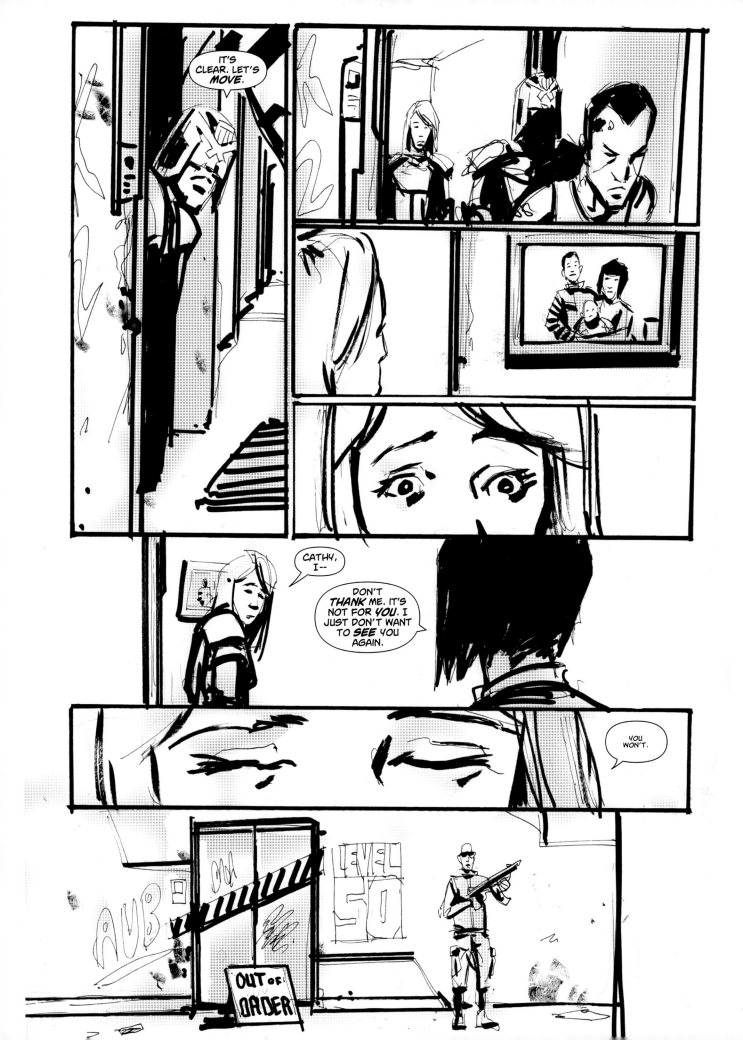

But- PING.

The elevator just arrived.

The CLAN MEMBER turns as the doors open.

And sees DREDD pointing a gun right at his head.

The next moment, the CLAN MEMBER drops, shot silently, right between the eyes.

CUT TO -

INT. CCTV IMAGES - CONTINUOUS

- a CCTV image of the dead CLAN MEMBER, crumpled on the floor by the service elevator.

CLAN TECHIE (O.S.)

We've got one here.

CUT TO -

- the strewn bodies outside the med center.

CLAN TECHIE (O.S.) (CONT'D)

Maybe twenty outside the med center.

CUT TO -

- the bodies in the stairwell.

CLAN TECHIE (O.S.) (CONT'D)

Eight in the stairwell.

CUT TO -

- the bodies in the corridor.

CLAN TECHIE (V.O.) (CONT'D)

And another five on level eighteen.

CUT TO -

INT. MA-MA'S BASE/CCTV ROOM - CONTINUOUS

- the bank of monitors on which these images are being shown.

Watching these images, over the shoulder of the CLAN TECHIE, is MA-MA and her BODYGUARDS.

CLAN TECHIE

They've downed thirty plus, and haven't even taken a scratch.

MA-MA

Where are they now?

The CLAN TECHIE points to the monitors.

CLAN TECHIE

These bodies are from level forty six and forty eight, but -

The CLAN TECHIE breaks off.

CLAN TECHIE (CONT'D)

Wait - I just picked them up. Level fifty, west quadrant.

He points them out on the monitor. Zooms in the image.

CLAN TECHIE (CONT'D)

Do you want me to hook you up to the Tanoy? We could get level forty through sixty converging on them.

MA-MA processes. Quickly.

MA-MA

No. Can you seal them in there?

CLAN TECHIE

Nuke override gives me full control of the building.

The CLAN TECHIE starts tapping in commands to his console.

CLAN TECHIE (CONT'D)

There. I just triggered the fire protocols. All doorways to stairwells, elevator shafts, and access corridors are all sealed. Full lockdown. They're going nowhere.

MA-MA nods.

MA-MA

They're in the west quadrant, so I want three miniguns set up on the east.

Tight on MA-MA. The ice in her eyes.

MA-MA (CONT'D)

I tried to do this clean. But they wouldn't let me. So now we do it messy.

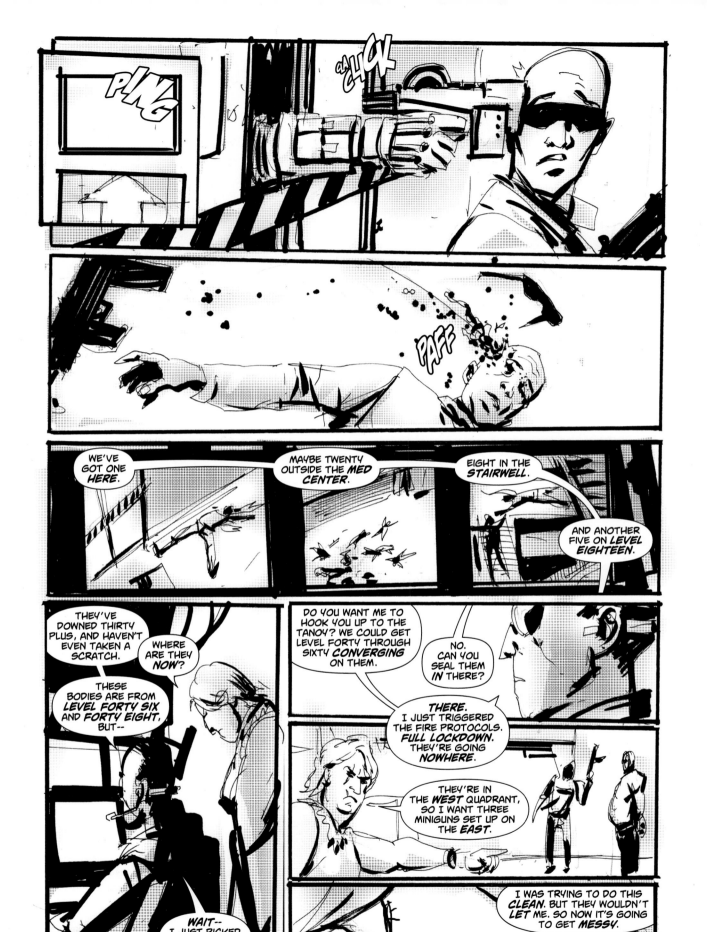

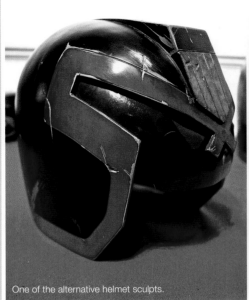

One of the alternative helmet sculpts.

CUT TO -

INT. LEVEL FIFTY/LOBBY - CONTINUOUS

DREDD, ANDERSON and KAY stop in their tracks, as all around them, in a strange ripple of sound, all the doorways are locking.

The noise starts from down the corridor, then passes over them like a wave, and continues away from them.

Then a computerised voice comes over the Tanoy.

> **TANOY**
>
> Warning. Warning. Fire containment protocol initiated. All citizens remain in your apartments until further notice.

> **DREDD**
>
> This isn't good.

DREDD'S gaze flicks to the CCTV camera in the corner of the lobby.

He knows the Clan are watching.

He lifts his gun and -

CUT BACK TO -

INT. MA-MA'S BASE/CCTV ROOM - CONTINUOUS

- fires.

The monitor image goes dead.

> **MA-MA**
>
> Too late, Judge.

MA-MA lifts her handset.

> **MA-MA** (CONT'D)
>
> Caleb, come in.

INT. PEACH TREE CONTROL ROOM - CONTINUOUS

CALEB lifts his radio.

> **CALEB**
>
> Here, Ma.

> **MA-MA**
>
> We've got them cornered. We're taking them down, right now.

INT. LEVEL FIFTY/CORRIDOR - DAY

A blast door covers the entrance to a stairwell.

DREDD is checking it out.

> **DREDD**
>
> We'll need oxyacetylene to even make a dent.

ANDERSON looks around.

They are in a long corridor, with further corridors leading off. There is no cover, except the shallow recesses of the doorways.

> **ANDERSON**
>
> Why aren't they coming? They know where we are.

> **DREDD**
>
> Not sure.

He lifts his gun and shoots out the ceiling lights of the section of corridor they are in, leaving this section of the corridor in darkness.

> **DREDD** (CONT'D)
>
> (to Anderson)
>
> You'll see anyone coming before they see you. It'll give you a chance.

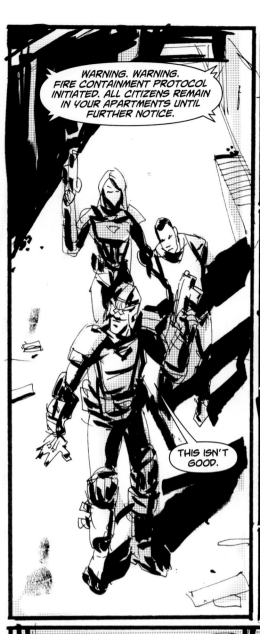

WARNING. WARNING. FIRE CONTAINMENT PROTOCOL INITIATED. ALL CITIZENS REMAIN IN YOUR APARTMENTS UNTIL FURTHER NOTICE.

THIS ISN'T GOOD.

BLAM

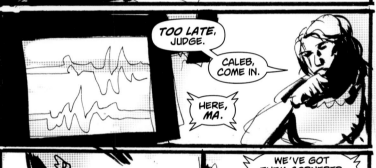

TOO LATE, JUDGE.

CALEB, COME IN.

HERE, MA.

WE'VE GOT THEM CORNERED. WE'RE TAKING THEM DOWN, RIGHT NOW.

ON OUR WAY.

WE'LL NEED OXYACETYLENE TO EVEN MAKE A DENT.

WHY AREN'T THEY COMING? THEY KNOW WHERE WE ARE.

NOT SURE.

BLAM

YOU'LL SEE ANYONE COMING BEFORE THEY SEE YOU. IT'LL GIVE YOU A CHANCE.

ANDERSON

Where are you going?

DREDD

To find out what they're up to.

He starts to walk away.

Then stops and looks back.

DREDD (CONT'D)

If I don't come back, and you get cornered, you might not want to be taken alive.

(beat)

Your call.

ANDERSON

... Sir.

DREDD turns and goes. Leaving ANDERSON alone with KAY, in the darkness.

INT. LEVEL FIFTY/CORRIDOR - CONTINUOUS

DREDD moves cautiously down a corridor.

The corridor is empty.

As he walks down, we cut to the interiors of the apartments ...

INT. LEVEL FIFTY/APARTMENTS - CONTINUOUS

... and see the lives inside.

The people. The families.

This is the reality of the world inside Peach Trees. Normal people, managing as best they can.

And right now, they are silent. Frightened. Huddled. Fathers with a hand on the shoulder of teenage daughters. Mothers trying to keep babies from crying.

Because on their security monitors, and through the fish-eye lenses of the spyholes on their doors, they can see the JUDGE passing by outside.

They know trouble is coming.

INT. LEVEL FIFTY/CORRIDOR - CONTINUOUS

DREDD turns a corner.

Ahead, he can see where the next section of corridor ends ...

... at the ringed balcony around the atrium.

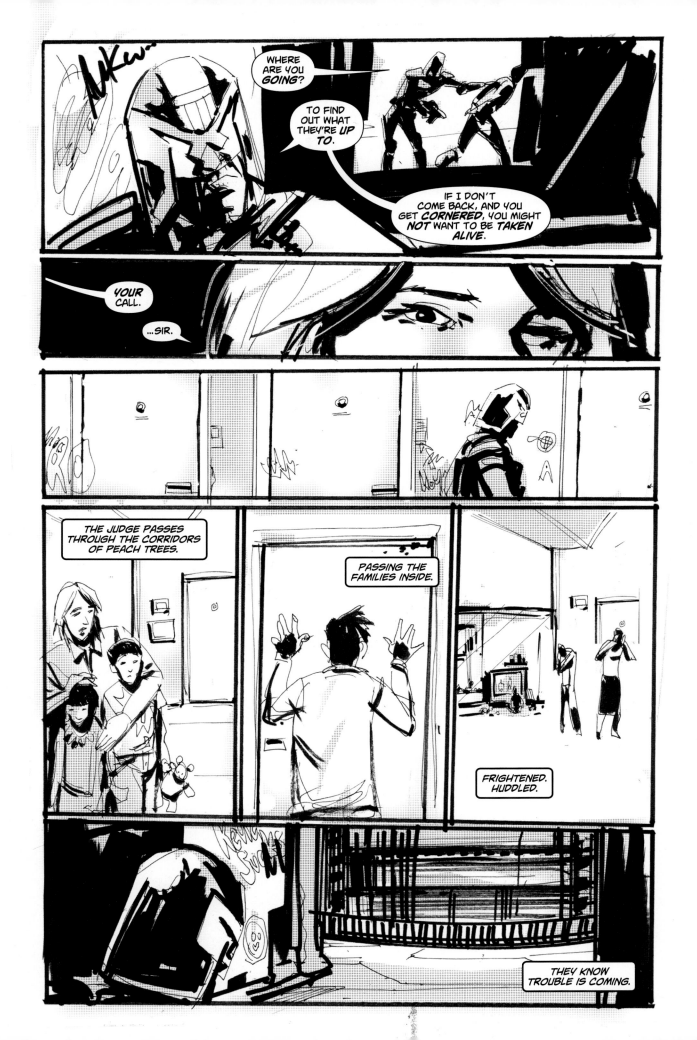

INT. LEVEL FIFTY/DARK CORRIDOR - CONTINUOUS

ANDERSON waits with KAY.

KAY is sat on the floor, hands still cuffed behind his back.

ANDERSON'S gaze is flicking between the two lit ends of the corridor.

KAY'S gaze is on only ANDERSON.

His tongue wets his lips.

Then, after a few moments -

> **KAY**
>
> He's right, you know.

ANDERSON reacts. Partly because KAY has broken his silence. Partly because of what he's said.

> **KAY** (CONT'D)
>
> About not wanting to be taken alive.
>
> (beat)
>
> The stuff the Clan would do to a girl like you ...
>
> (shakes his head)
>
> Nasty.

Beat.

> **KAY** (CONT'D)
>
> I mean, there was this one time, we got a girl about your age and -
>
> (he breaks off)
>
> Well anyway. I'm just saying. Save the last bullet for yourself.

> **ANDERSON**
>
> If I do, I'll save the second from last bullet for you.

KAY smiles to himself.

She's made a mistake. By attempting to show that she isn't getting rattled, she has in fact shown that she is.

> **KAY**
>
> Sure.

Beat.

> **KAY** (CONT'D)
>
> So - you're a mutant. I've heard about your kind. Psychics, right?

Beat.

> **KAY** (CONT'D)
>
> Kind of hard to believe it's real. Like - what am I thinking about right now?

ANDERSON turns and gazes at him evenly, determined to show he can't get to her.

> **ANDERSON**
>
> You're picturing a violent sexual liason between the two of us in a pointless attempt to shock me.

KAY raises his eyebrows.

> **KAY**
>
> You're good.
>
> (beat)
>
> But I wasn't trying to shock you. If I'd have been trying to shock you, I'd thought of *this*.

ANDERSON suddenly winces at the image he had dropped on her.

Then - snaps.

She lashes out with her fist.

Catches KAY full in the face, and drops him.

> **ANDERSON**
>
> What are you thinking about *now*?

Through bloody and busted lips, KAY looks up at her and smiles.

He might be bleeding and cuffed, but the victory in this encounter is his.

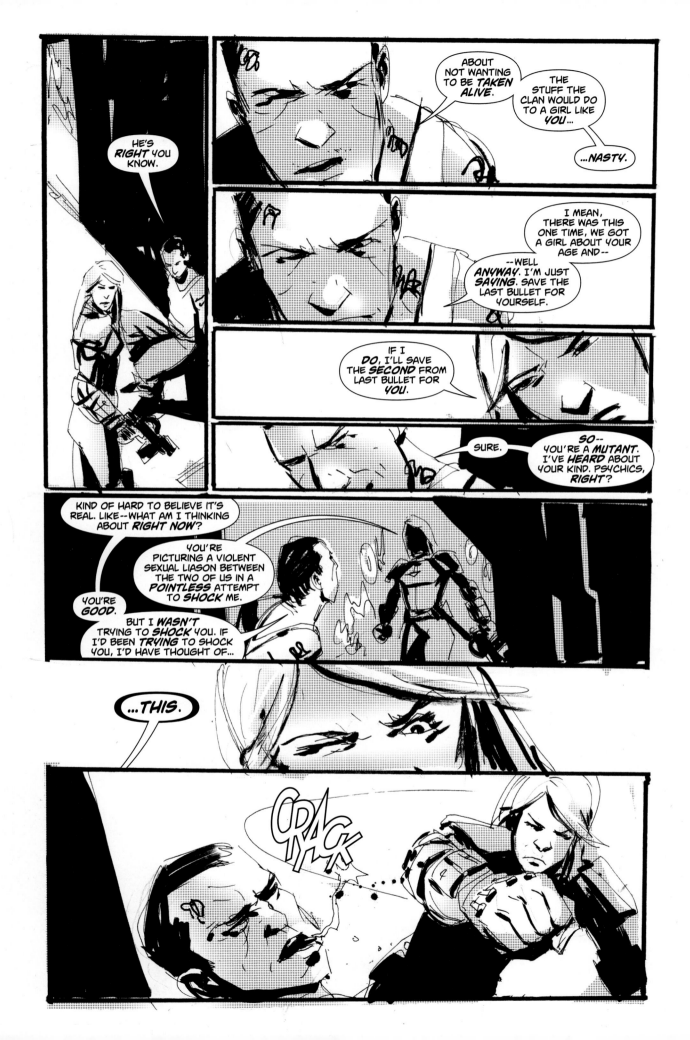

INT. ATRIUM - CONTINUOUS

We are spiralling up through the levels, to level fifty.

At level fifty, we find DREDD pressed to the wall of a corridor, as it exits on to the west quadrant of the interior balcony.

The camera continues its spiral motion, but remains at level fifty, to reveal to the east quadrant.

Directly opposite the west.

As three MINGUNS appear over the balcony rail.

Each with six rotating barrels, electric driven, air-cooled, firing six thousand rounds a minute.

Behind the machine guns are MA-MA, her BODYGUARDS, CALEB, and his men.

CUT TO -

DREDD.

 DREDD

 ... Damn.

CUT TO -

MA-MA.

 MA-MA

 Fire.

CUT TO -

DREDD.

Sprinting back down the corridor.

Back to ANDERSON.

As the miniguns open up.

'The first 3D build of the helmet (top row). I painted over it to get the shapes nearer to the more recognisable look.' - *Jock*

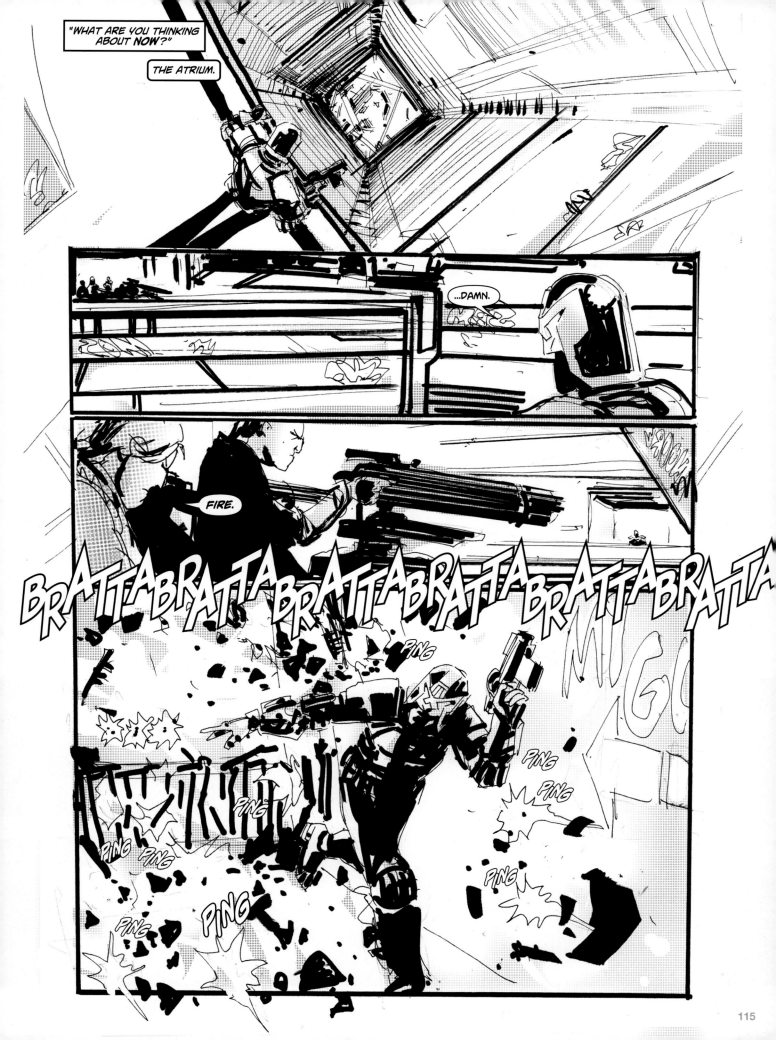

Mega-City signs
designed by the
production department

CUT TO -

INT. LEVEL FIFTY MASSACRE - CONTINUOUS

- a staggering shooting sequence.

The tracer rounds from the miniguns create an effect like a continuous streak of light.

Their effect on the western quadrant is like a band-saw cutting through the building.

Shredding and ripping through walls and doors. Through apartments. Annihilating everything inside.

Objects. Pets. People. All destroyed. All vapourised in clouds of blood and glass and dust.

MA-MA is sacrificing the entire Western community of level fifty in order to be sure of killing the judges and KAY. A micro-genocide.

And sprinting just ahead of the wave of destruction, DREDD.

Shouting to ANDERSON.

> **DREDD**
>
> Get down!

INT. ATRIUM/LEVEL FIFTY/EASTERN BALCONY - CONTINUOUS

Behind the miniguns, MA-MA and her men are electrified by the level of destruction they are causing.

Jaws open. Laughing. Howling. Inaudible over the roar of the gunfire.

'Any Dredd fan will see a ton of easter eggs in these street signs. It was interesting trying to keep elements from the comic in there, but never at the cost of believability.' - *Jock*

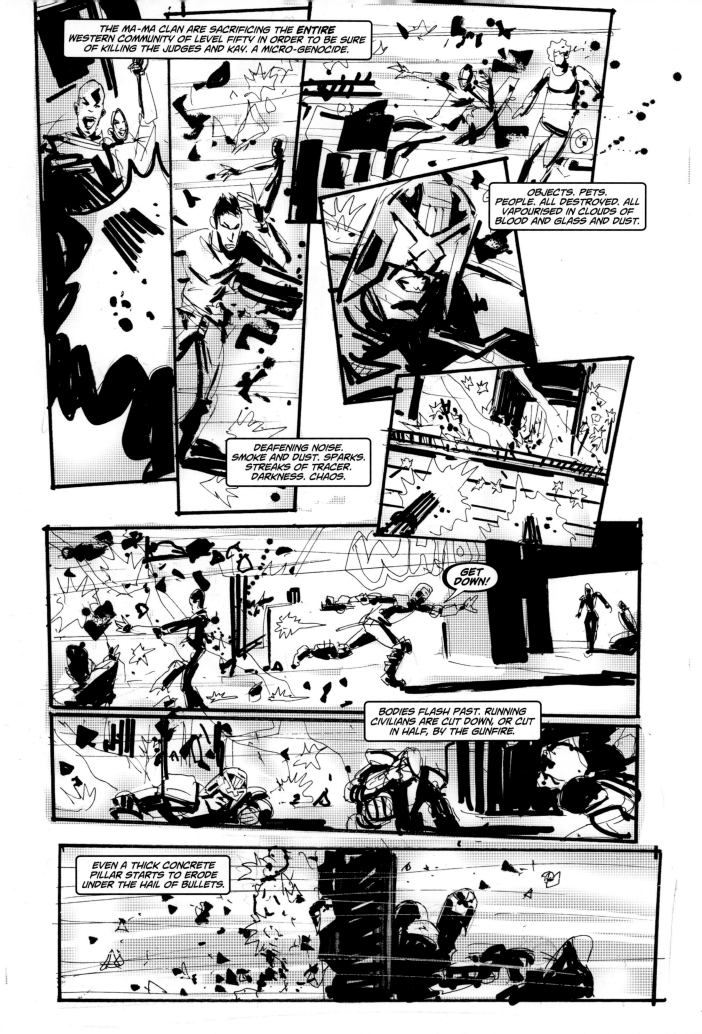

INT. LEVEL FIFTY MASSACRE - CONTINUOUS

Deafening noise. Smoke and dust. Sparks. Streaks of tracer. Darkness. Chaos.

DREDD, ANDERSON and KAY are crawling on their bellies.

Bodies flash past them. Civilians running.

Some are cut down, or cut in half, by the gunfire.

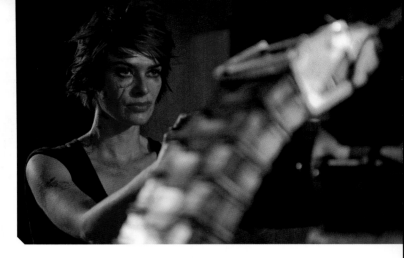

DREDD, ANDERSON and KAY scramble to shelter behind a thick upright concrete pillar -

- which immediately starts to erode under the hail of bullets.

The pillar isn't going to last long, and there is nowhere left to run.

Then - on the wall opposite them, taking the full force of the rounds - a single point of BRIGHT LIGHT appears through the smoke and dust.

DREDD sees it.

Lifts his gun.

> **DREDD**
>
> *Hi-Ex!*

The setting on DREDD'S gun changes.

DREDD fires at the single point of light.

And the high explosive round blows a massive hole in the wall, through which BRIGHT LIGHT floods through.

> **DREDD** (CONT'D)
>
> GO!

DREDD rises, driving KAY ahead of him, running into the light.

ANDERSON follows.

And as she goes through, **CUT TO -**

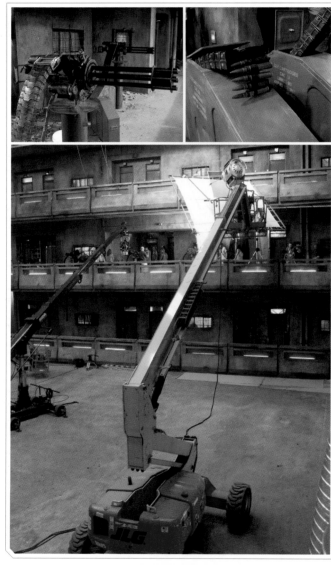

EXT. PEACH TREE BLOCK/LEVEL FIFTY - CONTINUOUS

- the exterior of Peach Trees.

ANDERSON has exited into thin air.

The brightness is revealed as daylight. DREDD has blown a hole in the side of the building.

ANDERSON starts to fall -

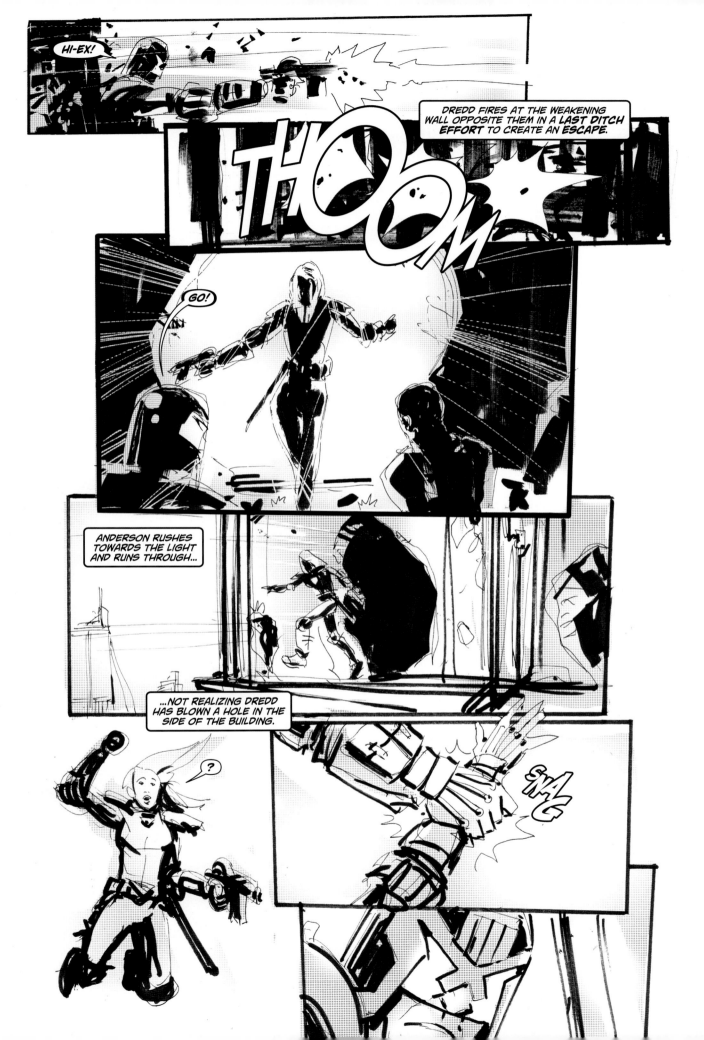

- but not fifty stories to ground.

Only a couple of metres - to the SKATEPARK.

Where the SKATERS stand, awestruck, as just above them, tracers fire rips through the hole in the side of Peach Trees.

CUT BACK TO -

INT. ATRIUM/LEVEL FIFTY/EASTERN BALCONY - CONTINUOUS

- the three miniguns.

Which, one by one, run out of ammunition.

The roar of gunfire is replaced by ratchet clicks as the smoking barrels keep rotating for a few moments.

Then come to a stop.

Leaving silence.

MA-MA and CALEB stare across the atrium at the destruction opposite.

CALEB

I think we got 'em.

CUT BACK TO -

EXT. PEACH TREE BLOCK - CONTINUOUS

- wind clearing the smoke on the outside of the building.

Revealing DREDD, ANDERSON, KAY and the SKATERS in the skatepark.

DREDD'S radio suddenly fuzzes into life.

CONTROL

(over radio)

Responders in vicinity of block Tom Frame. Small arms fire reported in shopping zone.

DREDD and ANDERSON react.

ANDERSON

The radios are working!

DREDD lifts his glove to speak into his radio.

DREDD

Control. Do you read me?

CONTROL

(over radio)

Affirmative.

DREDD

10-24 on my GPS. We are under fire and need immediate assistance.

CONTROL

(over radio)

Copy, 10-24. Your location is showing as Peach Trees, Sector Thirteen. Confirm.

DREDD

Confirm. Be advised, nuke defenses have been triggered in order to seal the building.

CONTROL

(over radio)

Can you hold your current GPS?

DREDD glances over the ledge at the precipitous drop.

DREDD

Negative. If they come for us, we've got nowhere to go. Have to keep moving.

CONTROL

(over radio)

Copy that. Just stay alive. Back up is on its way.

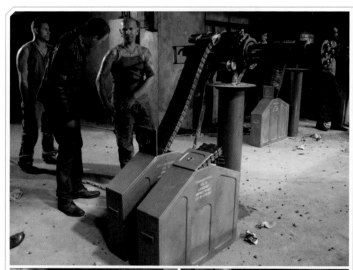

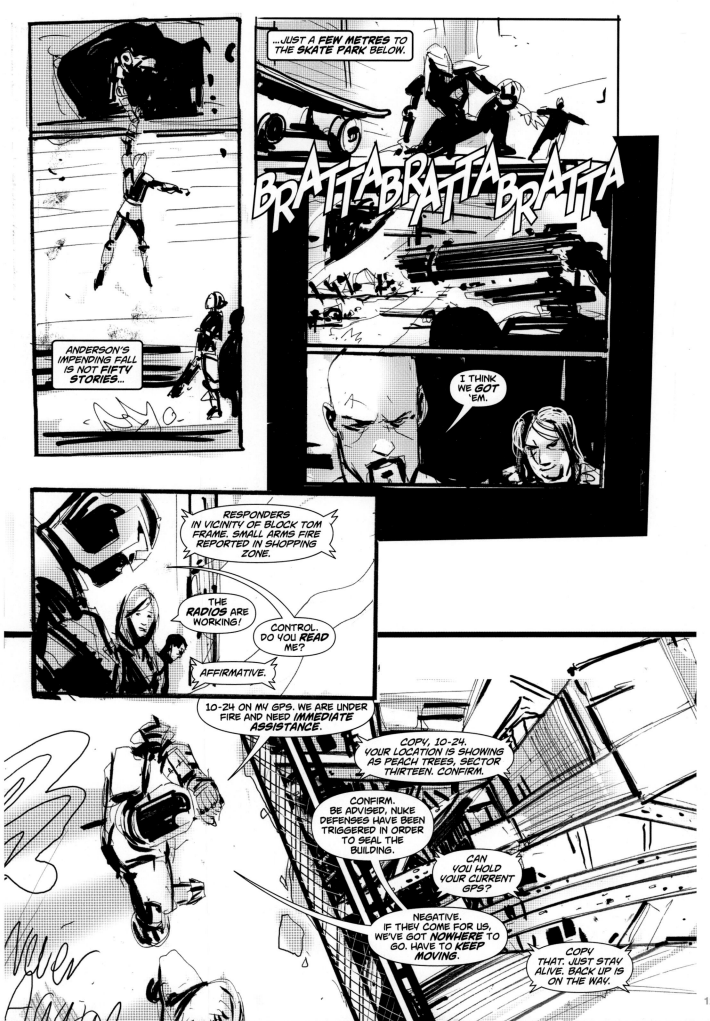

121

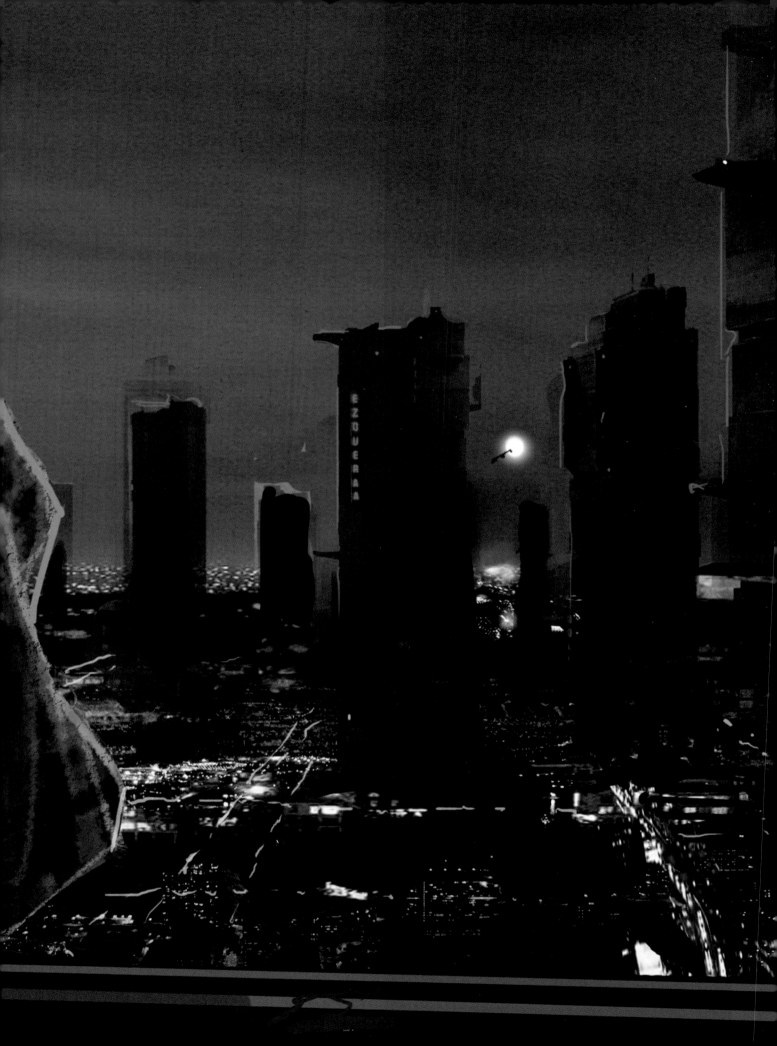

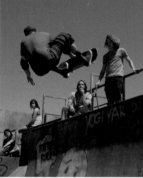

INT. LEVEL FIFTY/CORRIDOR - DAY

A blast door raises -

- revealing CALEB and five heavies on the other side.

INT. LEVEL FIFTY/REMAINS OF WEST QUADRANT - CONTINUOUS

CALEB and his men step into the rubble of what was the west quadrant of level fifty.

In the hanging dust, they can't see more than ten metres ahead of them.

Ahead of them, a glowing band of light shows where the exterior wall once was.

Half poking through the rubble at their feet are the mangled remains of the people and families who have been slaughtered.

> **HEAVY 2**
>
> No way they survived.
>
> **CALEB**
>
> They're not dead until we find them dead.

At CALEB'S feet, an extremely badly damaged body is resting.

> **CALEB** (CONT'D)
>
> Or part of them anyway.

They fan out, keeping their guns raised.

INT. LEVEL FIFTY/REMAINS OF WEST QUADRANT - CONTINUOUS

We are looking back at CALEB and his men as they cautiously move forwards.

So we see what CALEB and his men don't.

Barely visible through the dust, a dark shape appears fleetingly behind them.

Then -

- one of the five HEAVIES suddenly jerks backwards, out of sight, as if yanked by an invisible wire.

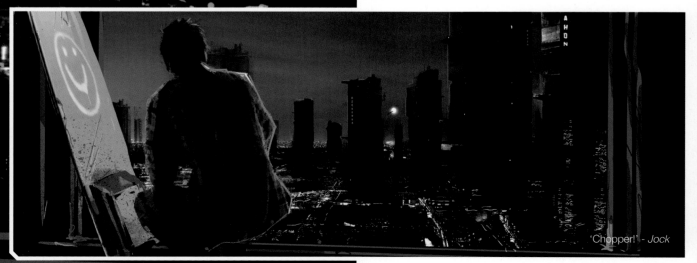

'Chopper!' - *Jock*

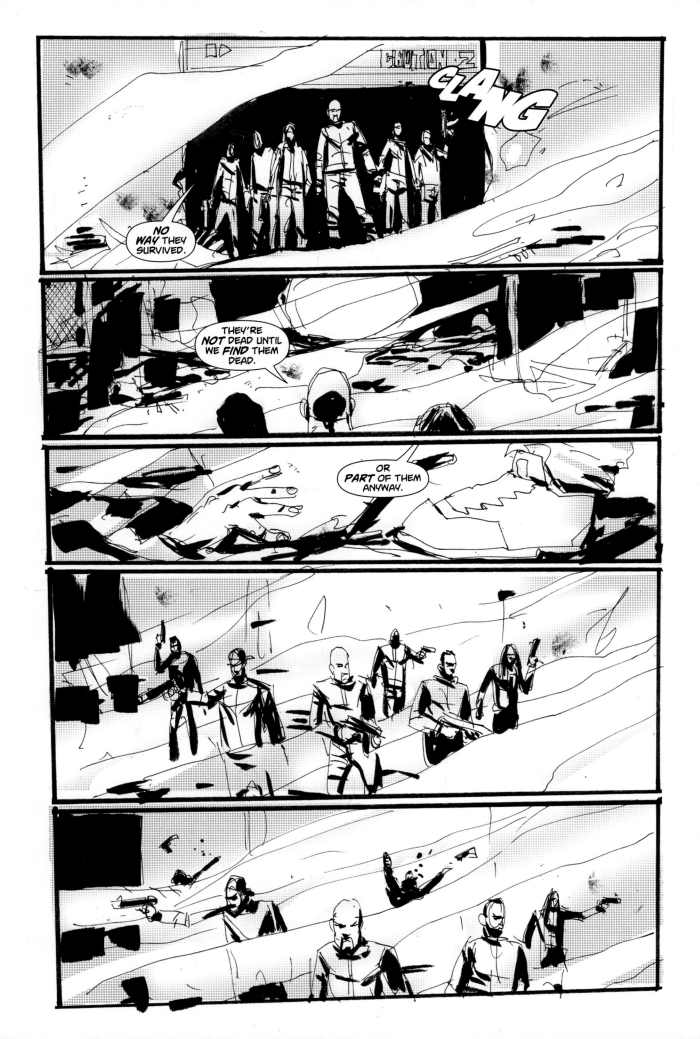

125

A couple of beats later, a second HEAVY vanishes in exactly the same way.

CALEB now has only three men with him, and he doesn't even realise it yet.

But one of his surviving HEAVIES does.

HEAVY 3

(looking round)

Hey - where's the others?

CALEB and the others all turn.

They see the missing space where the men had been.

But don't see -

- what's happening to HEAVY 3.

HEAVY 3 would shout out in alarm, if DREDD'S right hand wasn't closed around his mouth.

The man's head is snapped sideways. Neck broken.

And HEAVY 3 is pulled from view ...

a beat before CALEB looks round, and sees that another of his men has gone.

Immediately, the remaining three men panic.

They open up with their weapons, aiming wildly all around them. But in the heavy dust, they're firing blind. They're shooting at a ghost.

They keep the fire sustained, emptying their clips.

After the gunfire, a silent beat as they hurriedly reload.

HEAVY 5

(panicky)

This is fucked up.

How did he do that? There's only three of us left!

But there isn't.

There's two.

Somehow, during the firing, HEAVY 4 was spirited away.

It's all happened so fast.

Only CALEB and HEAVY 5 are left.

The two men look at each other, stunned, as if wondering which of them will be next.

And as if in answer, a red bullet hole from a silenced round punches in the middle of HEAVY 5's forehead.

Then his knees give way, and he drops.

CALEB

(quiet)

Ma.

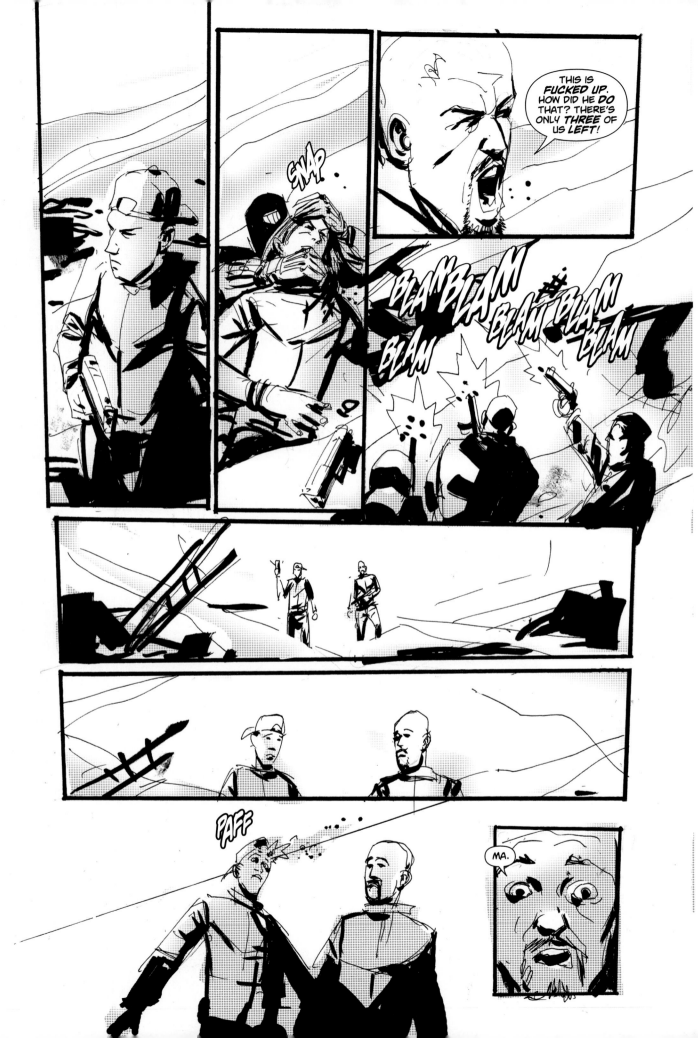

INT. ATRIUM/LEVEL FIFTY/EASTERN BALCONY - CONTINUOUS

The dust cloud is slowly drifting into the atrium from the wreckage of the level fifty western quadrant.

Out of the dust cloud, into the thin air of the atrium, a body is ejected.

It's CALEB.

Screaming, as he starts the fifty storey fall down to the ground level.

Reveal -

- MA-MA watching, as CALEB drops out of sight.

Silence.

Then, out of MA-MA'S mouth, a howl of rage.

INT. ATRIUM - CONTINUOUS

MA-MA'S howl seems to echo down the atrium, reverberating through the entire building.

LAWGIVER EVOLUTION
A bulkier front end to this lawgiver.

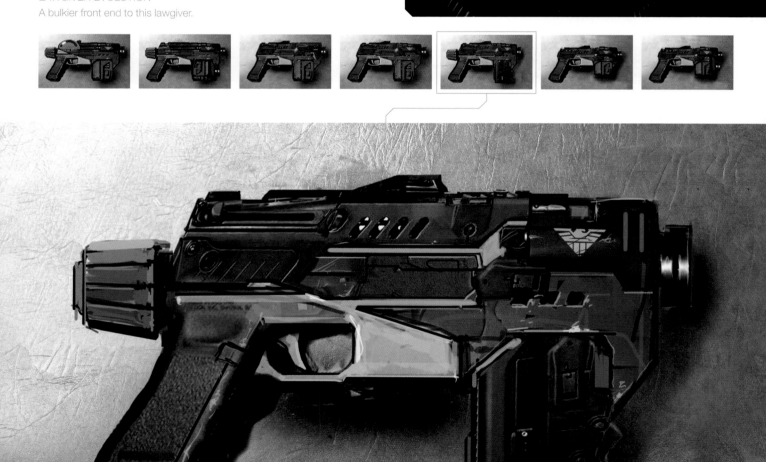

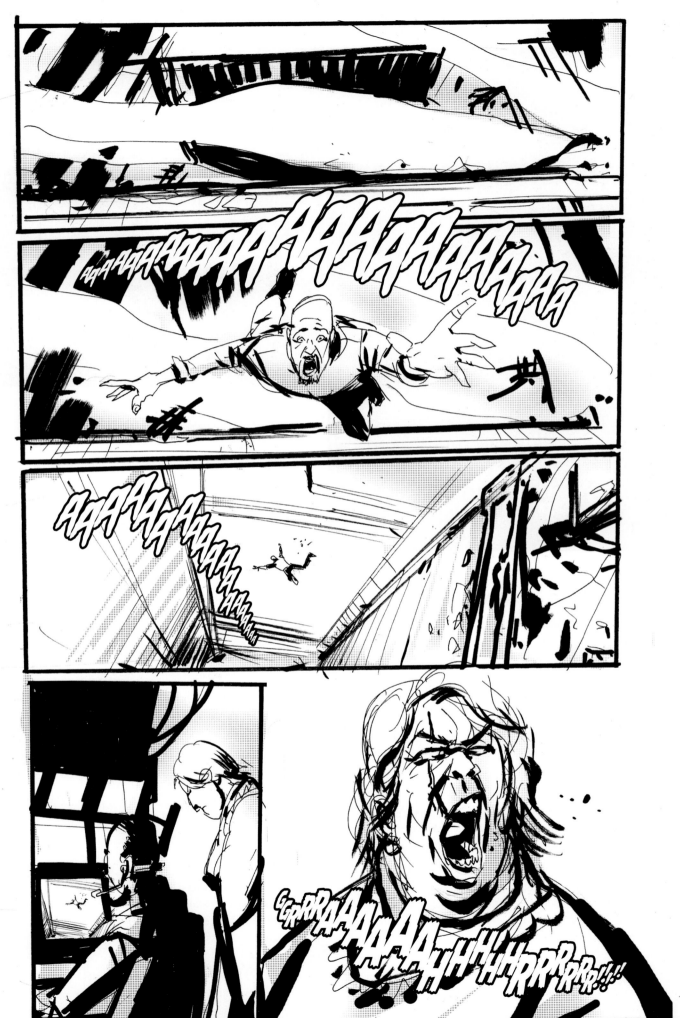

129

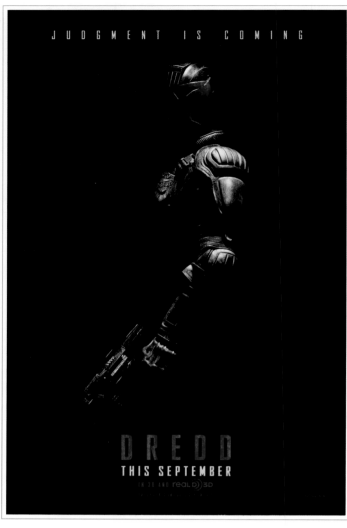

INT. ABANDONED APARTMENT - CONTINUOUS

KAY is thrown inside.

Landing hard, face first. Unable to break his fall because his hands are cuffed behind his back.

DREDD jams the door to the apartment closed.

Then turns to KAY.

> **DREDD**
>
> Homicide investigation, busting a narcotics den, bringing in a suspect for interrogation. Any other block in Mega-City One, it's routine. In Peach Trees, it's war.

KAY says nothing. Just spits blood, and gazes back at DREDD.

> **DREDD** (CONT'D)
>
> Your gang locks down the whole block. Massacres an entire quadrant of men, women, children. Just to take out two judges. Sound like overkill to you?

DREDD unholsters his weapon. Checks the clip.

> **DREDD** (CONT'D)
>
> Tell you what I think. If we'd executed you in the bust, Ma-Ma would have let us walk out of here.

KAY reacts slightly. DREDD'S on the money.

> **DREDD** (CONT'D)
>
> What she doesn't want is you taken back to the sector house and interrogated. Because she's afraid of what you might say.
>
> (beat)
>
> That's got me curious.

INT. CORRIDOR - CONTINUOUS

The sound of MA-MA'S howl is becoming mingled with another noise.

Not a howl of rage. A scream of pain.

We close in on the source of the scream.

Which turns out to be KAY'S mouth.

And he's screaming, because DREDD is propelling him down the corridor, with his wrist twisted behind him in a nasty looking pressure hold.

ANDERSON follows behind.

Something in DREDD'S manner feels different. In his body language, the speed he's moving, his total lack of concession for KAY'S pain - he's not fucking around.

They pass an apartment with the door broken off its hinges.

Inside, it is a burned-out shell, long abandoned.

DREDD stops.

> **DREDD**
>
> This'll do.

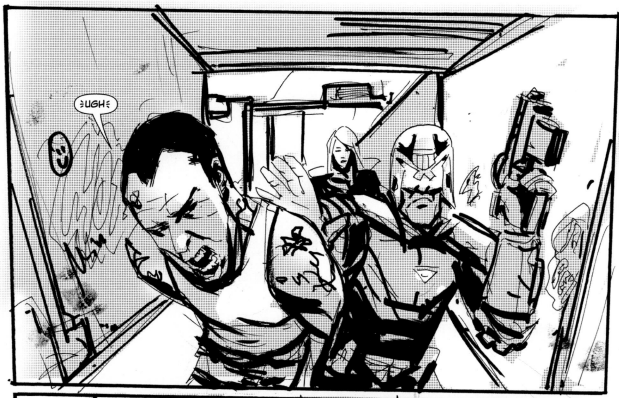

ЭUGHЄ

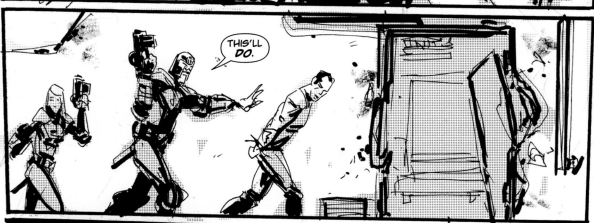

THIS'LL *DO*.

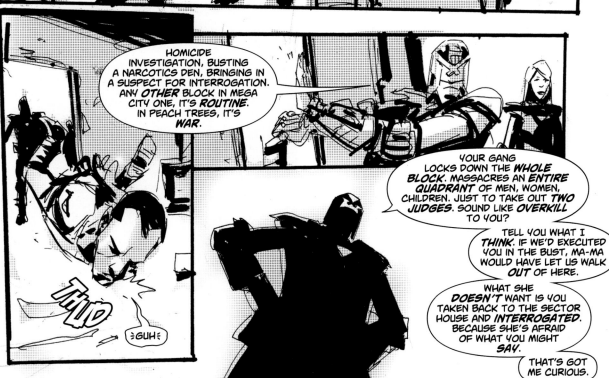

HOMICIDE INVESTIGATION, BUSTING A NARCOTICS DEN, BRINGING IN A SUSPECT FOR INTERROGATION. ANY *OTHER* BLOCK IN MEGA CITY ONE, IT'S *ROUTINE*. IN PEACH TREES, IT'S *WAR*.

YOUR GANG LOCKS DOWN THE *WHOLE BLOCK*. MASSACRES AN *ENTIRE QUADRANT* OF MEN, WOMEN, CHILDREN. JUST TO TAKE OUT *TWO JUDGES*. SOUND LIKE *OVERKILL* TO YOU?

TELL YOU WHAT I *THINK*. IF WE'D EXECUTED YOU IN THE BUST, MA-MA WOULD HAVE LET US WALK *OUT* OF HERE.

WHAT SHE *DOESN'T* WANT IS YOU TAKEN BACK TO THE SECTOR HOUSE AND *INTERROGATED*. BECAUSE SHE'S AFRAID OF WHAT YOU MIGHT *SAY*.

THAT'S GOT ME CURIOUS.

THUD

ЭGUHЄ

DREDD steps over to KAY, yanks his hair back, and puts the muzzle against KAY'S head.

DREDD (CONT'D)

Start talking.

KAY

Fuck you.

ANDERSON

Sir.

DREDD hesitates.

ANDERSON (CONT'D)

If you leave it to me, he doesn't have to talk.

CUT TO -

INT. ABANDONED APARTMENT - DAY

KAY is kneeling on the floor, with his hands plasticcuffed behind his back.

ANDERSON is standing opposite him, looking down.

DREDD is watching.

KAY

What are you up to, bitch?

ANDERSON doesn't respond, except to close her eyes.

And as she does so -

- DREDD and surrounding walls of the abandoned apartment melt away.

Leaving just her and KAY alone, in a dark, undefined space.

INT. UNDEFINED SPACE - CONTINUOUS

ANDERSON opens her eyes again.

KAY looks around.

The walls and substance of the space are constantly shifting, never quite resolved.

KAY

What the -

ANDERSON

Welcome to the inside of your head.

She glances around.

ANDERSON (CONT'D)

Kind of empty.

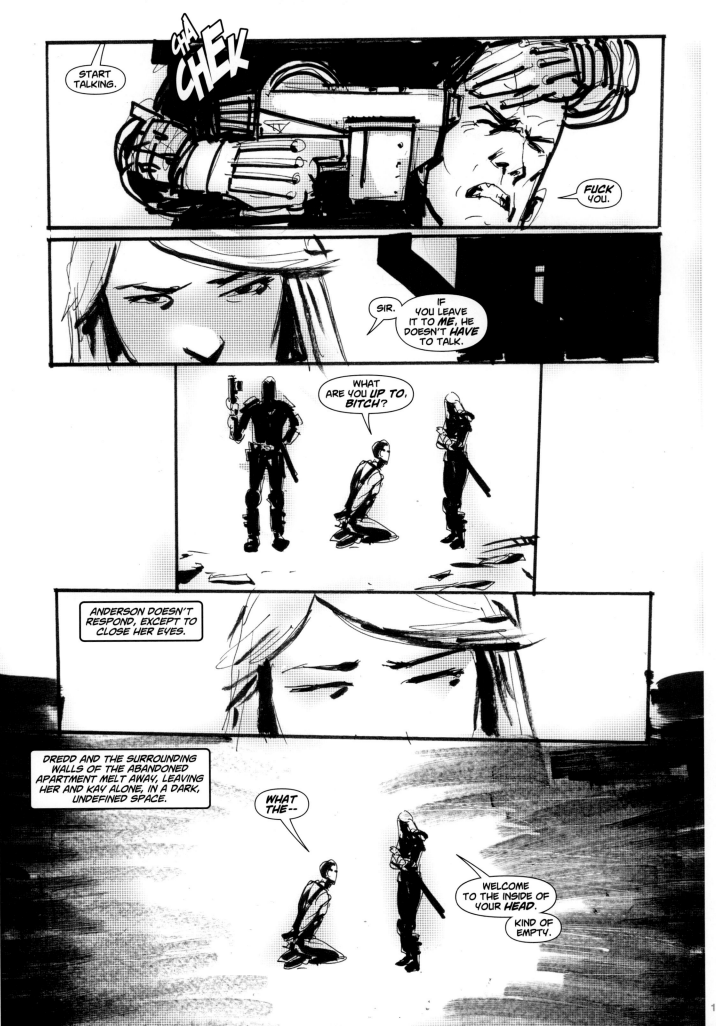

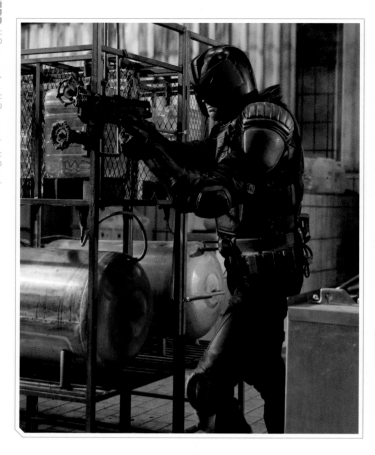

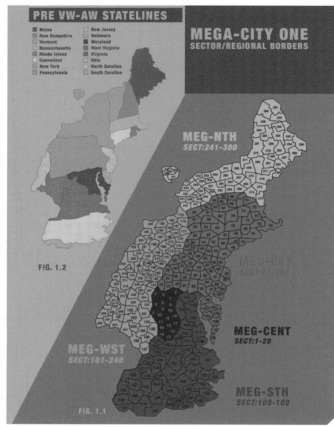

KAY looks a little weirded out.

KAY

I don't know what fucked up mutant shit this is, but if I wasn't cuffed, I'd -

ANDERSON

(cuts in)

You aren't cuffed. Do what you like.

KAY frowns.

CUT TO his plastic-cuffed hands.

Exploratory, he pulls his wrists apart ...

... and the cuffs fall away, as if they were never there.

A beat.

Then KAY stands.

Puts his hands in front of him.

KAY

Huh.

He smiles nastily.

KAY (CONT'D)

My head. Do what I like.

ANDERSON

Sure.

KAY reaches out with his hand -

- and ANDERSON'S weapons suddenly springs out her holster, into his waiting palm.

Immediately, without any delay or ceremony, he lifts the gun, and fires a volley of shots at point blank range into ANDERSON'S face.

And when the last muzzle flash has faded, and the smoke has cleared, ANDERSON stands before him, just as before, unscathed.

ANDERSON (CONT'D)

Thinking about hurting me doesn't actually hurt me.

KAY

Oh. Yeah. Point to you.

He tosses the gun.

KAY (CONT'D)

Except - there is that thing. That thing we already established.

ANDERSON

What thing was that?

KAY

That I know how to freak you the fuck out.

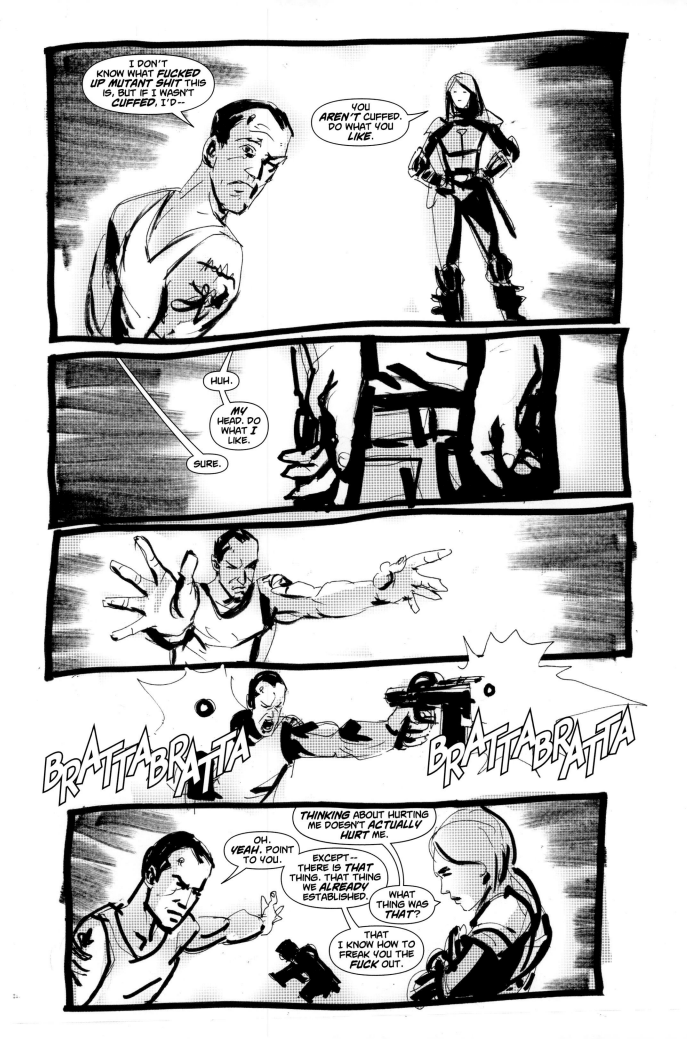

When we cut back to ANDERSON, her uniform has vanished leaving her completely naked.

KAY (CONT'D)

See, if we're talking about my fucked-up head versus your fucked-up head ...

As he's talking, an invisible force compels ANDERSON to a kneeling position in front of him.

KAY (CONT'D)

... your fucked-up head is going to lose.

KAY unzips himself.

KAY (CONT'D)

Speaking of head.

We close in on KAY'S upper body.

He laughs.

KAY (CONT'D)

Figured that would shut you up. Gives me a moment to think up something really -

ANDERSON (O. S.)

Hey.

KAY jumps.

ANDERSON'S voice came from over his shoulder.

His head turns, and he sees her. She's back in uniform, and standing directly behind him.

ANDERSON (CONT'D)

Guess what?

(into Kay's ear)

I can play mind games too.

KAY

What the -

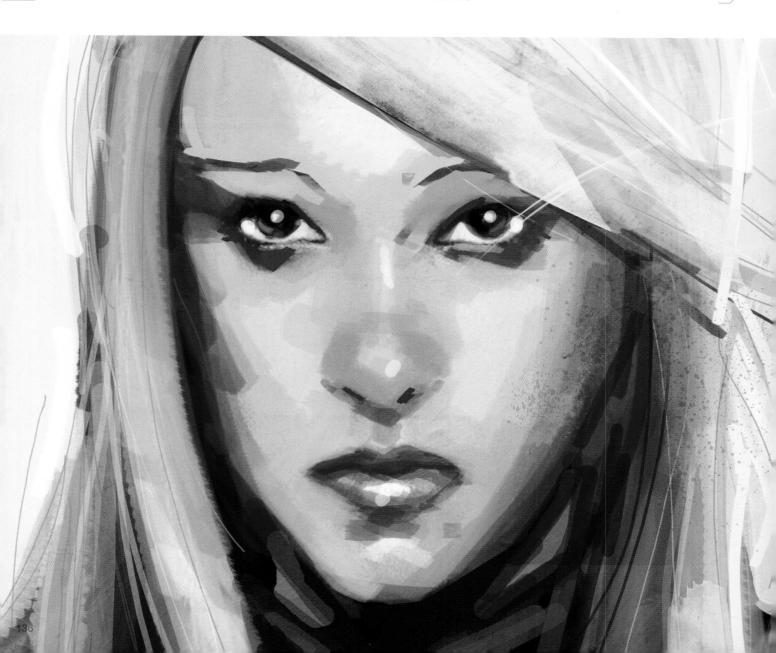

KAY'S head turns again, to see who is felating him -

- and SHOUTS with alarm.

> **KAY** (CONT'D)
>
> *Fuck!*

The naked woman felating him is MA-MA.

KAY pulls back like a scalded cat.

> **KAY** (CONT'D)
>
> *Aaaagh!* Fuck! *Jesus!* FUCK! You sick *bitch!*

ANDERSON spins him round.

> **ANDERSON**
>
> Sick? We haven't even started.

CUT TO -

INT. ABANDONED APARTMENT - CONTINUOUS

- stillness and quiet in the abandoned apartment.

From what DREDD can see, there is no indication of the strange battle of wits between ANDERSON and KAY.

They are both in the same positions they were in previously.

KAY kneeling with his hands cuffed.

ANDERSON standing in front of him.

Both with their eyes closed.

The calm moment is sustained.

Then, abruptly, KAY pisses himself.

As the dark stain spreads across his trousers, ANDERSON opens her eyes and looks at DREDD.

> **ANDERSON**
>
> Peach Trees is the manufacturing base for all the slo-mo in Mega-City One. Ma-Ma is controlling the production and distribution across the whole city.

KAY looks down at the puddle on the floor, then up at ANDERSON.

In KAY'S eyes, it's pure hatred.

> **DREDD**
>
> Interesting.

139

CUT TO -

INT. MA-MA'S BASE/CONTROL ROOM - DAY

The CLAN TECHIE looks under even more pressure than usual. He's shaking with fear.

MA-MA is leaned over behind him, with her head uncomfortably close to his, and her right arm around his torso.

On the monitor in front of him, we can see the exterior of the south entrance.

And standing by the closed blast door are three judges.

CLAN TECHIE

But Ma, please - they're *Judges*! I *can't* refuse them entry! They can go where ever they like!

REVEAL that MA-MA is holding a knife across the CLAN TECHIE'S stomach. Ready to cut.

MA-MA

If you want to keep your insides in, you better keep the Judges out. So I guess you'd better think of something fast.

The CLAN TECHIE takes a steadying breath.

Then flicks a switch on the console and speaks into his headset.

CLAN TECHIE

Peach Trees. Can I help you?

On the MONITOR, one of the judges speaks into the intercom.

JUDGE

(over intercom)

We're responding to a report of judges under fire from within this block.

CLAN TECHIE

Judges under fire? I'm not aware of any such activity. We're actually under a scheduled nuke defense test...

JUDGE

(over intercom)

Not any more you're not. Open the blast door right now.

Sweat rolls down the TECHIE'S face. But he keeps his voice under control.

CLAN TECHIE

Yes, sir. The problem is, we have a software malfunction and we've lost control over the system. We've had a fire on level forty ...

The JUDGE glances upwards, to the hole DREDD blasted in the side of the building.

JUDGE

(over intercom)

You'd better get control. Fast. Or I'm slapping you with an obstruction of justice charge. Five years in the cubes, mandatory.

CLAN TECHIE

Will do, sir. On it right now.

The CLAN TECHIE hits the disconnect button and pulls his headset off.

Wipes his hand over his mouth.

Then glances round at MA-MA nervously.

Beat.

MA-MA

Good.

'An early idea showing dark shadows and the slums of the city. Much of the environment would be in the shadow of these huge Mega Blocks, so the squalor is given an extra dimension.' - *Jock*

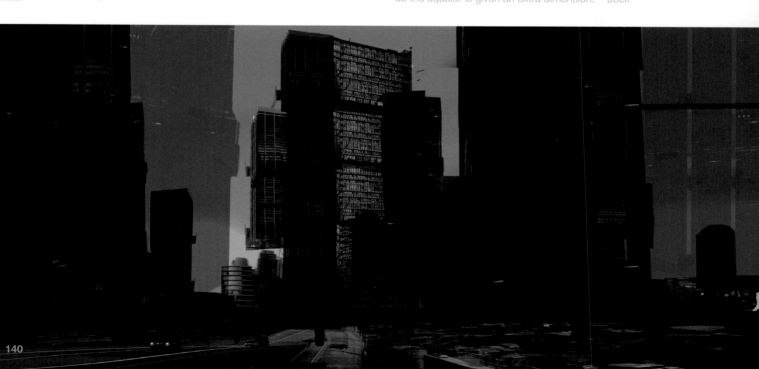

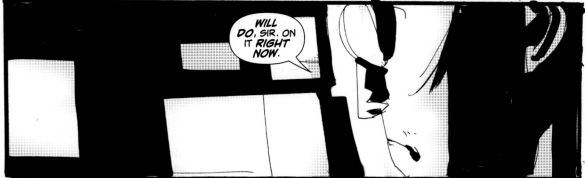

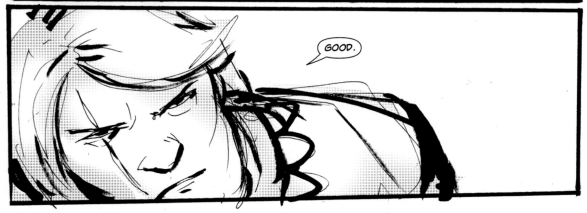

141

CUT TO -

INT. CORRIDOR - CONTINUOUS

- a ten year-old boy, standing in the corridor on which the abandoned apartment is situated.

The KID points with his index finger.

> **KID**
>
> They went that way. All the way down. Then went in to three-four-nine.

Behind the KID are two CLAN. They are AMOS and FREEL.

> **AMOS**
>
> You sure it was them?

> **KID**
>
> They walked right past my door. Two judges and one of the clan. He was screaming. I think one of the judges was breaking his arm.

> **FREEL**
>
> Shit. Why'd have to be us that found them?

> **AMOS**
>
> (to the kid)
>
> All right, Joey. Run back home. And stay there.

The KID legs it.

> **AMOS** (CONT'D)
>
> Okay. Let's do it.

AMOS and FREEL raise their guns, and start making their way down the corridor.

ON THEIR FACES -

- we can see how nervous they are. Bright beads of sweat on the top lips. Eyes darting.

Then, from ahead down the corridor, from the doorway of the abandoned apartment, a CLICK of a door opening.

CUT TO -

INT. CORRIDOR - CONTINUOUS

- DREDD exiting from the abandoned apartment, into the corridor.

He looks left and right ...

...and the corridor is empty.

> **DREDD**
>
> Clear.

ANDERSON, leading KAY ahead of her, follow.

CUT TO -

INT. CORRIDOR/DOORWAYS - CONTINUOUS

In the recess of two doorways, opposite each other in the corridor, AMOS and FREEL are hiding.

They whisper to each other:

> **AMOS**
>
> Why didn't you shoot them?

> **FREEL**
>
> Why didn't *you*?

AMOS peeks around the recess - and sees the judges and their prisoner, walking away from them.

> **AMOS**
>
> We could do it now.

> **FREEL**
>
> Go on then.

AMOS looks back around the recess -

- and the corridor is empty.

The judges have gone.

> **AMOS**
>
> Shit.

AMOS wipes the sweat off his face with the back of his sleeve.

> **AMOS** (CONT'D)
>
> Come on.

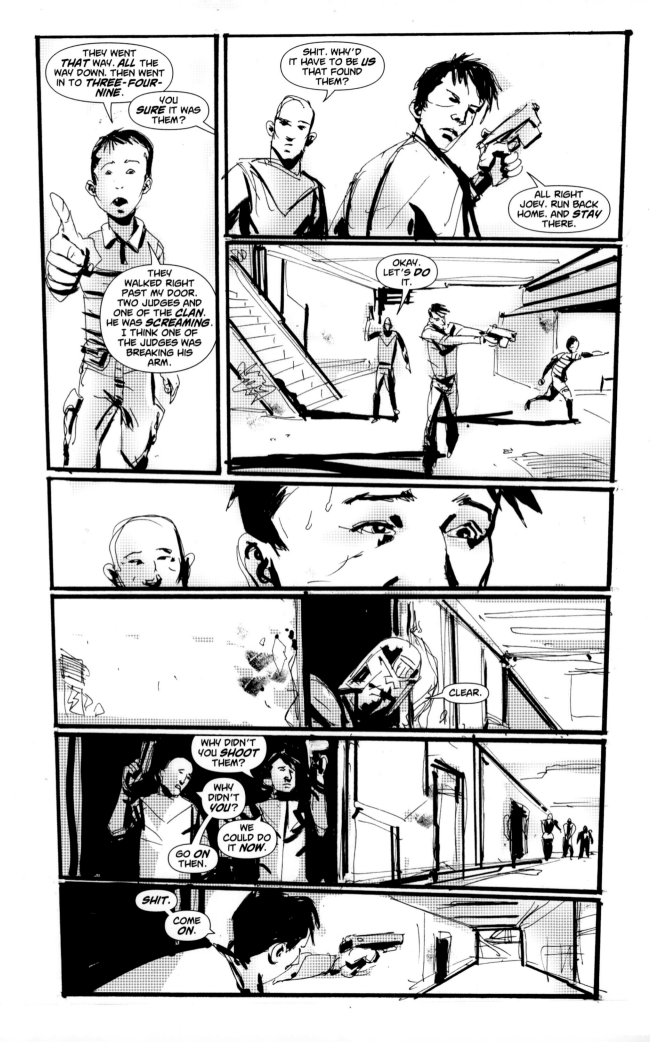

INT. CORRIDOR - CONTINUOUS

DREDD, ANDERSON and KAY move down the corridor away from the abandoned apartment.

DREDD

We have new intel about Ma-Ma, and we've managed to get a 10-24 call to Control. Parameters are shifting. What are our options, rookie?

ANDERSON

Find a position to defend, or keep moving and attempt to avoid further detection. Same as before. Except now at least we know back-up is inbound.

DREDD

Two options.

ANDERSON

Yes, sir.

DREDD

What about we head straight for Ma-Ma.

ANDERSON

... Is that an option?

DREDD

She's guilty. We're judges.

ANDERSON

Sir - if back-up is inbound we should wait until the odds have shifted in our favour.

Beat.

ANDERSON (CONT'D)

... Wrong answer?

DREDD

You're the psychic.

ANDERSON glances at DREDD.

Beat.

Then looks away.

INT. SHOPPING ZONE - CONTINUOUS

Ahead of them, the corridor widens into a lobby area.

It's a mini-shopping zone - like the clusters of shops at the bases of large estate tower blocks. Metal grills over the windows. Everything covered in the ubiquitous graffiti.

The shops are all abandoned or closed.

Set into the wall is a machine that looks like a large cash dispenser. It is in fact a BLOCK INFO POINT.

There is also an elevator door.

DREDD

Wait. Map point. Let's get bearings.

DREDD approaches the INFO POINT.

Taps the console.

Surprisingly, it works.

He taps the screen.

Brings up a map of the block, similar to the map we saw in the med center.

He rotates the map.

A flashing marker reads:

YOU ARE HERE.

They are about half way up the block.

AT THAT MOMENT -

- AMOS and FREEL make their move.

AMOS

FREEZE!

DREDD looks round.

By the entrance to the lobby, AMOS and FREEL are standing with their guns aimed respectively at DREDD and ANDERSON.

A beat.

DREDD sees - the fear in their eyes. The sweat. The shake in their hands.

CUT TO -

- KAY, who is standing beside ANDERSON with his hands cuffed behind him. Next to the elevator control panel.

CUT BACK TO -

- DREDD.

DREDD

Why?

AMOS

...Why what?

DREDD

Why should I freeze?

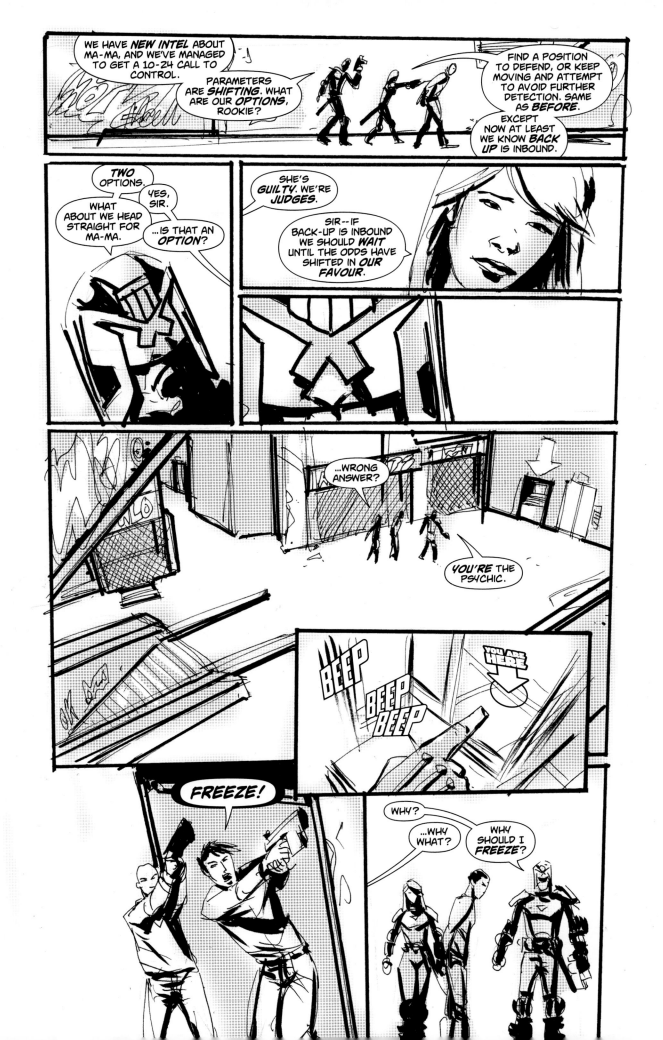

AMOS is momentarily thrown.

AMOS

...Because otherwise I'll shoot you.

DREDD

with the safety catch on.

AMOS'S eyes flick to the safety catch of his gun.

Which is, in fact, off.

AMOS

It isn't -

The words dry up.

In the brief instant that AMOS and FREEL glanced at their weapons, DREDD and ANDERSON have drawn their own guns, and are pointing them back at AMOS and FREEL.

DREDD

Drop the weapons.

AMOS gulps.

DREDD (CONT'D)

You aren't killers. If you were, you'd have shot us already. Put the guns down, and you get to live.

CUT TO -

- KAY.

Who can see the way this is about to go.

And now makes *his* move.

The following action is fast and fluid. A surprise.

KAY'S hands are cuffed behind him.

In a contortionist's move, KAY DISLOCATES HIS LEFT SHOULDER, then sweeps his looped arms over his head.

Now, like magic, his cuffed hands are in front of his body.

It's an amazing trick, and he's obviously been waiting for the right moment to do it.

ANDERSON is reacting to KAY'S move -

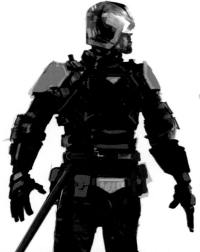

'The helmet was the one element of the uniform that no-one wanted to change from the comic. That's the icon of Dredd. Still, we tried it with grey, rather than red detailing.' - *Jock*

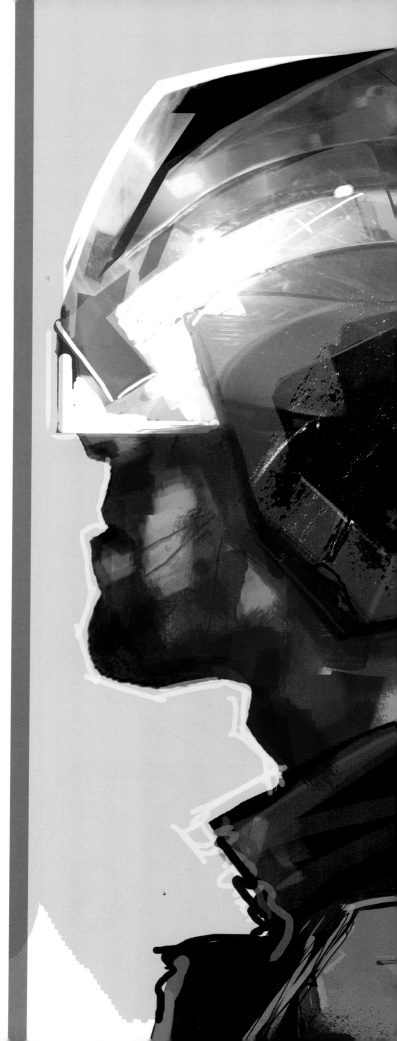

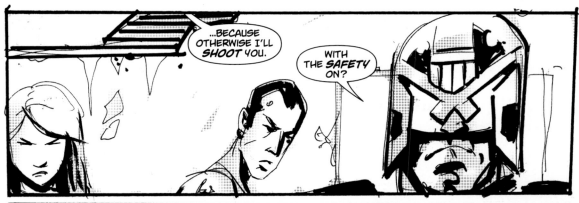

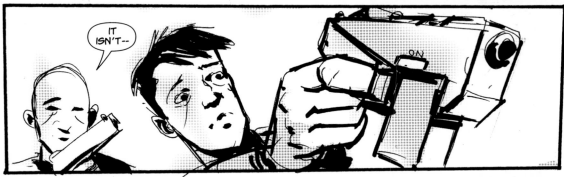

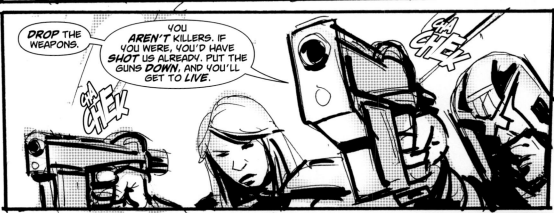

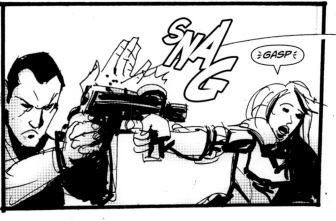

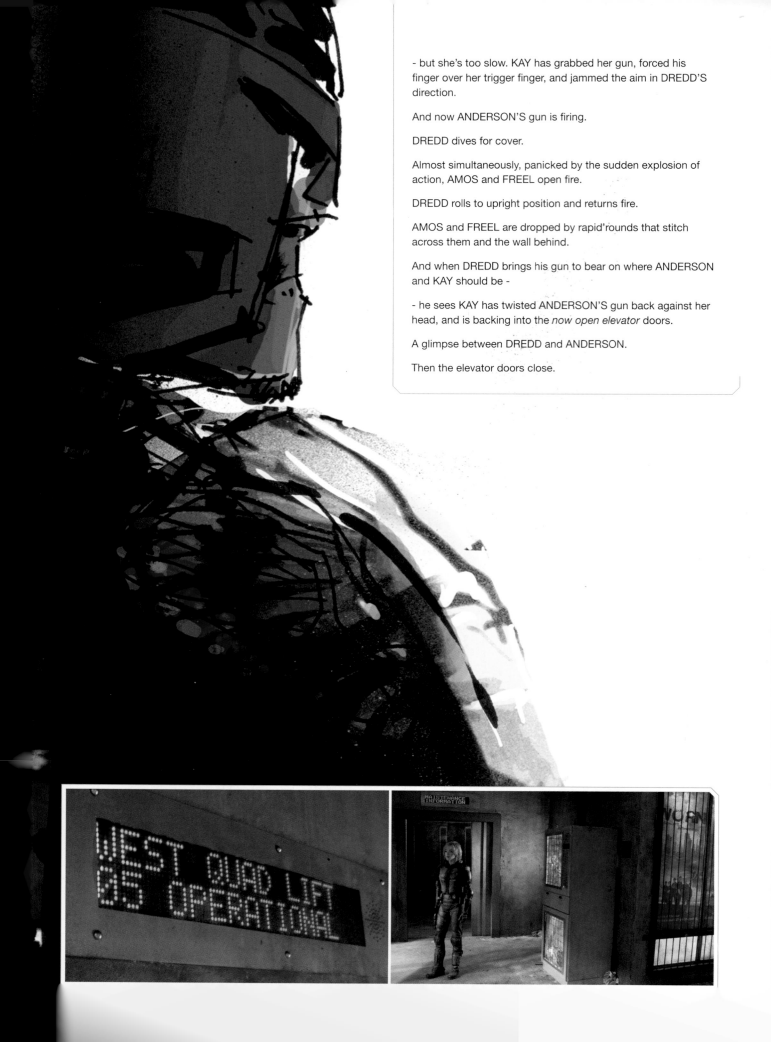

- but she's too slow. KAY has grabbed her gun, forced his finger over her trigger finger, and jammed the aim in DREDD'S direction.

And now ANDERSON'S gun is firing.

DREDD dives for cover.

Almost simultaneously, panicked by the sudden explosion of action, AMOS and FREEL open fire.

DREDD rolls to upright position and returns fire.

AMOS and FREEL are dropped by rapid'rounds that stitch across them and the wall behind.

And when DREDD brings his gun to bear on where ANDERSON and KAY should be -

- he sees KAY has twisted ANDERSON'S gun back against her head, and is backing into the *now open elevator* doors.

A glimpse between DREDD and ANDERSON.

Then the elevator doors close.

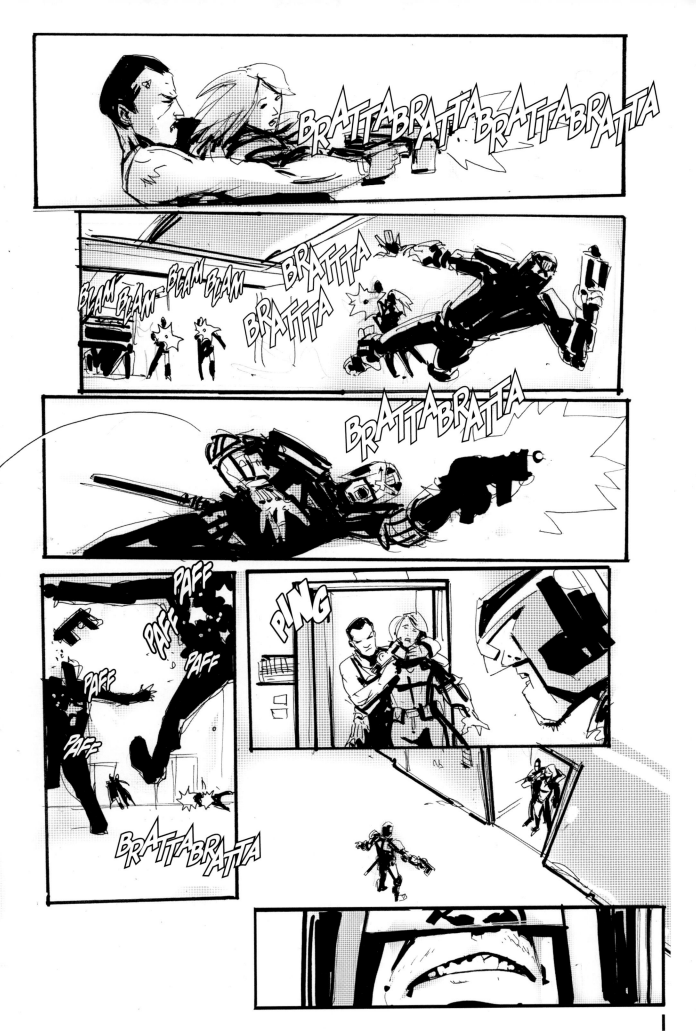

INT. ELEVATOR - CONTINUOUS

The elevator is rising.

Still gripping ANDERSON, KAY slams his shoulder against the side of the lift, popping it back in to place.

Looks unbelievably painful, but KAY deals with it.

> KAY
>
> Wow.

KAY pushes the gun harder against ANDERSON'S head.

> KAY (CONT'D)
>
> You are so fucked.

INT. SHOPPING ZONE/LIFT SHAFT - CONTINUOUS

DREDD forces open the outer doors to the elevator, and looks up the lift shaft.

Far above, he can see the lift car, rapidly ascending.

INT. SHOPPING ZONE - CONTINUOUS

Outside, in the lobby, we can see the digital display show the position of the lift.

The numbers rise - all the way up to 200.

Then stop.

A beat.

INT. SHOPPING ZONE/LIFT SHAFT - CONTINUOUS

High above, a noise floats down the lift shaft.

It sounds at first like a scream.

As if it might be ANDERSON.

But there's something weird about the noise.

It takes us a moment to realise, it is in fact the sound of metal, rending and tearing.

INT. SHOPPING ZONE - CONTINUOUS

The numbers on the digital display start descending again, at an accelerating rate, much faster than before.

INT. SHOPPING ZONE/LIFT SHAFT - CONTINUOUS

DREDD pulls back just in time to avoid being struck by the plummeting lift car.

It continues down, severed cabled whipping through the air, all the way to the bottom.

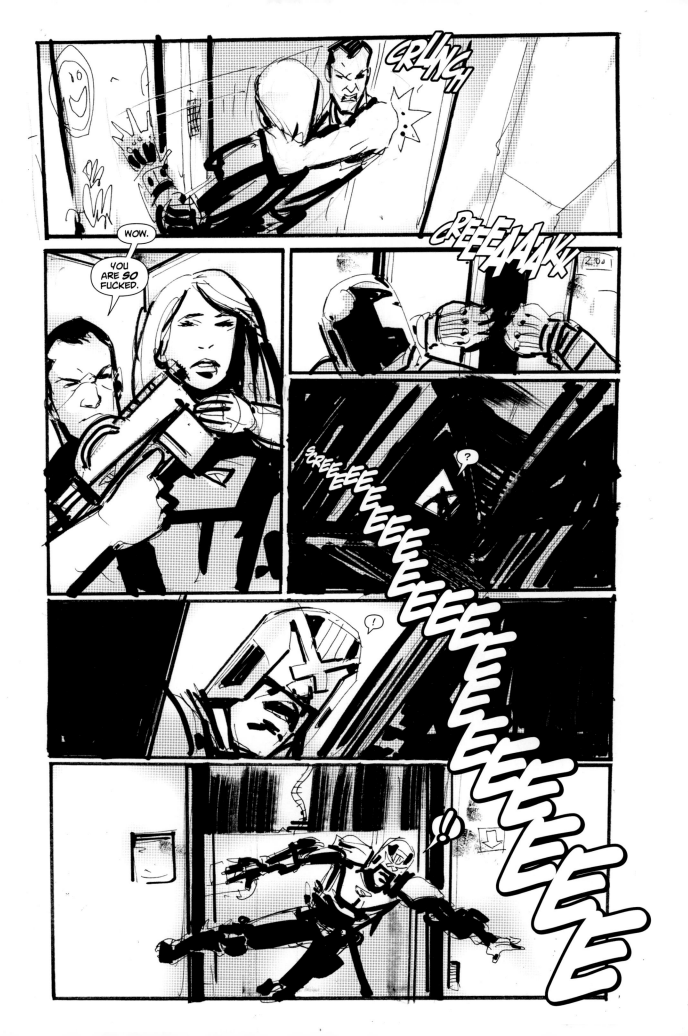

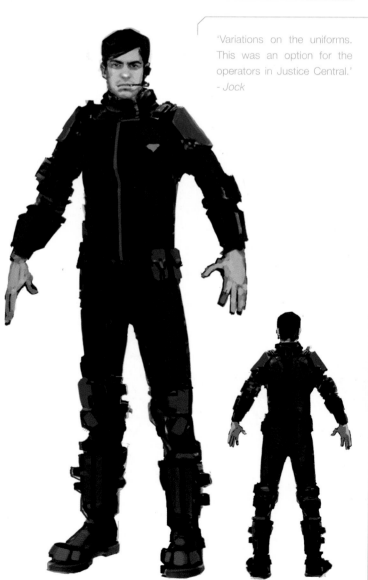

'Variations on the uniforms. This was an option for the operators in Justice Central.'
- Jock

CUT TO -

INT. MA-MA'S BASE - CONTINUOUS

- KAY. Back on home turf - and a hero. Dragging ANDERSON through a group of CLAN, who are cheering the capture of one of the judges, and slapping KAY on the back.

KAY throws ANDERSON to the floor.

> **KAY**
>
> Now then. What am I going to do with you?
>
> **MA-MA**
>
> You're going to do nothing.

KAY turns.

Sees, coming through the CLAN, MA-MA and her BODYGUARDS.

> **MA-MA** (CONT'D)
>
> All this trouble is your doing. When you got busted, you should have killed the judges or been killed yourself. But instead, you let yourself get taken. Like the dumb fuck you are.
>
> **KAY**
>
> But -

MA-MA silences him with a vicious blow from the back of her hand.

> **MA-MA**
>
> Shut the fuck up. I'd kill you myself, but I already lost plenty today, and I can't afford to lose more.

MA-MA turns to ANDERSON. Looks her up and down.

> **MA-MA** (CONT'D)
>
> Sooner or later, the Justice Department is going to come through the blast doors, looking for their judges. And they'll find their bodies, all shot up. One on level fifty five, and one in the slo-mo den they took down. Just a bust that went wrong.

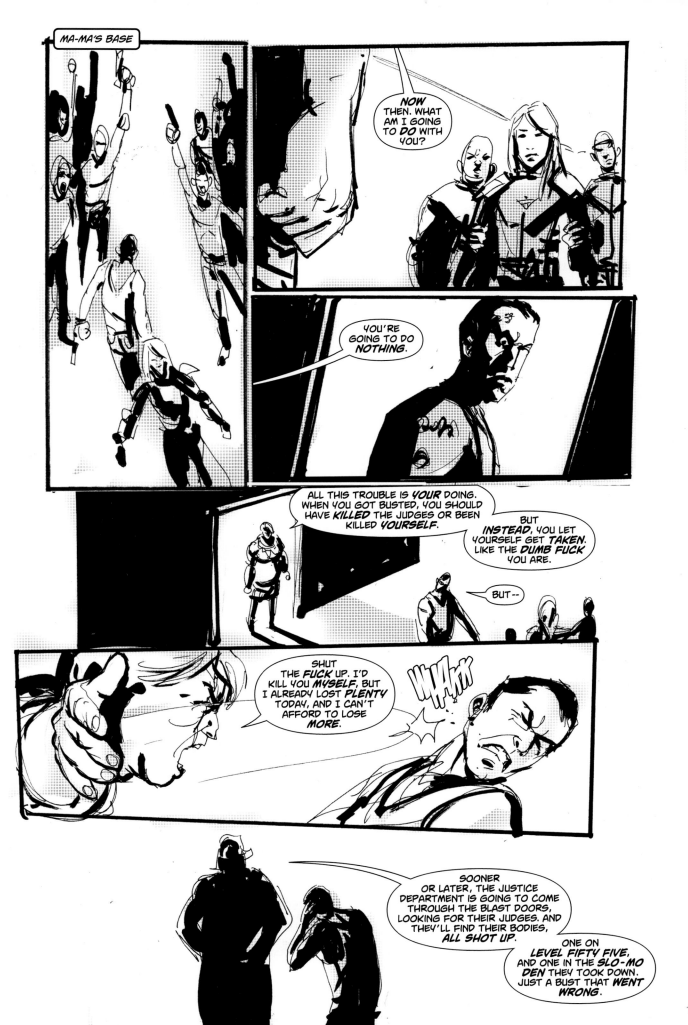

MA-MA'S hand reaches back, and closes around KAY'S hair, allowing her to yank his head close to hers.

MA-MA (CONT'D)

That means no torture. No raping. No skinning. Just a bunch of bullets in the head and chest. You understand me?

KAY hesitates.

MA-MA'S fist tightens so hard we can see the hairs getting pulled out of KAY'S head.

MA-MA (CONT'D)

Do you fucking understand me?

KAY

Yes.

MA-MA

Good.

AT THAT MOMENT -

- a CLAN MEMBER arrives.

CLAN MEMBER

Ma.

MA-MA turns. Wipes stray hairs from her hand.

The guy looks worried.

CLAN MEMBER (CONT'D)

You'd better come quick.

INT. MA-MA'S BASE/CCTV ROOM - CONTINUOUS

MA-MA, followed by KAY, enters the CCTV room.

The CLAN TECHIE is hurriedly working his console.

MA-MA

Now what?

CLAN TECHIE

It's the other judge. He's patched himself in to one of the terminals. I think he's trying to access the Tanoy.

MA-MA

Can't you stop him?

CLAN TECHIE

I can shut down the whole system. But if we let him talk, I can trace which terminal he's using. We'll know exactly where he is.

On cue, over the Tanoy, DREDD'S VOICE cuts in.

DREDD'S VOICE

Inhabitants of Peach Trees. This is Judge Dredd speaking.

The CLAN TECHIE looks back to MA-MA.

MA-MA

Let him talk.

INT. ATRIUM - CONTINUOUS

DREDD'S VOICE echoes down the whole atrium.

All around the balconies and apartments, the citizens, many of them armed, listen.

DREDD'S VOICE

In case you people have forgotten: this block operates under the same rules as the rest of the city. Ma-Ma is not the law. *I* am the law.

CUT TO -

- MA-MA and KAY walk out on to the top level balcony.

DREDD'S VOICE (CONT'D)

Ma-Ma is a common criminal.

On MA-MA'S FACE:

DREDD'S VOICE (CONT'D)

Guilty of murder. Guilty of the manufacture and distribution of the narcotic known as slo-mo.

MA-MA'S head snaps round to KAY.

The look in her eyes silences him.

DREDD'S VOICE (CONT'D)

And as of now, under sentence of death.

CUT TO -

- groups of armed citizens.

DREDD'S VOICE (CONT'D)

Any who obstruct me in carrying out my duty will be treated as an accessory to her crimes. You have been warned.

The armed citizens exchange glances.

CUT TO -

MA-MA.

DREDD'S VOICE (CONT'D)

As for you, Ma-Ma ...

CUT TO -

CLOSE UP ON DREDD'S MOUTH.

DREDD'S VOICE (CONT'D)

Judgement time.

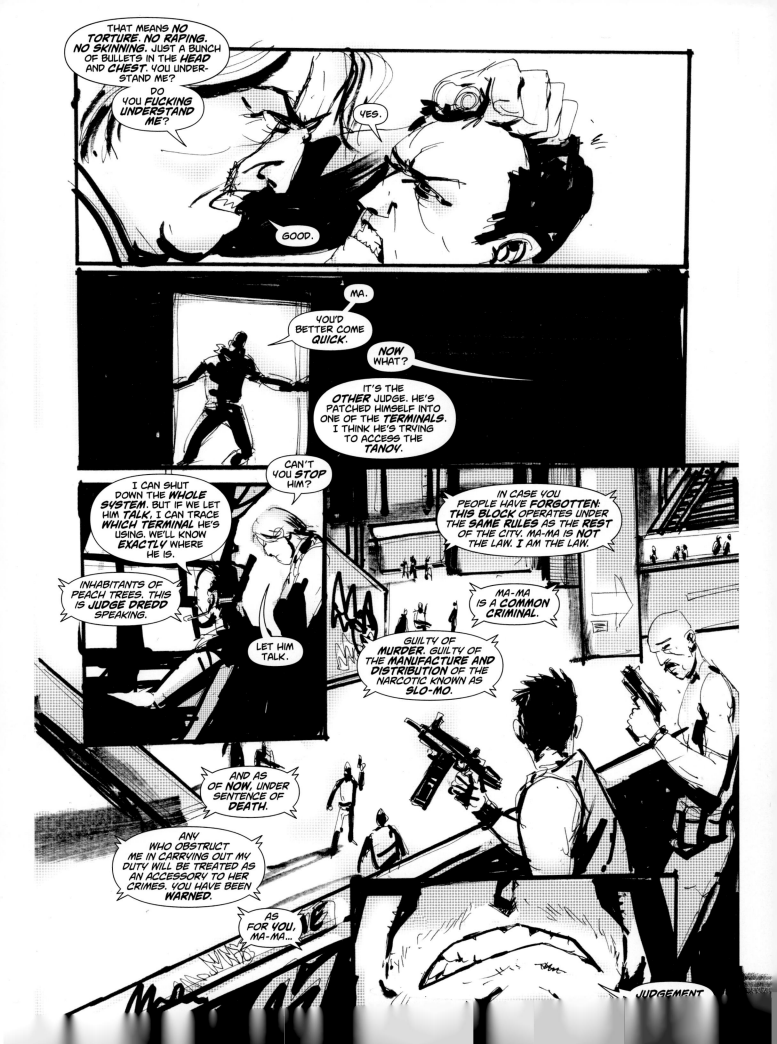

JUDGEMENT

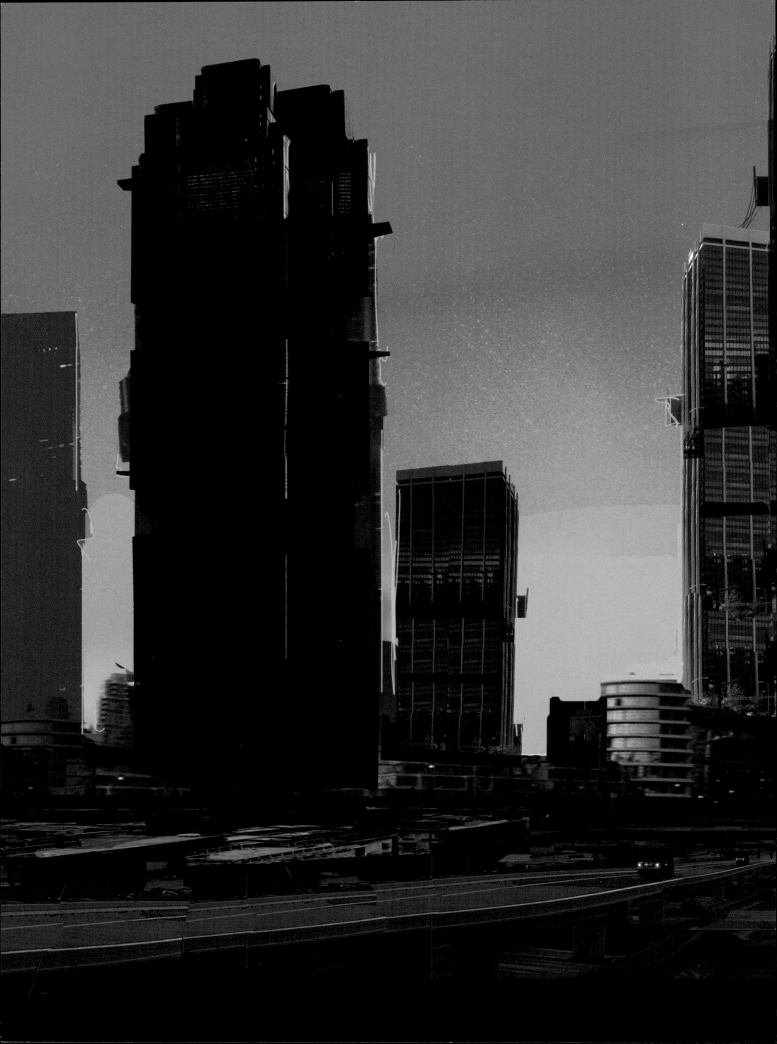

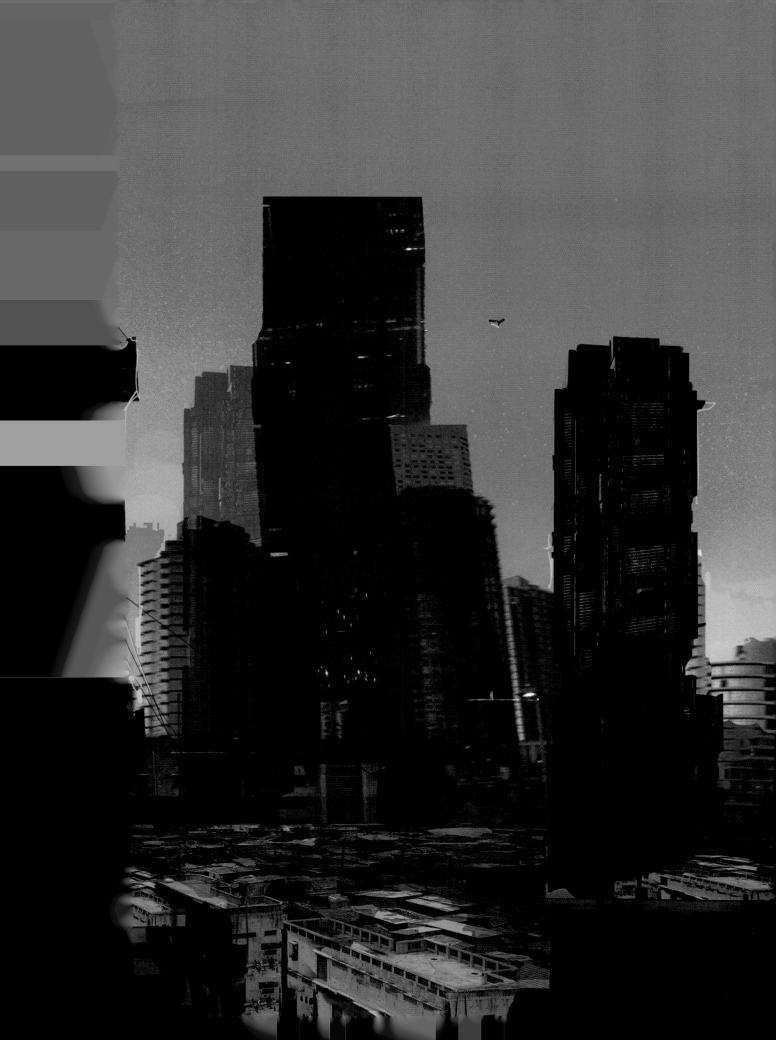

INT. ATRIUM/TOP BALCONY - CONTINUOUS

As the Tanoy cuts out, we find MA-MA, standing by the rail, gripping it hard in her huge fists.

Beside her, KAY, ashen-faced.

Behind her, the CLAN-TECHIE, appearing.

> **CLAN TECHIE**
>
> I've got him. He's only ten levels below us. south quad balcony. Terminal five.

CUT TO -

INT. LEVEL 190/CORRIDORS - DAY

Two groups of CLAN, automatic weapons in hand, run down corridors, exiting onto the -

INT. LEVEL 190/BALCONY - CONTINUOUS

- balcony, where they converge on Terminal Five: one of the information access booths dotted around the block.

Through the frosted glass of the booth, we can just make out the shape of a tall man.

> **CLAN MEMBER**
>
> He's still in there!

The two converging groups of Clan open fire as one.

Hundreds of rounds simultaneously smash into the frosted glass.

Blood and glittering shards cloud our vision.

And when they clear -

- we find the body of a CLAN member.

Dead. Shot to pieces. But still held upright by the plasticuffs that secure him to the terminal console.

Justice Department logo designs by the Production Department.

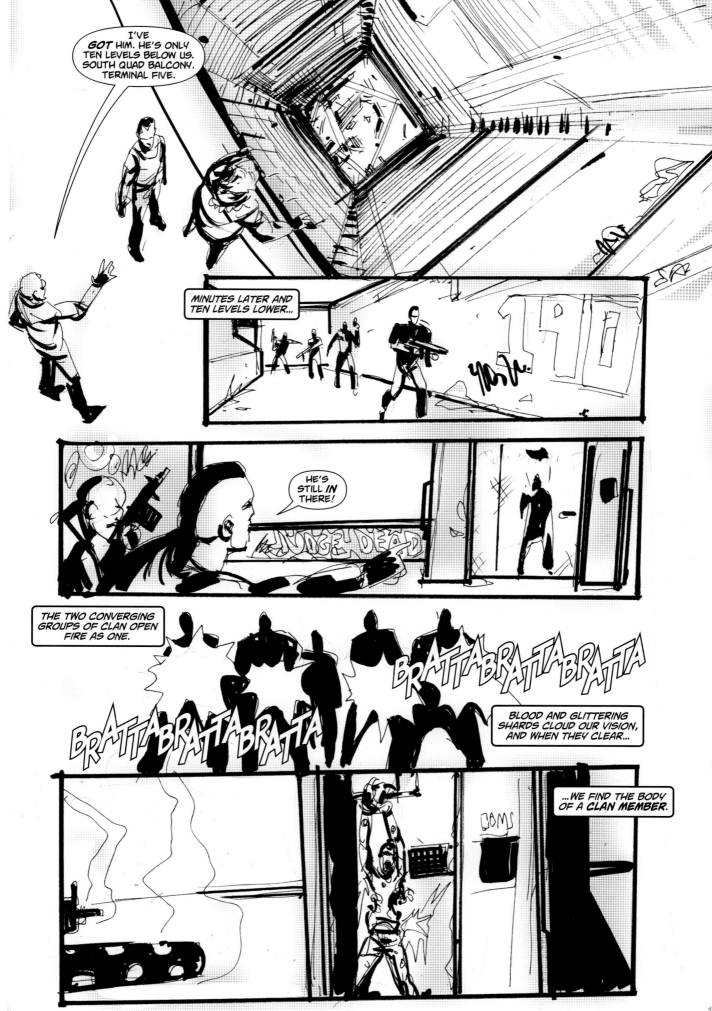

159

PULL BACK FAST TO -

INT. LEVEL 191/BALCONY - CONTINUOUS

- the opposite balcony of the next level up.

Where DREDD is standing.

Looking down.

> **DREDD**
>
> Incendiary.

The setting on DREDD'S gun changes.

Then he opens up.

As the incendiary rounds make contact, they erupt into fireballs, engulfing the balcony of level 190.

DREDD walks, calmly shooting. Spreading the flame.

Until it is a ring of fire.

Out of which, blazing Clan, blinded by fire and pain, throw themselves into the void of the atrium.

A PARTICULARLY LARGE FIREBALL erupts.

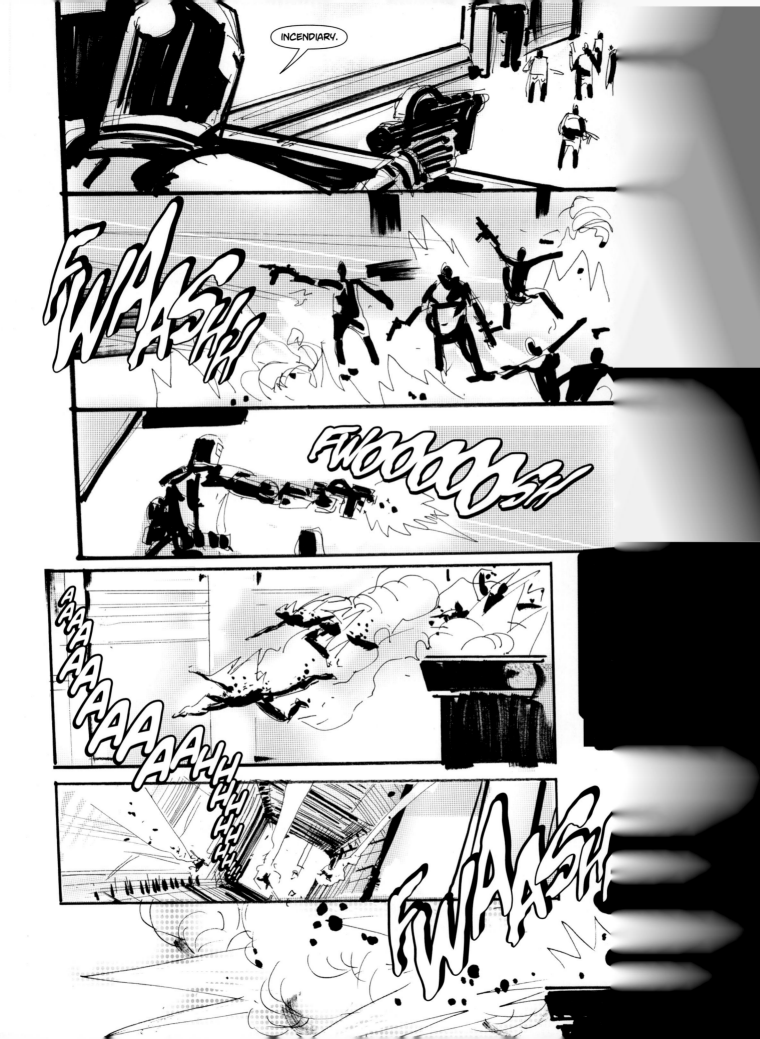

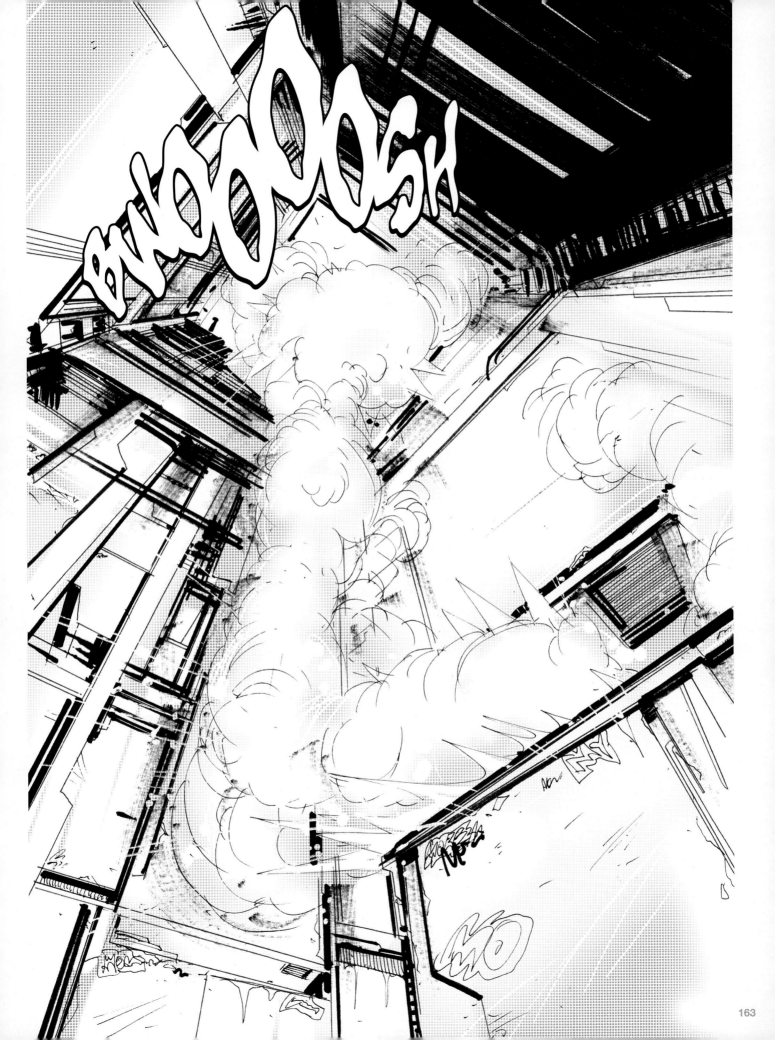

INT. ATRIUM - CONTINUOUS

We FOLLOW the FIREBALL upwards, as it rolls through the atrium ...

... until it hits and dissipates on the roof ...

Sending MA-MA, KAY, and the CLAN TECHIE recoiling back from the edge of the balcony, and diving for the floor.

'A shot of the exterior destruction from Ma-Ma's genocide of the western quadrant of Peach Trees. Brutal.' - *Jock*

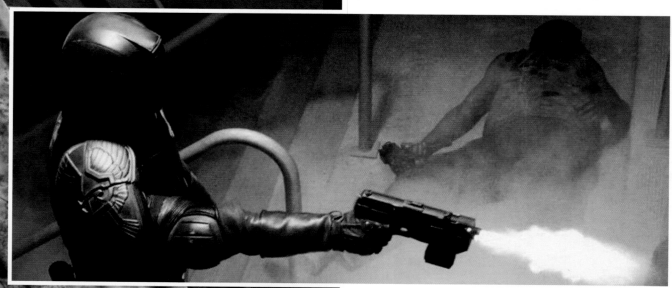

When the CLAN TECHIE and MA-MA look up, they see the KAY tearing at his head, screaming.

He didn't pull back from the balcony quickly enough, and the fireball has caught his hair on fire.

> **KAY**
>
> Aaah! AAAAH!

KAY beats the flames on his head out.

When he's done, half his hair is burned to the scalp.

> **KAY** (CONT'D)
>
> *Fuck!*

MA-MA goes back to the balcony.

Looks down at the devastation.

KAY watches her, smoke curling up from his head.

> **KAY** (CONT'D)
>
> Ma, this is going to shit! You've got to fucking stop this guy! what are we going to do?

Fire reflecting in MA-MA'S eyes.

> **MA-MA**
>
> Got no choice. Dial 911.

CUT TO -

EXT. MEGA CITY ONE - NIGHT

- SIRENS in Mega-City One.

Blue lights strobing the night.

Four judges, straight-line formation, on bikes.

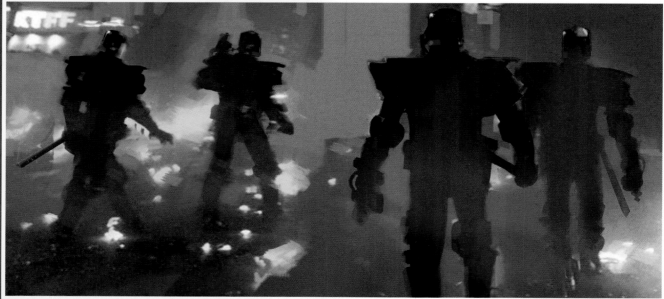

We see them each in turn.

They are judges ALVAREZ, CHAN, KAPLAN, and LEX.

Each more hard-bitten than the last.

Riding up the ramps, down the walkways, scattering pedestrians...

...then pulling up at the SOUTH ENTRANCE of Peach Trees.

As they get off their bike, we see ALVAREZ is armed differently to the other three. Instead of a handgun, he carries a bulky MACHINE GUN.

EXT. PEACH TREE BLOCK/SOUTH ENTRANCE - CONTINUOUS

LEX approaches the three JUDGES who are already on the scene.

LEX is very like DREDD. Same build. Same granite face. Speaks with total economy in a low growl.

LEX

Got a 10-24 from this block. Two judges under fire, requesting urgent assistance. And you're standing outside.

JUDGE

Block's under lock-down. Malfunction with their nuke defense system.

LEX glances at the blast doors.

ALVAREZ, the HEAVY WEAPONS JUDGE, walks over to the intercom. Speaks into it.

ALVAREZ

Open up. Now.

A beat.

Then ...

the heavy door starts to rise.

LEX looks back at the judges.

LEX

You're relieved.

'All the weapons were based on existing models, so the armourers could retro-fit the elements on top of a working gun. I liked this shotgun a lot, but they couldn't get the particular shotgun in South Africa - the final gun seen in the film (belonging to Judge Alverez) has a different look.' - *Jock*

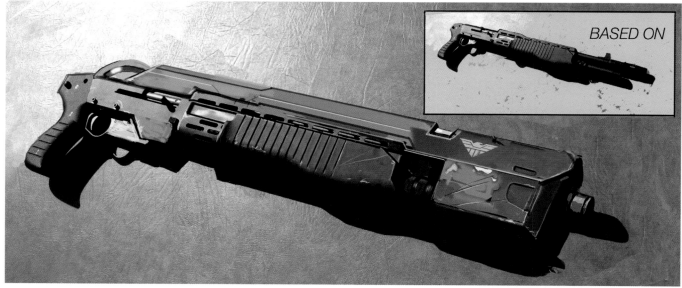

BASED ON

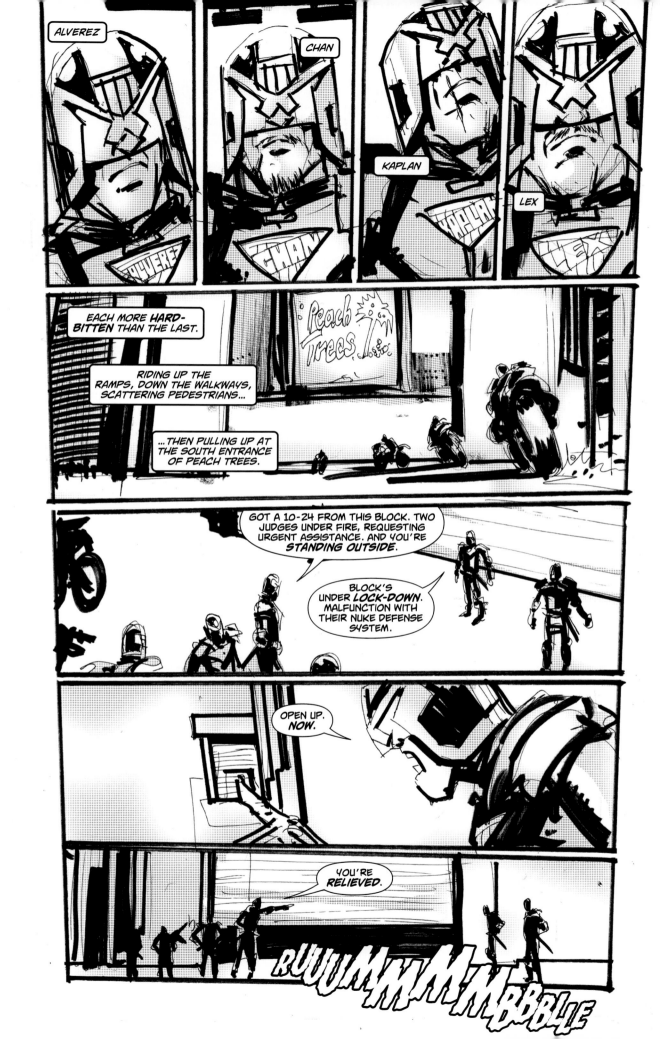

ALVEREZ

CHAN

KAPLAN

LEX

EACH MORE *HARD-BITTEN* THAN THE LAST.

RIDING UP THE RAMPS, DOWN THE WALKWAYS, SCATTERING PEDESTRIANS...

...THEN PULLING UP AT THE SOUTH ENTRANCE OF PEACH TREES.

GOT A 10-24 FROM THIS BLOCK. TWO JUDGES UNDER FIRE, REQUESTING URGENT ASSISTANCE. AND YOU'RE *STANDING OUTSIDE.*

BLOCK'S UNDER *LOCK-DOWN.* MALFUNCTION WITH THEIR NUKE DEFENSE SYSTEM.

OPEN UP. *NOW.*

YOU'RE RELIEVED.

RUUUMMMMMMBBBLLE

INT. PEACH TREE BLOCK/SOUTH ENTRANCE - CONTINUOUS

Seen from a CCTV POV, LEX, ALVAREZ, KAPLAN and CHAN enter the darkened entrance.

The three judges on the outside watch them.

until the blast door suddenly slams shut again.

REVEAL -

INT. PEACH TREE BLOCK/MEDICAL CENTER - CONTINUOUS

- that the CCTV image is being watched by the PARAMEDIC.

He jumps up, runs to his security, and punches in the code to unlock it.

INT. ATRIUM - CONTINUOUS

LEX, CHAN, ALVAREZ and KAPLAN stand at the base of the atrium.

It's the bottom of a pit of Hell.

Dark, apart from the glow of emergency lighting.

A hundred and ninety stories up, fire burns.

The base of the atrium is littered with smouldering bodies, crumpled and half exploded from the impact of their fall.

LEX

So what we got here?

CHAN

Two judges trigger a turf war. Judges die in pursuit of duty.

LEX

And the perps who killed the judges?

CHAN gestures at the bodies.

CHAN

Laid out here.

LEX

Sounds right.

PARAMEDIC

Excuse me.

The four judges turn.

See the PARAMEDIC, who has approached them from the shadows.

PARAMEDIC (CONT'D)

That's not what's happened. I've been here right from the start. This killing is all because of one gang - the Ma-Ma Clan. And from that fire up there, I'd say at least one of your two judges is still alive.

LEX gazes at the man a beat.

LEX

You prepared to testify to that?

PARAMEDIC

Sure.

CHAN shoots the PARAMEDIC in the head.

INT. LEVEL 199/CORRIDOR - CONTINUOUS

DREDD exits a stairwell into a corridor of level 199. One level down from MA-MA'S penthouse base.

One end of the corridor opens into the atrium, where we can see the glow of flames from the fire he has started.

Smoke hangs in the air. Gives everything a strange, heavy atmosphere.

Ahead of DREDD is an elevator lobby.

The digital display by the call button shows the elevator moving between floors, upwards through the building.

The elevator gets closer and closer to level 199.

As the countdown is about to reach his floor, DREDD takes aim, to catch whoever is inside as the doors open ...

... but the elevator continues to the floor above.

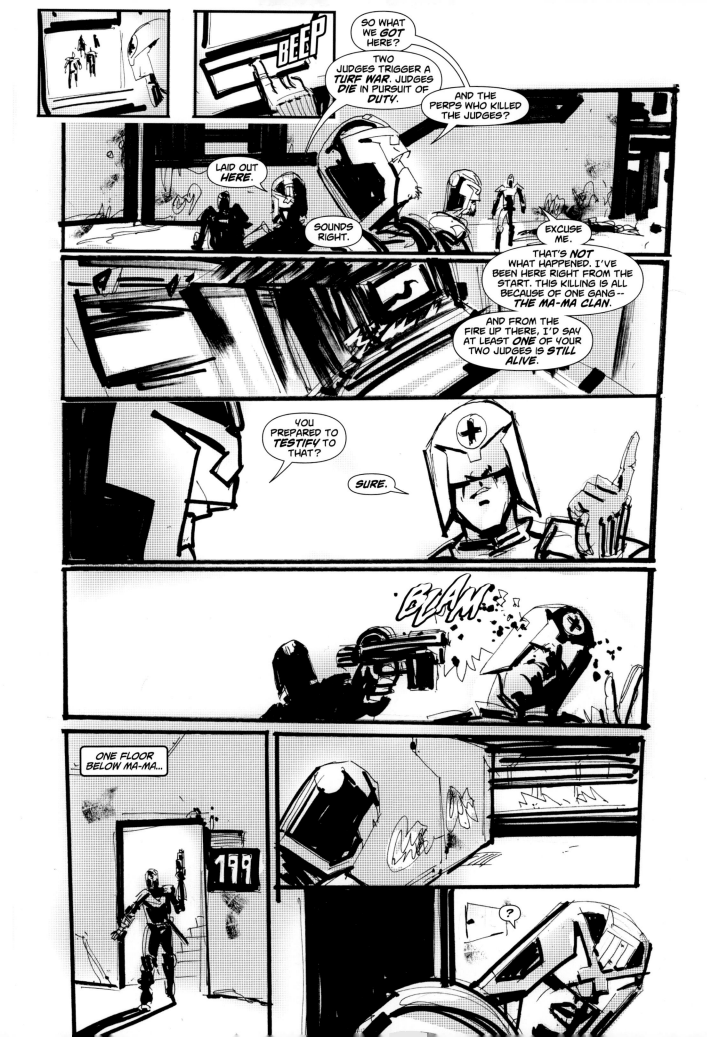

NO SOONER HAS IT PASSED -

- than there is a sound behind DREDD.

He turns, fast, firing.

Coming out of a doorway, a CLAN MEMBER is almost shot in half by the volley.

ON DREDD'S GUN -

- a WARNING LIGHT flicks on.

DREDD glances down.

On the DIGITAL DISPLAY it reads: AMMUNITION LOW

CUT TO -

INT. MA-MA'S BASE - CONTINUOUS

Elevator doors open, revealing the four judges.

The four judges exit.

Waiting for them are MA-MA and KAY.

> **LEX**
>
> One million credits.

> **MA-MA**
>
> A million?

> **LEX**
>
> You got a problem with a judge. Know who he is?

> **MA-MA**
>
> No.

> **LEX**
>
> I do. One million.

Beat.

> **MA-MA**
>
> Fine.

> **LEX**
>
> Muggers, protection detail on client. Thoz and El, we're flushing him out.

> **ALVAREZ**
>
> Got it.

LEX turns back to MA-MA.

> **LEX**
>
> Where's the other one? The rookie.

> **MA-MA**
>
> We've got her here.

> **LEX**
>
> Dead or alive?

> **MA-MA**
>
> Alive.

> **LEX**
>
> Make her dead.

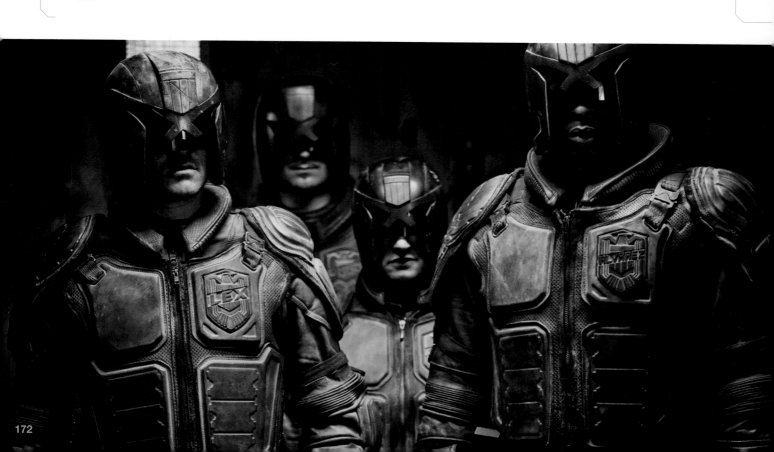

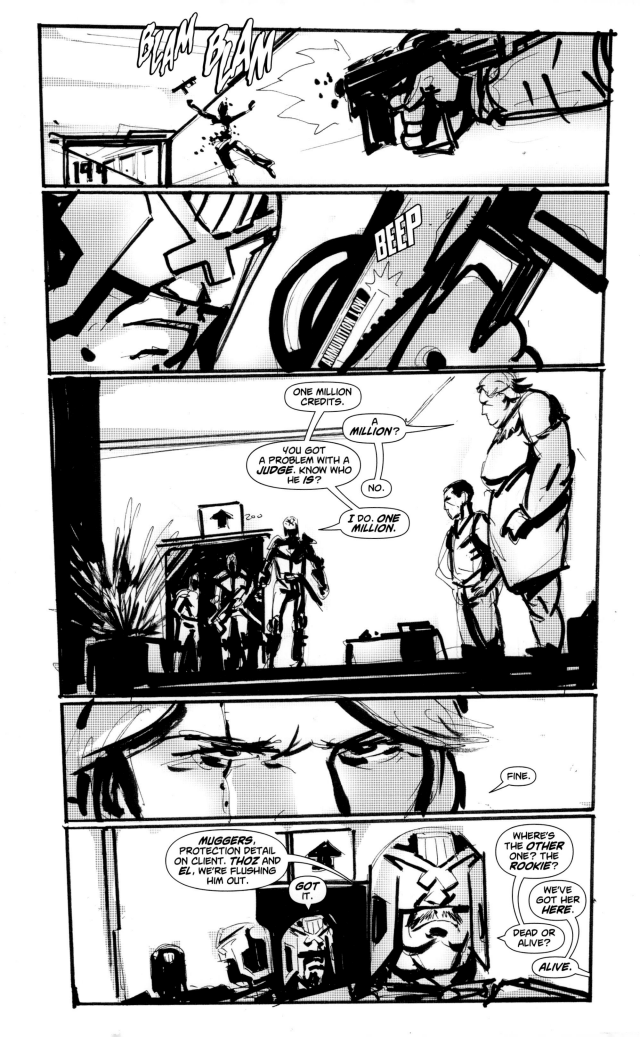

INT. LEVEL 199/SMOKE-FILLED CORRIDOR - CONTINUOUS

Smoke hangs in a corridor.

Bright sparks swirl in the air, floating up from the fire.

And the sparks, through the smoke, are changing their movement ...

... as DREDD appears through them, gun raised.

INT. LEVEL 199/SMOKE-FILLED CORRIDOR - CONTINUOUS

LEX, CHAN and ALVAREZ appear out of a stairwell.

LEX silently gestures to the other two judges - telling them to fan out.

They nod, and move, each taking a different direction.

INT. LEVEL 199/SMOKE-FILLED CORRIDOR - CONTINUOUS

DREDD moves forwards.

Reacts to a movement in the smoke.

Brings his gun to bear, as the smoke momentarily clears.

Revealing nothing.

Just a shadow.

INT. MA-MA'S BASE/CORRIDOR - CONTINUOUS

KAPLAN leads MA-MA and KAY down a corridor, towards MAMA'S penthouse.

> KAY
>
> I'll do the girl.

MA-MA gives KAY the nod.

KAY peels off.

INT. LEVEL 199/SMOKE-FILLED CORRIDOR - CONTINUOUS

Back to the sparks.

DREDD seeing something ahead.

Through the haze and pinprick points of brightness ...

... the shape of another judge.

The shoulder pads. The curve of the helmet.

CUT TO -

- the REVERSE VIEW.

CHAN pulling back into an alcove, drawing his weapon.

CHAN lifts his glove and speaks into his mike.

> CHAN
>
> (quiet)
>
> Just eyeballed him.

CUT TO -

- LEX, elsewhere in the smoke filled corridors, lifting his glove.

> LEX
>
> Don't take him one on one. Stick with the plan.

CUT TO -

CHAN.

> CHAN
>
> (quiet)
>
> Copy that.

CHAN lowers his glove.

Then calls out.

> CHAN (CONT'D)
>
> You there. Identify yourself.

CUT TO -

DREDD. Also ducked into an alcove, weapon drawn.

> DREDD
>
> Dredd. Sector Thirteen.

Ahead of him, CHAN steps out of cover.

> CHAN
>
> Thoz. Sector Nine. Responding to your 10-24.

CHAN walks towards DREDD.

> CHAN (CONT'D)
>
> Good to see you, Dredd.

> DREDD
>
> Likewise. You alone?

> CHAN
>
> Negative. Three man squad. Closing on my vector right now.

CHAN smiles.

> CHAN (CONT'D)
>
> So relax. Cavalry's here.

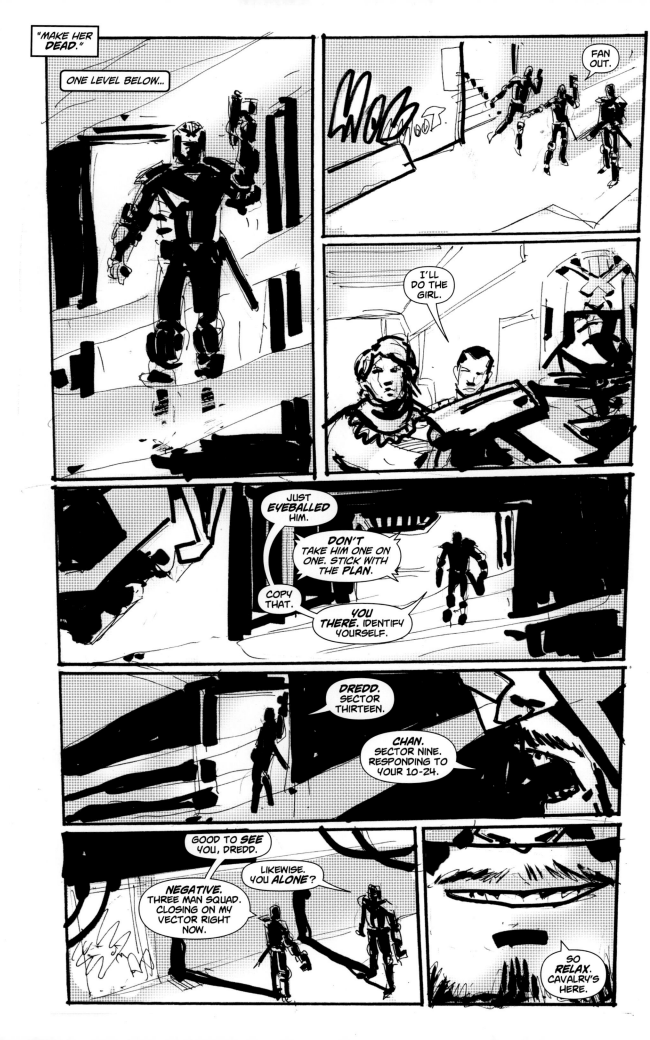

Beat. On DREDD. His sixth sense, catching bullshit.

It's CHAN'S smile.

Then:

> **DREDD**
>
> There were two of us.
>
> **CHAN**
>
> Two.
>
> **DREDD**
>
> Two of us called in the 10-24. Wondering why you haven't asked about the other one.

Beat.

Then CHAN lifts his left glove ...

> **CHAN**
>
> Lex - move it -

CHAN is cut off.

DREDD'S hand catches his gun-arm around the wrist -

- and with equal speed, CHAN has done the same to DREDD, holding DREDD'S gun by the barrel.

For a moment, the TWO judges face each other, each neutralising the other's handgun.

Then -

- the fight kicks off.

DREDD pushes forwards, jamming CHAN'S wrist back, forcing his gun to drop.

CHAN twists, turning DREDD one eighty, pulling DREDD'S gun up so that the weapon is jammed against DREDD'S throat.

To prevent being choked, DREDD must release the gun.

Immediately, DREDD snaps his helmet back into CHAN with a reverse headbutt.

And now it's just silent HAND TO HAND COMBAT.

Incredibly fast and vicious.

Pure fight to the death between two hard-as-nails street judges.

Carried out in the hanging smoke and whirling sparks.

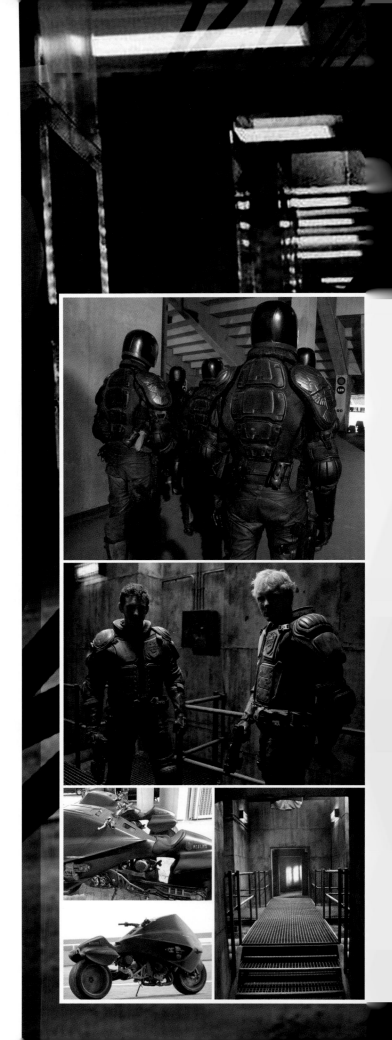

CUT TO -

INT. LEVEL 199/SMOKE-FILLED CORRIDOR - CONTINUOUS

- LEX hooking up with ALVAREZ.

Joining to move fast down the corridor.

CUT TO -

DREDD and CHAN in HAND TO HAND COMBAT.

Ending on a fast jab. An open hand. DREDD'S fingers slamming into CHAN'S neck.

It stops CHAN in his tracks.

When DREDD'S hand pulls back, there is a weird concave dip, several inches deep, in CHAN'S throat.

His windpipe has been crushed.

He can't breathe.

As CHAN'S hands move up to his neck, as if trying to push it back into shape -

- DREDD steps away.

And calmly picks up his handgun.

BACK TO -

LEX and ALVAREZ.

Turning a corner.

Seeing, ahead of them, the silhouette shape of a judge.

Their guns immediately snap to him.

But don't shoot, as the figure takes a hesitant, drunken step towards them.

Revealing himself as CHAN.

A final strangled noise comes out of CHAN'S blood-filled mouth.

Then he drops to his knees. Hard.

Then falls face down and lies still.

LEX and ALVAREZ exchange a glance.

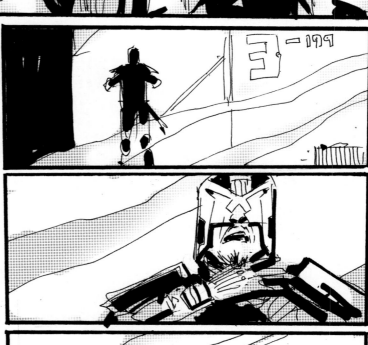

CUT TO -

INT. LEVEL 199/SMOKE-FILLED CORRIDOR - CONTINUOUS

- DREDD, who backs through a doorway.

As the door closes behind him, pulled shut by a hydraulic mechanism that slows the door on its final inches ...

LEX and ALVAREZ appear, guns drawn.

LEX gestures at the door.

ALVAREZ nods.

INT. SLO-MO MANUFACTURING BASE - CONTINUOUS

DREDD looks around at the space he has just entered into.

Apartment walls have been knocked out, as have sections of ceiling and floor. All to accommodate pipes, tanks, heaters, condensers ...

... and racks of large COMPRESSED GAS CANISTERS, the size of a scuba-diver's air tank.

The machinery for the large-scale manufacture and refining of the slo-mo narcotic.

This is MA-MA'S MANUFACTURING BASE.

As the WORKERS see DREDD, and scatter, **CUT TO -**

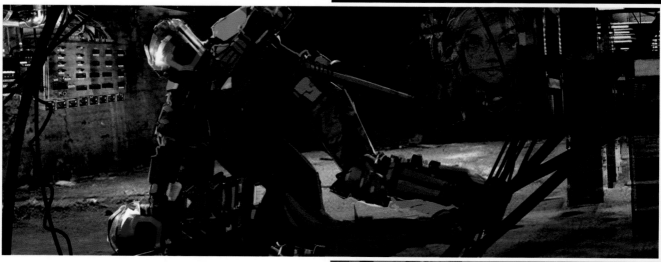

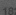

AS THE DOOR SHUTS BEHIND HIM, DREDD TURNS TO SURVEY THE SPACE HE HAS JUST ENTERED INTO.

APARTMENT WALLS HAVE BEEN KNOCKED OUT, AS HAVE SECTIONS OF CEILING AND FLOOR. ALL TO ACCOMMODATE PIPES, TANKS, HEATERS, CONDENSERS...

...AND RACKS OF LARGE COMPRESSED GAS CANISTERS, THE SIZE OF A SCUBA-DIVER'S AIR TANK.

THE MACHINERY FOR THE LARGE-SCALE MANUFACTURE AND REFINING OF THE SLO-MO NARCOTIC.

THIS IS MA-MA'S MANUFACTURING BASE.

INT. MA-MA'S BASE/ROOM - CONTINUOUS

- KAY. Half his hair burned off.

Looking at a variety of objects, laid out on a table. Objects taken from ANDERSON.

There are ammunition clips. Lock knife. Med kits. Plasticuffs ...

... and the PHOTO of ANDERSON and her parents.

KAY'S gaze hesitates on it.

Then -

- turns to ANDERSON, who is kneeling in front of him.

Head down, not meeting KAY'S gaze. No hope left for her. Defeated, it seems.

KAY glances at the weapon in his hand.

It's ANDERSON'S LAWGIVER.

> **KAY**
>
> Bet you thought you were going to make your parents proud. Not much chance of that now.

KAY shakes his head.

> **KAY** (CONT'D)
>
> You were shit out of luck when you ran into the Ma-Ma Clan.

KAY turns over ANDERSON'S gun in his hand, appraising it.

ANDERSON'S eyes stay down.

> **KAY** (CONT'D)
>
> But don't feel too bad. I've seen a lot of Judges in my time, and you just weren't cut out for it. If it wasn't today you got killed, it would have been tomorrow. At best the day after.

Beat.

> **KAY** (CONT'D)
>
> Anyway. Today it is.

He looks back at ANDERSON.

> **KAY** (CONT'D)
>
> Any last words, bitch?

Beat.

Then -

> **ANDERSON**
>
> That's funny.

ANDERSON raises her head.

And in her eyes, there's no fear. She's totally calm, staring death right in the face. Not even blinking.

She may be a failed rookie, but she looks like a judge.

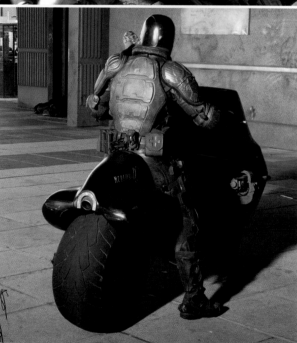

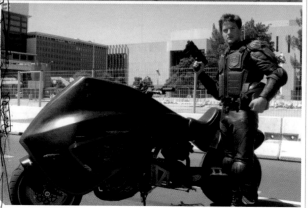

ANDERSON (CONT'D)

I was going to ask you the exact same thing.

(beat)

Bitch.

KAY'S wrong-footed. It's fleeting, but just for a moment, it's almost like he's scared of her.

Then his fingers close around ANDERSON'S gun.

He lifts it, aiming right at her head.

And squeezes the trigger.

Nothing happens.

KAY frowns.

Sees on the side of the gun -

- a small LED light. Strobing red.

Next to the light, the digital display. Which reads:

 ID FAIL.

Just as he has time to take this in -

- the gun EXPLODES.

A bright flash, a detonation.

And when it has passed, KAY'S arm is a stump, spraying blood everywhere. And he's screaming.

Cut short as ANDERSON rises ...

...and delivers a single roundhouse kick.

It contacts KAY'S jaw perfectly, snapping his head sideways.

Breaking his neck.

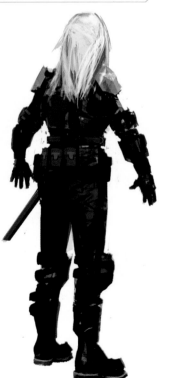
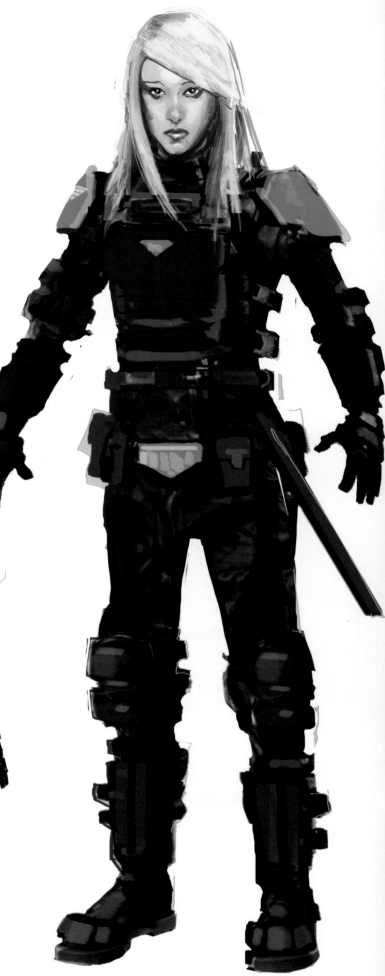

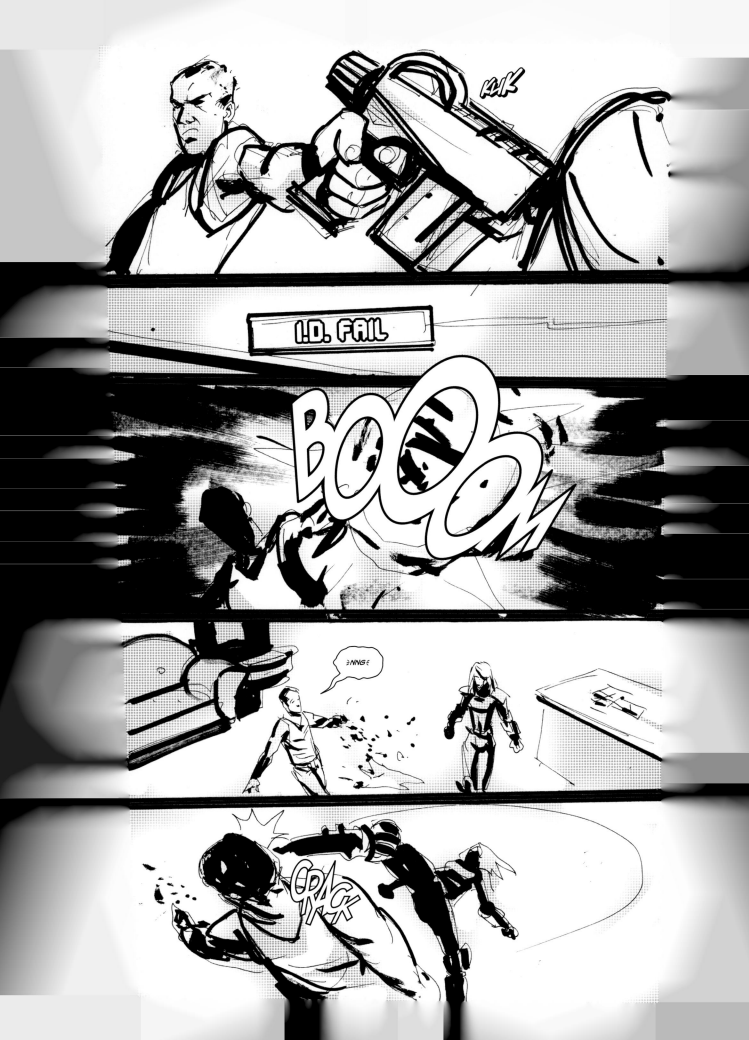

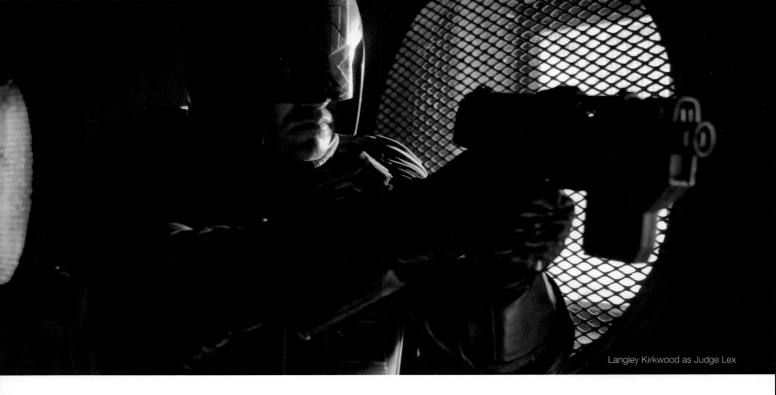

CUT BACK TO -

INT. SLO-MO MANUFACTURING BASE - CONTINUOUS

- DREDD.

Moving through the manufacturing base.

Keeping low, from cover to cover.

Peering out across the lab.

Seeing the door he came through

Tucking himself behind a counter, he calls out:

> **DREDD**
>
> What's the price of a judge these days?

CUT TO -

LEX and ALVAREZ.

On the other side of the room, doing the same as DREDD.

LEX silently gestures to ALVAREZ. Flat palm, held vertical to the ground, curving round.

ALVAREZ nods. Starts moving.

Then LEX calls back:

> **LEX**
>
> Million. Split four ways. **BACK TO -**

- DREDD.

Both DREDD and LEX are trying to keep the other talking. DREDD to get a fix on LEX, and LEX to allow ALVAREZ to work his way around.

> **DREDD**
>
> Three ways now.

> **LEX**
>
> Suits me.

DREDD starts to move again.

> **DREDD**
>
> Doesn't sound like much. To betray the law.

DREDD steals a look across the room towards where he thinks he has made LEX'S location.

> **DREDD** (CONT'D)
>
> Betray the city.

> **LEX**
>
> Save that shit for the rookies.
>
> Twenty years I've been on the streets.

DREDD now thinks he has a clear fix on LEX.

He's zeroed in on one spot - a long steel workbench.

Which is in fact exactly where LEX is hiding.

> **LEX** (CONT'D)
>
> You know what Mega-City One is, Dredd? It's a meat grinder.

REVEAL -

- BEHIND DREDD, while DREDD has been closing in on LEX, ALVAREZ has been flanking.

> **LEX** (CONT'D)
>
> People go in one end.

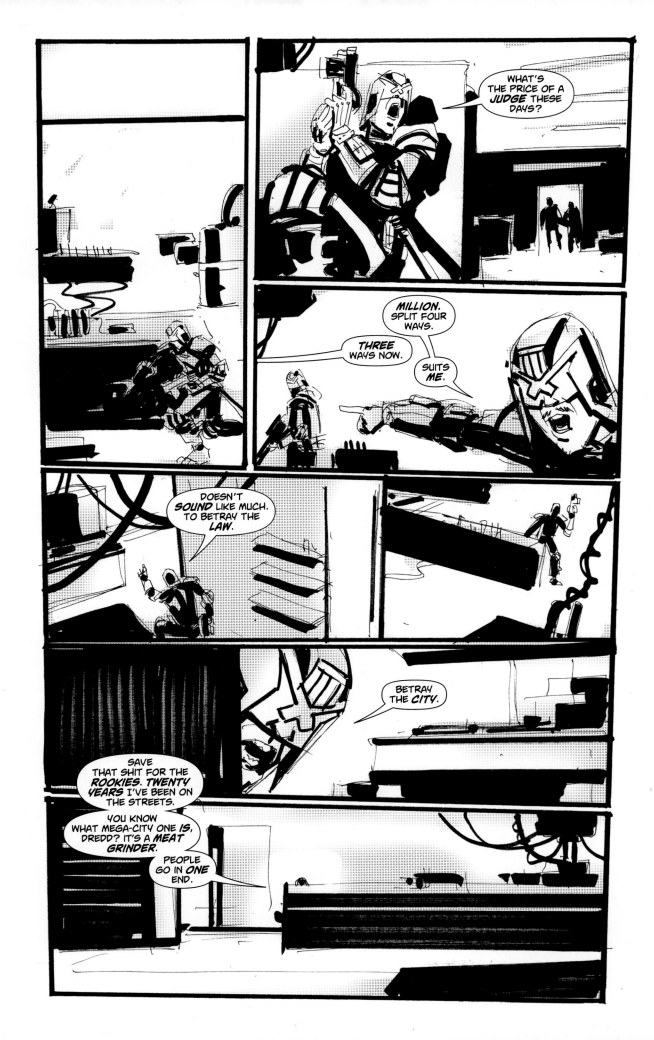

DREDD doesn't seem to have seen.

He's easing forwards, his gun trained on the workbench.

LEX (CONT'D)

Meat comes out the other.

DREDD hesitates.

Maybe having heard something. Maybe sensing the trap.

LEX (CONT'D)

All we do is turn the handle.

A fraction of a beat.

Then DREDD throws himself sideways, just in time, as rounds from ALVAREZ'S HEAVY MACHINE GUN trace into the space he occupied only a split second before.

INTENSE GUNPLAY immediately erupts.

GUNPLAY version of the HAND TO HAND.

DREDD starts returning fire in the direction of ALVAREZ.

ALVAREZ does the same in reverse.

As does LEX, breaking cover.

The manufacturing base starts disintegrating.

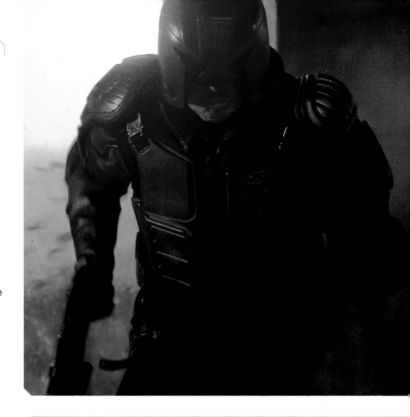

LAWGIVER EVOLUTION
Getting pretty close to the final gun here.

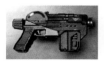 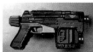 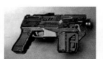 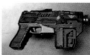 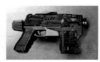 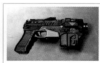 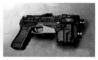

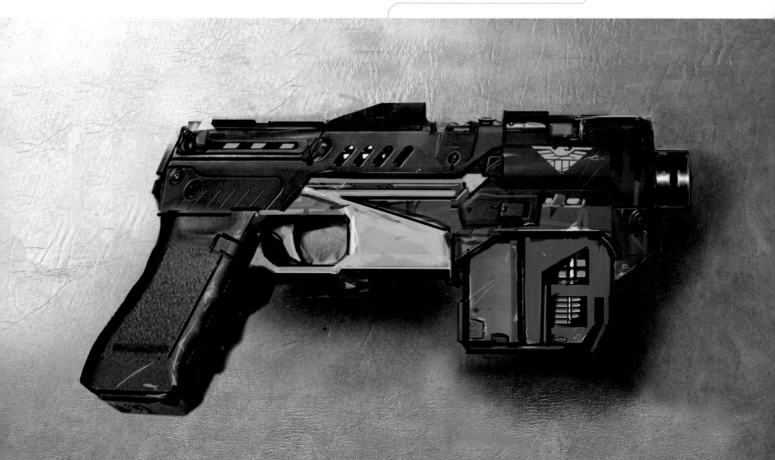

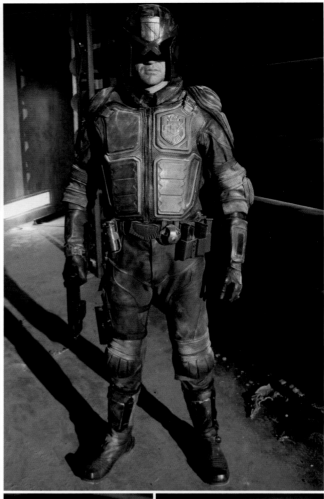

Amidst the glass vapourising, wood splintering, and metal puncturing -

- we find DREDD and ALVAREZ.

Finding a clear line of sight to each other.

Each bringing their guns to bear.

ALVAREZ fires first.

And nothing happens. The display on his HEAVY MACHINE GUN reads EMPTY.

> **ALVAREZ**
>
> Shit -

DREDD fires.

CLICK.

DREDD'S weapon also just found an empty chamber.

Both judges realise what's happening.

ALVAREZ reaches for his UTILITY BELT -

> **DREDD**
>
> Incendiary.

The gun setting changes. DREDD pulls the trigger again.

Click. Still empty.

ALVAREZ pulls out a fresh CLIP.

> **DREDD** (CONT'D)
>
> Rapid fire.

Click.

ALVAREZ jams the CLIP home.

> **DREDD** (CONT'D)
>
> Armour piercing.

Click.

ALVAREZ lifts the gun.

> **DREDD** (CONT'D)
>
> High Ex.

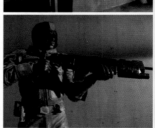

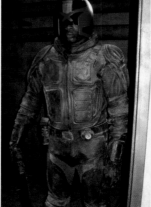

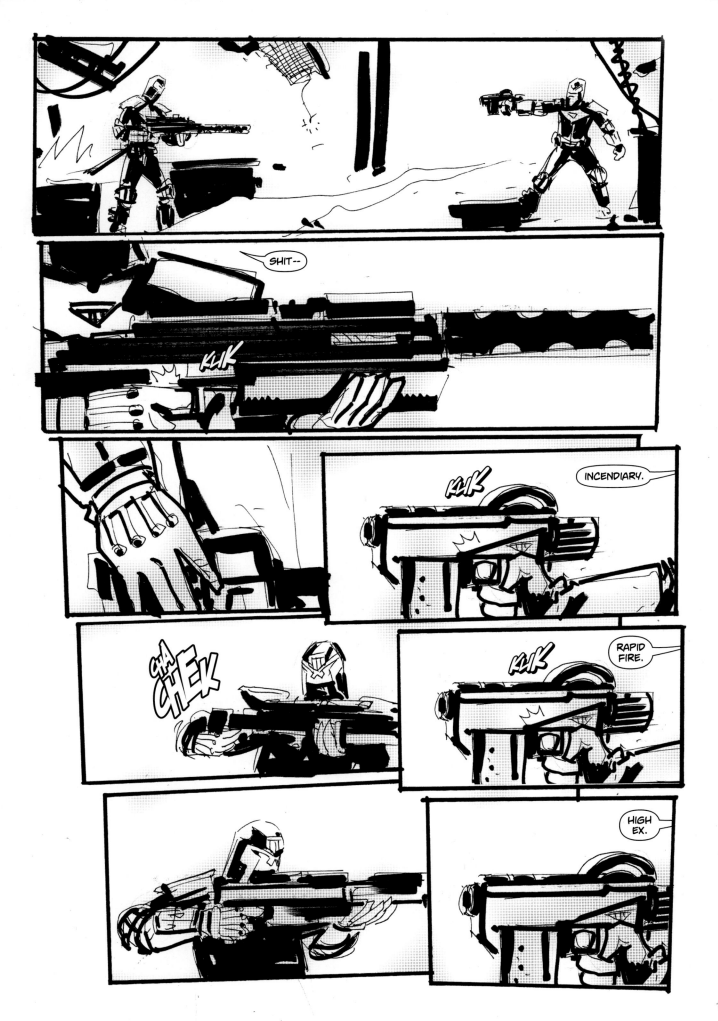

BANG.

As DREDD'S LAST BULLET flies out of his gun, the DIGITAL DISPLAY reads:

 EMPTY

THEN -

- ALVAREZ'S head is blown off.

It fragments.

The pieces fly apart.

CUT TO -

- LEX.

In cover, as blood patters around him like rain.

> **LEX**
>
> (under his breath)
>
> Motherfucker.

DREDD calls out.

> **DREDD**
>
> Two-way split.

In LEX, there's fury behind the steel.

He calls back:

> **LEX**
>
> Yeah. I'd be breaking a sweat. If you hadn't just run out of bullets.

LEX rises, and starts strafing the room.

As DREDD scrambles for cover, **CUT TO -**

INT. MA-MA'S BASE - CONTINUOUS

- ANDERSON.

Moving through MA-MA'S base.

She's unarmed.

But only for a moment.

Ahead of her are two CLAN.

She moves up behind them.

She doubles up the first with an extremely vicious kidney punch.

As the first folds over, the second is lifting his MACHINE PISTOL gun.

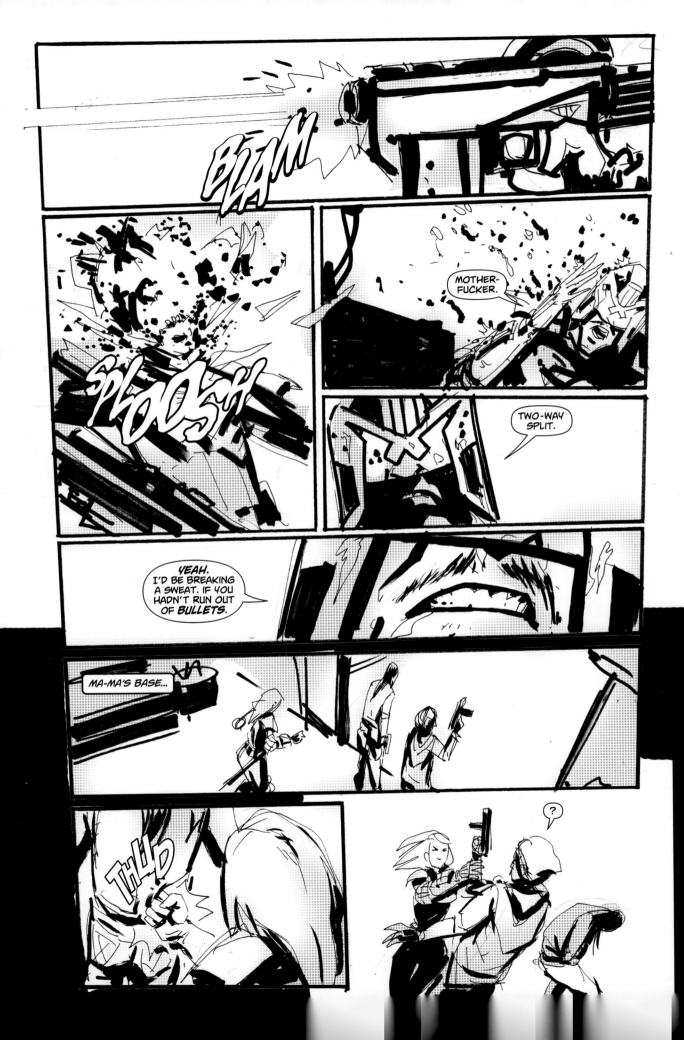

Only to have his wrist folded back on itself, so the barrel is aiming between his eyes.

ANDERSON forced the trigger down. The muzzle flash of the MACHINE PISTOL engulfs his whole face.

ANDERSON empties the clip.

When the muzzle stops flashing, the man's face is completely gone.

He remains standing, because ANDERSON is holding him upright, as she pulls another ammo clip from his belt.

Then she lets him go.

As he's falling, she's sliding in the new clip.

Then she turns, and shoots the man she dropped with the kidney punch.

'Various iterations of Mega-City One. Again, based on existing real-world locations' - *Jock*

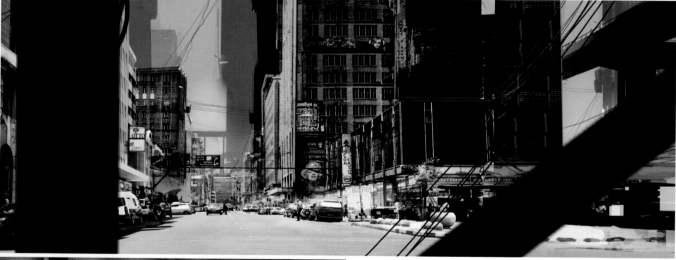

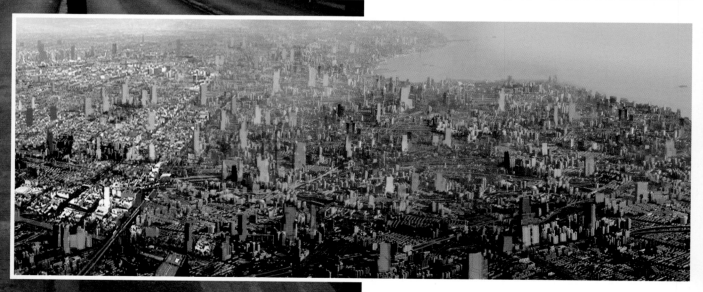

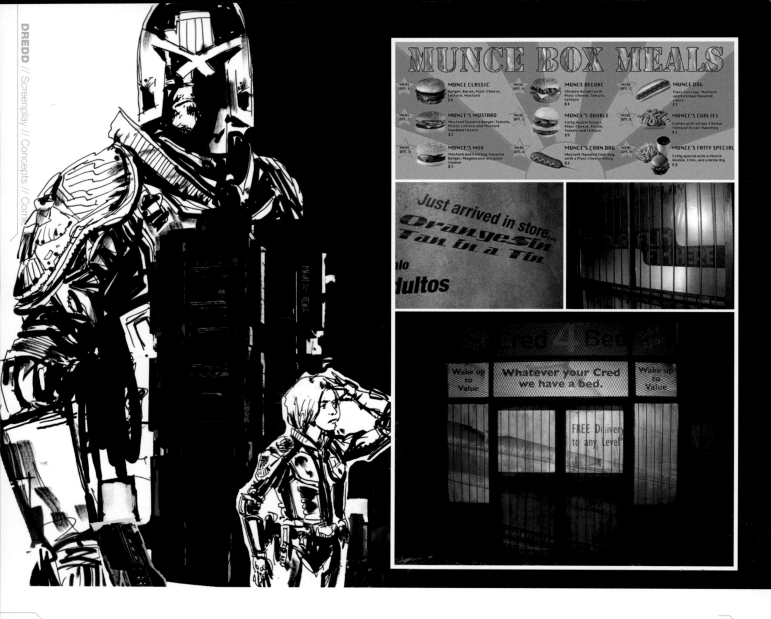

CUT TO -

INT. MA-MA'S BASE - CONTINUOUS

MA-MA and KAPLAN react to the burst of gunfire.

In the silence that follows:

MA-MA

Kay's dead.

KAPLAN

Get a gun. Find somewhere to hide.

MA-MA

Where are you going?

KAPLAN

I've got the girl cold. I see her first, I shoot her. She sees me first, she hesitates, then I shoot her.

CUT TO -

INT. MA-MA'S BASE/CORRIDOR - CONTINUOUS

- ANDERSON, moving fast in classic sweep, gun raised in two handed grip.

Rounding a corner.

Finding the corridor is clear.

Tense beats, as she moves towards the next blind spot.

A T-JUNCTION.

She swings around it, and -

- finds KAPLAN.

He's side on to her.

His head turns.

KAPLAN

Lower the gun, rookie. I'm your back up.

A beat on ANDERSON'S face.

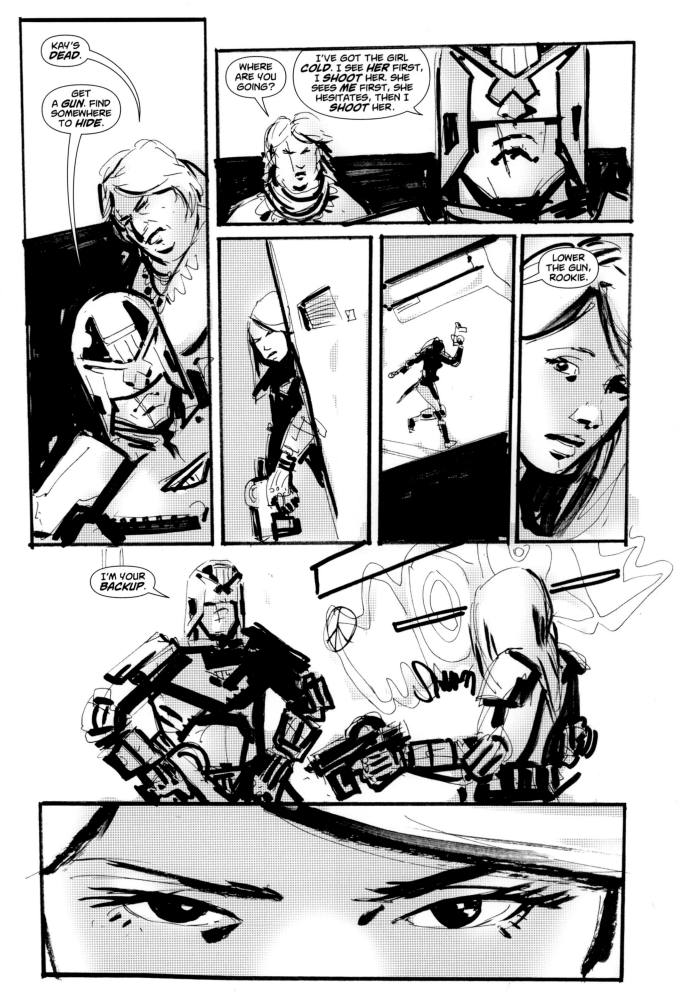

ONLY JUST LONG ENOUGH -

- for us to realise she's reading him.

Then she unloads into KAPLAN'S chest.

CUT TO -

INT. SLO-MO MANUFACTURING BASE - CONTINUOUS

- bullets punching the cover around DREDD.

DREDD moves for another place to hide.

But as soon as he reaches fresh cover, he is driven out by further volleys of bullets.

Finally, he finds himself behind a short section of wall. A remainder of the apartment walls that once stood. Five foot long.

Nothing to hide behind where he just came from, because everything is shot to pieces.

Nothing ahead but clear air.

DREDD'S options just ran out.

He knows it.

And on the other side of the wall, LEX knows it too.

CUT TO -

- LEX.

Unhurried.

> **LEX**
>
> Armour piercing.

The setting on his gun changes.

He takes aim at a mid-way point on the wall.

A final beat.

Then LEX fires.

CUT TO -

- a bullet rifling out of DREDD'S stomach.

We've seen a lot of bullets hit people up to now. This one is different. Almost understated.

The visual impact is not what in what the bullet has done, but in who it has hit.

THE SLO-MO MANUFACTURING BASE...

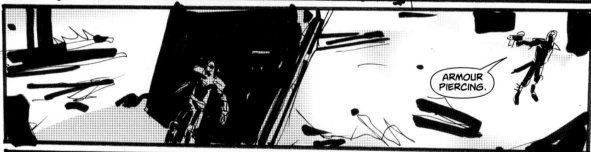

ARMOUR PIERCING.

In the wall opposite DREDD, a single hole is drilled.

DREDD looks at the hole a moment.

Then down to the hole in his lower torso, from which blood is running.

Down onto his utility belt. Down his leg.

starting to pool on the tread under his boot.

 DREDD

 Damn.

A beat.

LAWGIVER EVOLUTION
Closer to the final design, but with the extra grenade launcher added again.

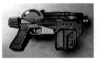 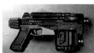 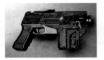 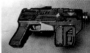 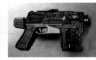 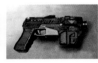 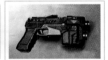

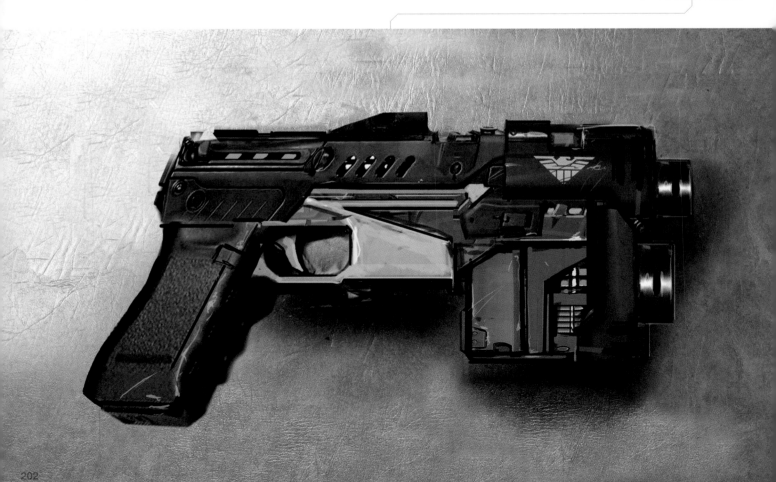

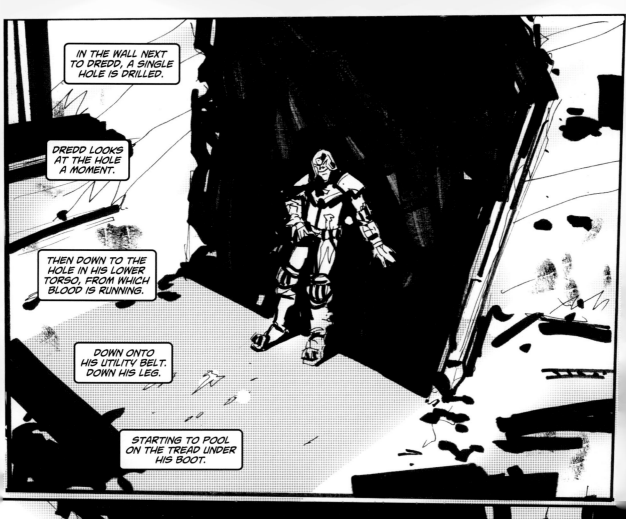

IN THE WALL NEXT TO DREDD, A SINGLE HOLE IS DRILLED.

DREDD LOOKS AT THE HOLE A MOMENT.

THEN DOWN TO THE HOLE IN HIS LOWER TORSO, FROM WHICH BLOOD IS RUNNING.

DOWN ONTO HIS UTILITY BELT. DOWN HIS LEG.

STARTING TO POOL ON THE TREAD UNDER HIS BOOT.

DAMN.

Then DREDD starts to slide down the wall.

Landing in a seated position.

And when he looks up, LEX is standing over him.

Gun trained on DREDD'S head.

A beat between the two judges.

Then:

>DREDD (CONT'D)
>
>Wait.

Beat.

LEX

'Wait'?

LEX hesitates.

>LEX (CONT'D)
>
>Are you kidding me? Did you just say: 'wait'? Judge Dredd. *The* Judge Dredd. Finally gets on the wrong end of a gun. And what he says is 'wait'.

LEX shakes his head, incredulous.

>LEX (CONT'D)
>
>You know what? I expected more of you.
>
>(hitting his stride)
>
>I mean, wait for what? Wait for me to change my mind? Wait for another two or three seconds of life, because you're so fucking weak you can't stand to see it end?

>DREDD
>
>No.

LAWGIVER EVOLUTION
A 3D render of the final lawgiver design.

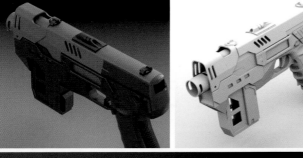

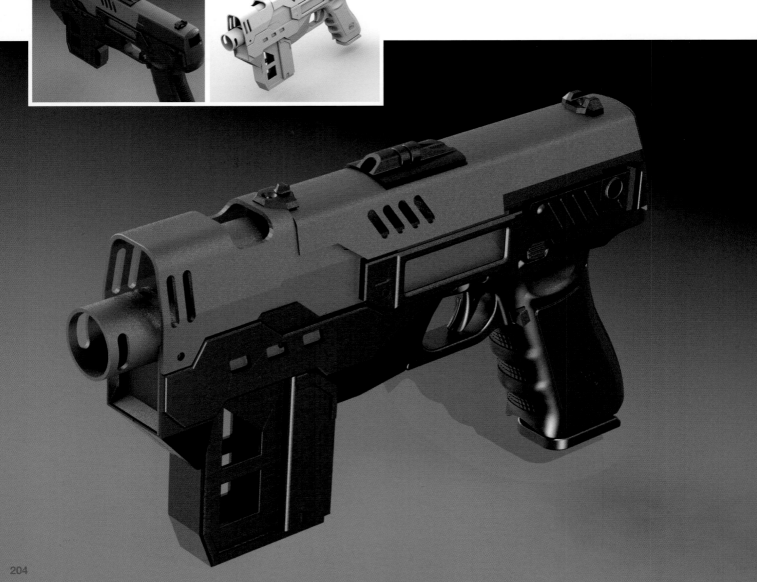

Abruptly, shockingly, LEX gets drilled with bullets.

They smash through his chest and helmet. Through his mouth and teeth.

As he drops, REVEAL ANDERSON, standing behind.

> DREDD (CONT'D)
>
> Wait for her to shoot you.

CUT TO -

- DREDD'S gloved and bloody fingers popping a pouch on his utility belt.

Pulling out a med-kit.

CUT TO -

- DREDD taking a compressed antiseptic foam canister from the med-kit.

CUT TO -

- DREDD sticking the nozzle into his bullet wound, and depressing the spray.

The wound fills with a foam, which solidifies instantly.

CUT TO -

- DREDD pulling another instrument from his utility belt. A weird little device which looks like a stapler. And pretty much is a stapler.

He holds the device up to the entry wound, and depresses it.

A small clamp punctures the flesh either side of the bullet hole, then contracts, stapling the wound shut.

CUT TO -

- DREDD taking LEX'S GUN from his dead hand.

Ejecting the clip.

Slotting the clip home into his own gun.

Then straightening.

And turning to ANDERSON.

> DREDD (CONT'D)
>
> Ready?

> ANDERSON
>
> Yes, sir.

A shared beat between then.

DREDD nods.

> DREDD
>
> You look ready.

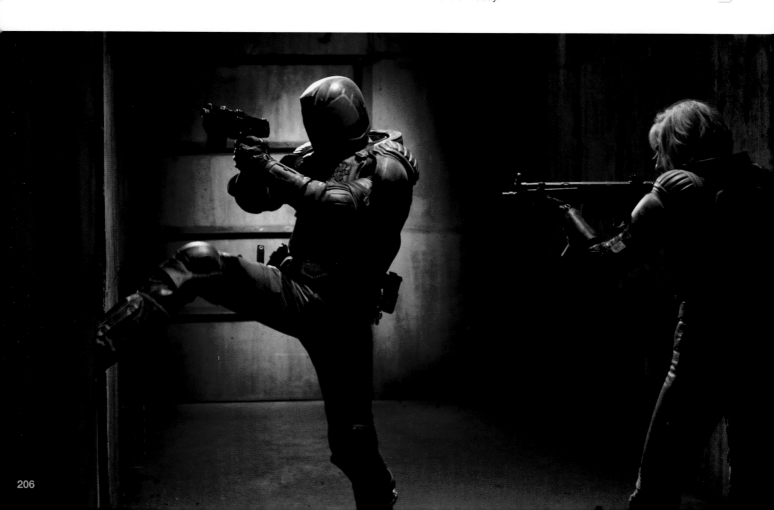

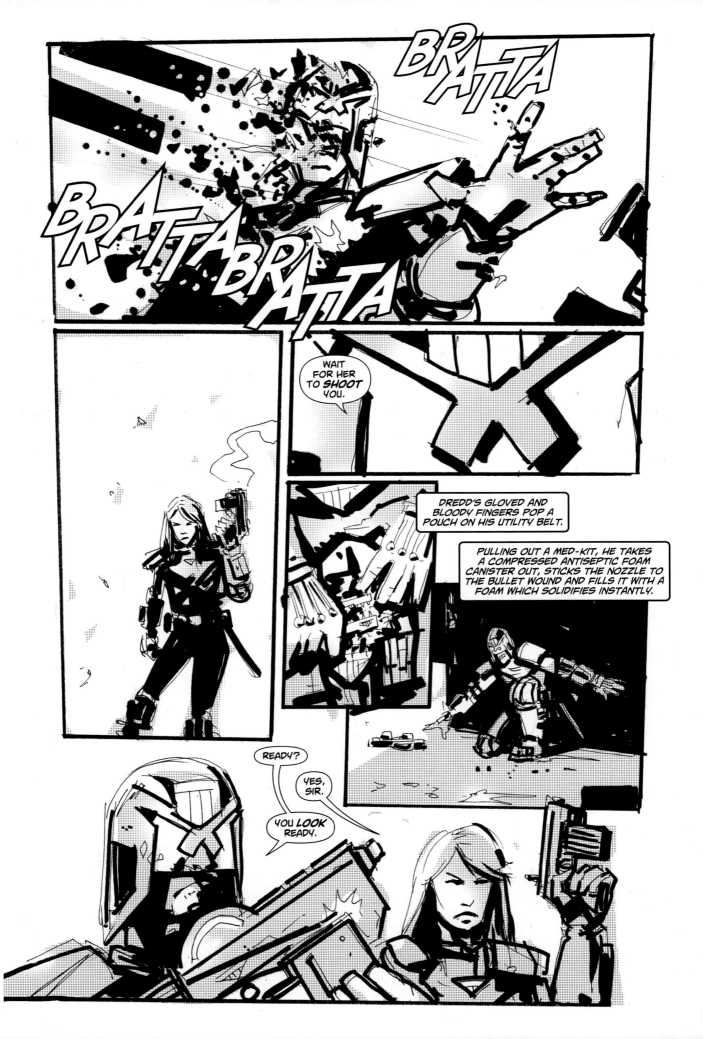

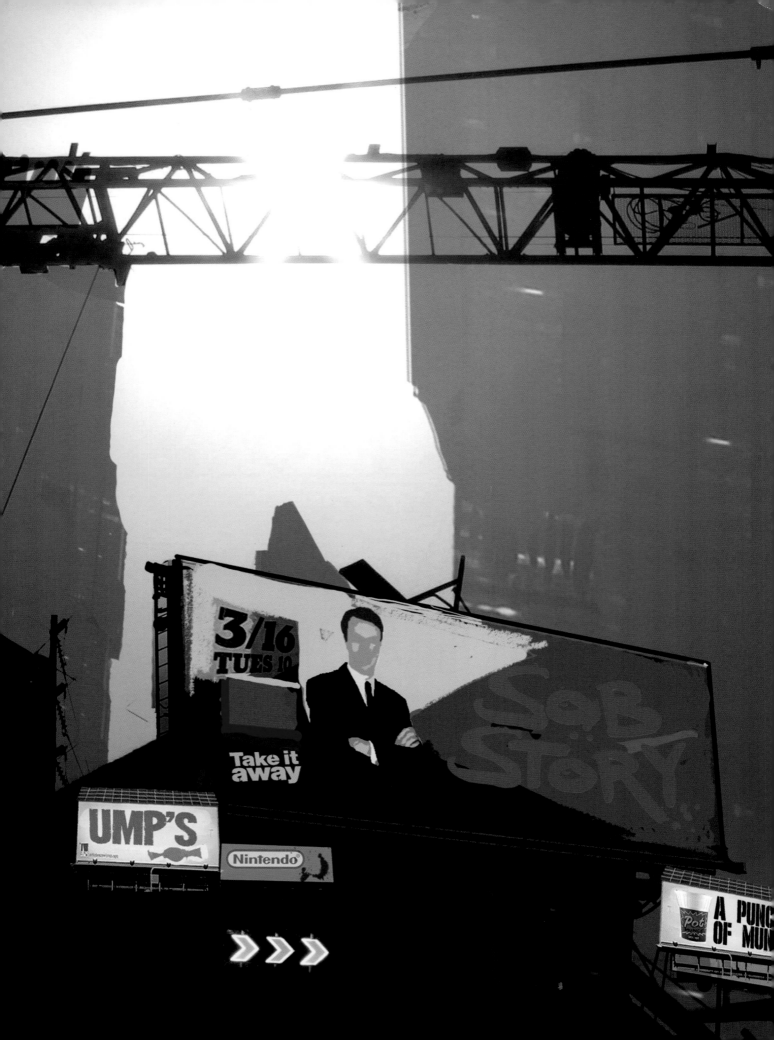

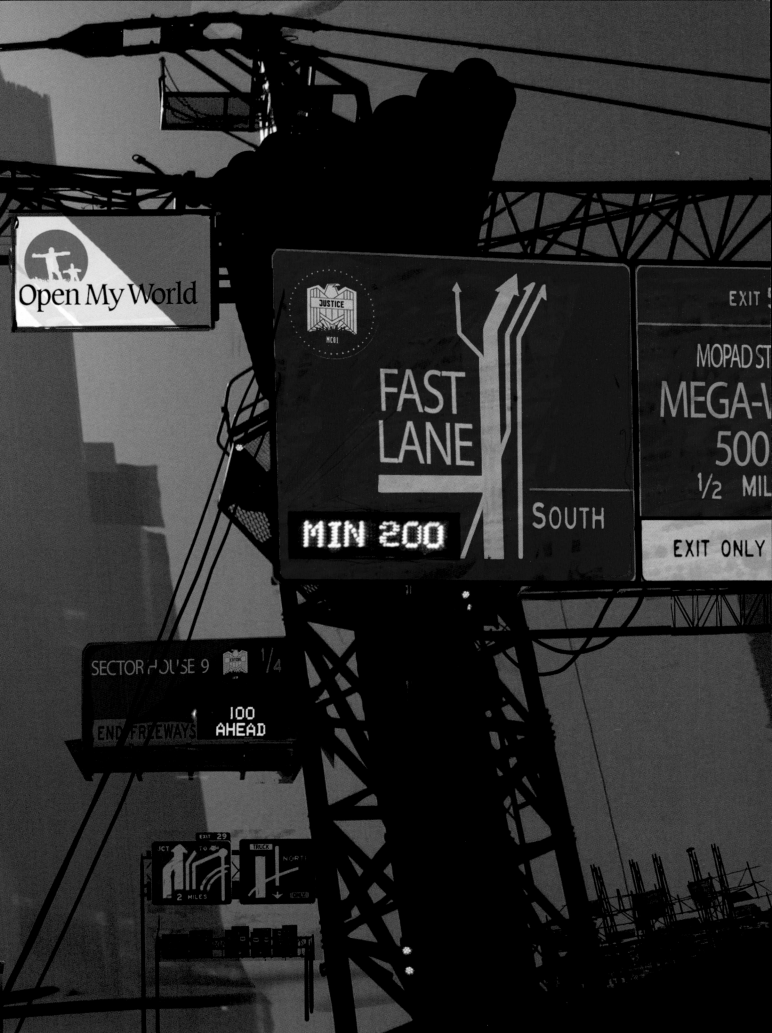

CUT TO -

INT. MA-MA'S PENTHOUSE/ENTRANCE HALL - DAY

- MA-MA'S penthouse.

In the entrance hall, eight CLAN are crouched behind cover. Guns trained at the front double doors ...

... which, a moment later, are blown open by an explosive charge.

Dust and smoke clear. And-

- nothing happens.

For a beat.

The CLAN exchange glances.

Then -

- one of the air-tank sized COMPRESSED GAS CANNISTERS is thrown into the room.

It bounces as it hits the ground.

Spinning up.

Then, in mid air, DREDD appears framed in the blown open doors, gas mask pulled down over his face ...

DREDD

Overdose.

... and fires once.

As the bullet hits the GAS CANNISTER, it explodes. And a micro second after it explodes, we go to -

- EXTREME SLOW MOTION.

Watching the metal expand. Like a kid's balloon. Rip open. Releasing an expanding cloud of shimmering iridescent gas.

Umpty Candy vending machine art and shop window designs by the Production Department.

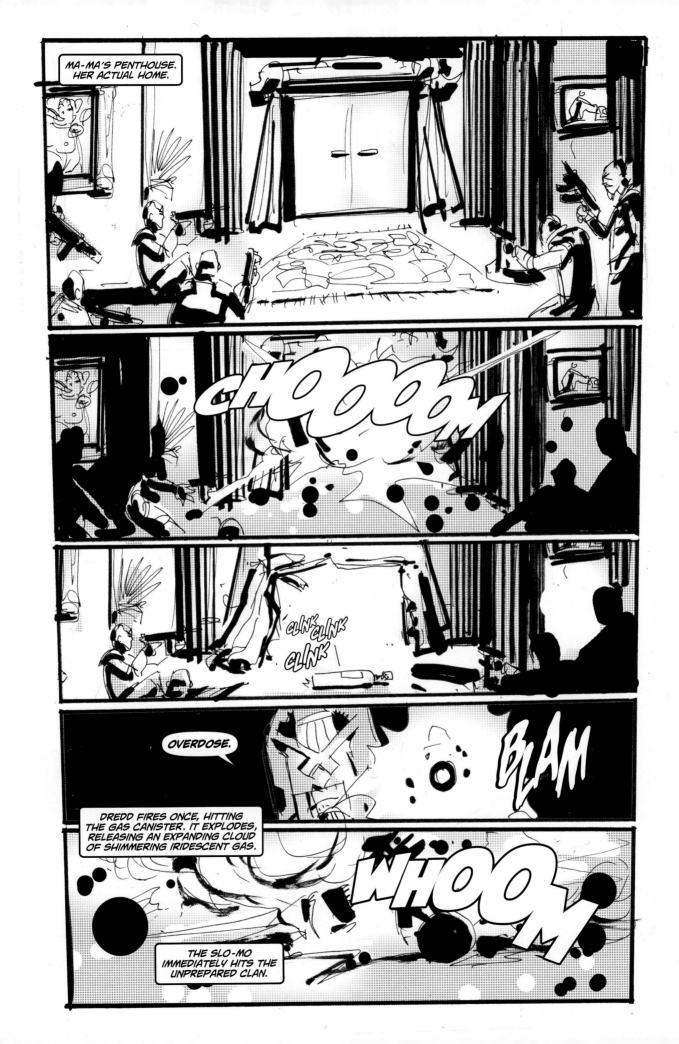

MA-MA'S PENTHOUSE. HER ACTUAL HOME.

CHOOOOM

CLINK CLINK CLINK

OVERDOSE.

BLAM

DREDD FIRES ONCE, HITTING THE GAS CANISTER. IT EXPLODES, RELEASING AN EXPANDING CLOUD OF SHIMMERING IRIDESCENT GAS.

WHOOM

THE SLO-MO IMMEDIATELY HITS THE UNPREPARED CLAN.

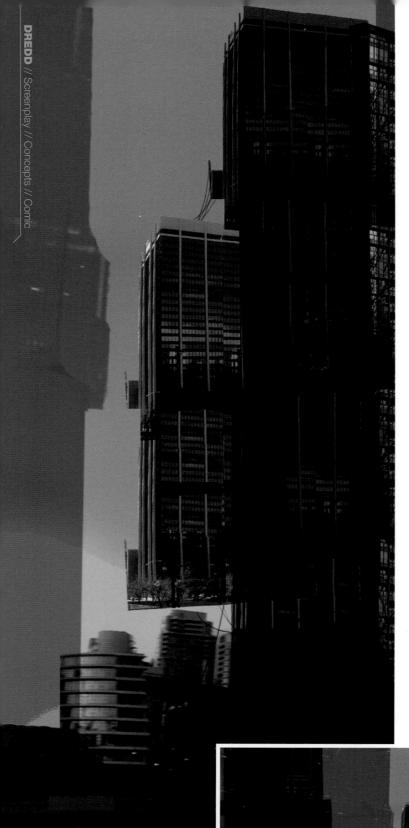

Then -

- cutting between NORMAL SPEED and SLO-MO as the GAS envelopes each of the CLAN in turn.

Becoming -

- cuts between DREDD'S unaffected POV, and the CLAN'S MASSIVELY OVERDOSED POV, where SLO-MO is almost STATIC, almost FREEZE FRAMES ...

... as DREDD and ANDERSON simply walk into the middle of the room. Side by side.

And shoot each of them in turn.

INT. MA-MA'S PENTHOUSE - CONTINUOUS

DREDD and ANDERSON are moving through the penthouse.

Cat and mouse through the space. Around corners. Through doorways.

Silence between DREDD and ANDERSON.

All hand gestures. Tension building. As they close in on a shut metal door at the end of a corridor. Beside which is a numbered keypad.

But before they reach it -

- ANDERSON suddenly turns, kicks open a side door.

Revealing the CCTV room.

INT. MA-MA'S BASE/CCTV ROOM

The room looks empty.

But ANDERSON enters, followed by DREDD. Weapons drawn.

ANDERSON straight to the bank of monitors, then reaches to the cavity underneath the console ...

... and hauls out the CLAN TECHIE.

CLAN TECHIE

Please, don't shoot, don't shoot! I'm not armed! And-

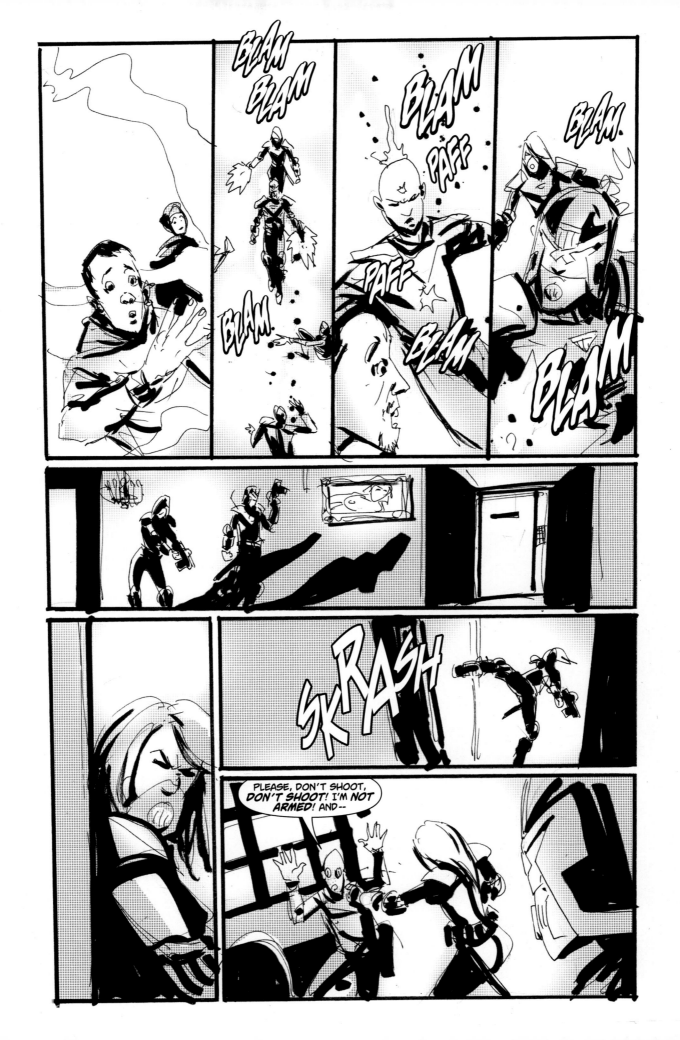

His gaze flicks between the two judges, and the guns trained on him. Sensing imminent death. Looking for the out.

CLAN TECHIE (CONT'D)

- and I can help you!

DREDD

How?

The TECHIE gestures back to the corridor outside.

CLAN TECHIE

Ma-Ma's in her private quarters - but it's behind ten inches of steel. There's no way inside without the keypad combination! And I can give it to you! I installed it myself!

ANDERSON

I don't need your cooperation to get the combination from you.

She puts her hand on the TECHIE'S shoulder to hold him steady. Then closes her eyes. Reads him.

Then -

- opens her eyes.

Frowning slightly.

But doesn't release the TECHIE.

Instead, closes her eyes, and reads him again.

CUT TO -

INT. UNDEFINED SPACE - CONTINUOUS

- inside the CLAN TECHIE'S head.

Similar to the UNDEFINED SPACE that existed inside KAY'S head.

The CLAN TECHIE and ANDERSON in the same positions relative to each other as they are in the real world, as -

- ANDERSON'S hand reaches out to touch the CLAN TECHIE'S cheek.

FLASH CUTS TO -

- the CLAN TECHIE'S memories. Key moments in his life, PLAYED BACKWARDS. Glimpsed.

IN REVERSE -

- *KAY laughing as he throws acid in the TECHIE'S face.*

- *The TECHIE (without eye implants) in an ELECTRONICS REPAIR SHOP, cowering beside the body of his FATHER, as pooled blood runs back into him, who then springs up to his feet, bullets popping back out of his chest and head, and back into the guns of the CALEB and two CLAN, who are sticking up the shop.*

- *the TECHIE sitting with his parents at home, as he watches his FATHER soldering a circuit board. The smoke curling back to the board.*

His FATHER turns and smiles at the TECHIE.

HOLD ON THIS a fraction longer than the other flashed images.

Then **CUT BACK TO -**

- the UNDEFINED SPACE.

ANDERSON with her hand cupping the face of the TECHIE.

Except the cheek she touches is that of the BOY.

Nine. Skinny. Anxious-looking.

Gazing back at ANDERSON uncertainly.

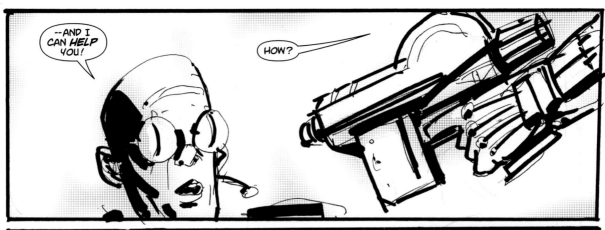

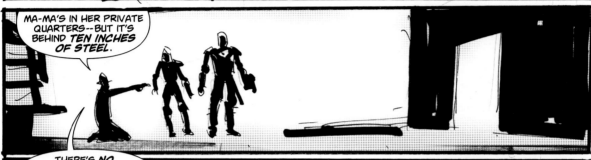

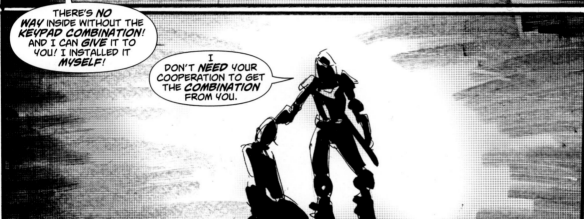

215

CUT TO -

INT. MA-MA'S BASE/CCTV ROOM - CONTINUOUS

- ANDERSON removing her hand.

Beat.

Then:

> **ANDERSON**
>
> Go.

The CLAN TECHIE doesn't understand.

> **ANDERSON** (CONT'D)
>
> You're free. Leave the block when you can and don't come back.

The CLAN TECHIE doesn't need to be told again.

He starts running, out the CCTV room, and is gone.

DREDD turns to ANDERSON.

> **DREDD**
>
> You mind explaining what you just did? Abetting a felon is not just a fail offense. It's a crime.

> **ANDERSON**
>
> I already picked up the fail when I lost my primary weapon. I'll never be a Judge, and I don't need to be a mind reader to know it.

She turns to DREDD. Stares him down.

> **ANDERSON** (CONT'D)
>
> But you haven't yet told me that. And until the assessment is formally over, I'm still entitled to dispense justice. And that's what I did: by letting him go.
>
> (to herself)
>
> Maybe that will be the one difference I do make.

She walks past DREDD.

> **ANDERSON** (CONT'D)
>
> The combination to Ma-Ma's quarters is four nine four three six. Let's finish this.

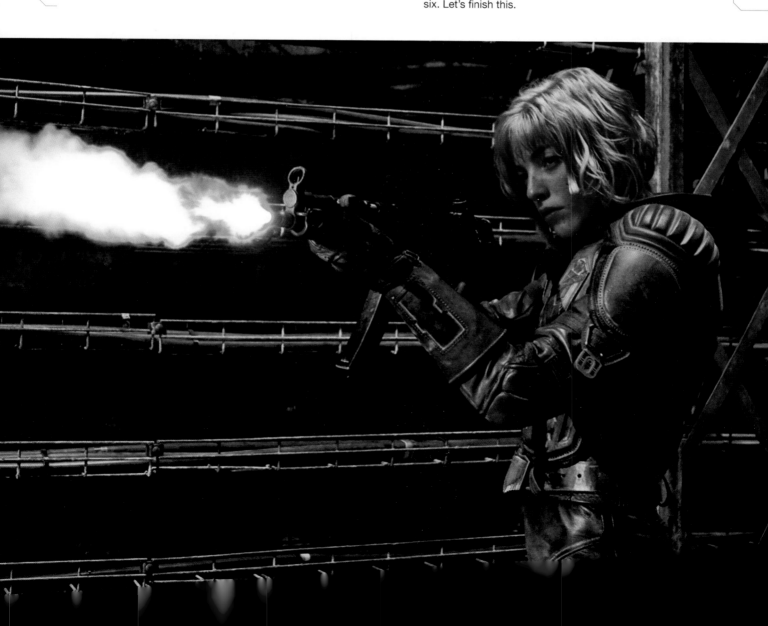

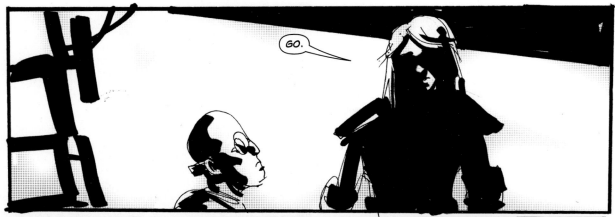

GO.

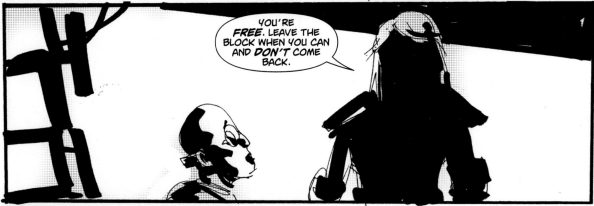

YOU'RE *FREE*. LEAVE THE BLOCK WHEN YOU CAN AND *DON'T* COME BACK.

YOU MIND *EXPLAINING* WHAT YOU JUST *DID*? ABETTING A FELON IS NOT *JUST* A FAIL OFFENSE. IT'S A *CRIME*.

I *ALREADY* PICKED UP THE AUTOMATIC FAIL WHEN I LOST MY PRIMARY WEAPON. I'LL *NEVER* BE A JUDGE, AND I DON'T NEED TO BE A *MIND READER* TO KNOW IT.

BUT YOU HAVEN'T YET TOLD ME THAT. AND UNTIL THE ASSESSMENT IS FORMALLY OVER, I'M *STILL* ENTITLED TO *DISPENSE JUSTICE*. AND *THAT'S* WHAT I DID: BY LETTING HIM *GO*.

MAYBE THAT WILL BE THE *ONE* DIFFERENCE I *DO* MAKE.

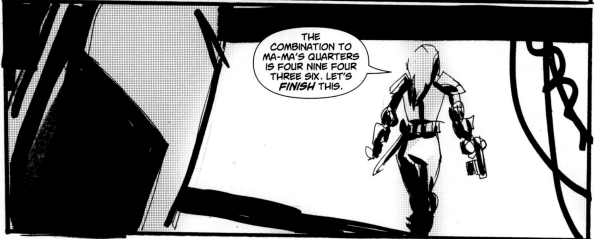

THE COMBINATION TO MA-MA'S QUARTERS IS FOUR NINE FOUR THREE SIX. LET'S *FINISH* THIS.

INT. MA-MA'S PENTHOUSE/MASTER BEDROOM - CONTINUOUS

The door to MA-MA'S bedroom bursts open.

Revealing DREDD and ANDERSON.

Opening fire on the two BODYGUARDS, who are riddled, and drop.

And when the smoke clears, we can see:

- a four poster with black silk sheets.

- a huge window, which doesn't look out over Mega-City One, but the ATRIUM. The world over which MA-MA was queen.

- beside the window, a plush daybed and coffee table, on which are piled SLO-MO inhalors.

- and on the ceiling, above the bed, a large mirror.

But no MA-MA.

Then room is empty.

DREDD and ANDERSON exchange a glance.

Enter the room, guns raised.

Sweeping.

> **DREDD**
>
> Escape route?
>
> **ANDERSON**
>
> No. She's near. But-

ANDERSON breaks off.

Then -

- looks up at the mirror.

At her own reflection.

Which suddenly -

- is drilled with two BULLET HOLES in quick succession.

ANDERSON is hit in the shoulder. As she falls backwards -

- the glass around the two bullet holes starts to splinter -

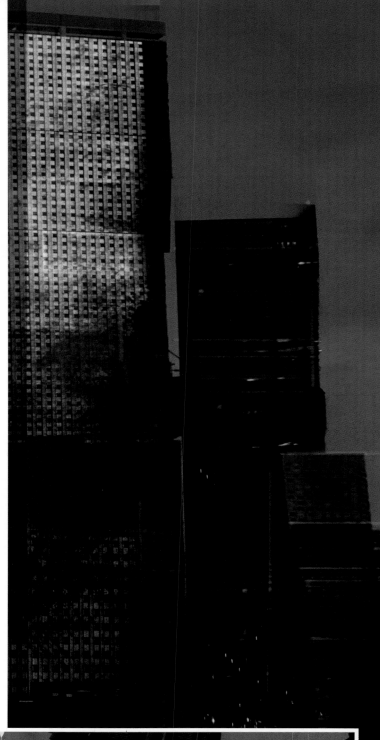

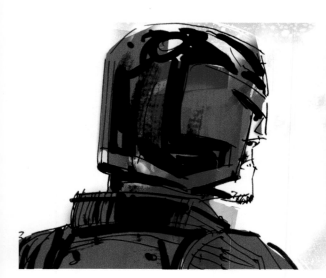

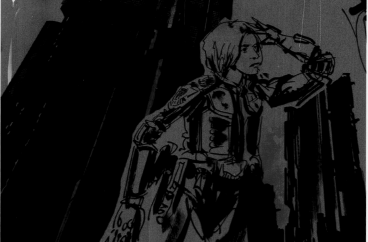

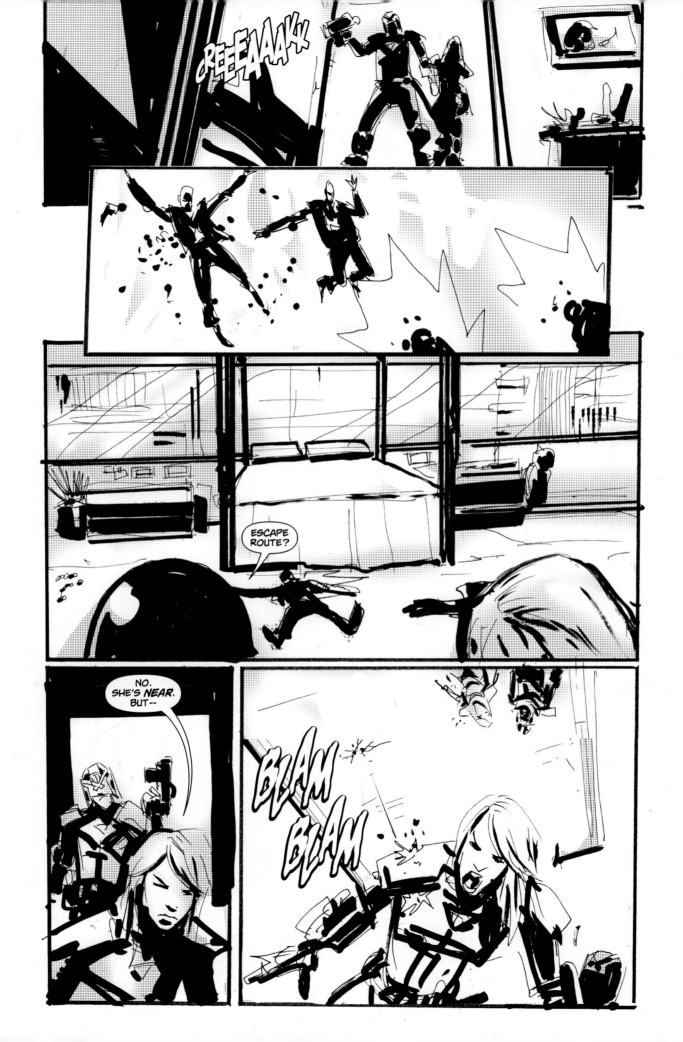

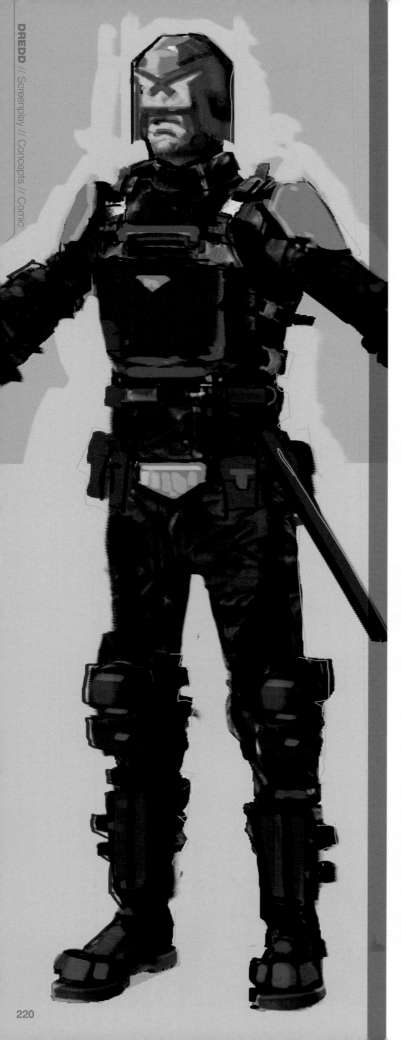

- and MA-MA drops down from above, directly in front of them.

She tries to bring her gun to bear on DREDD.

But she has no hope.

DREDD catches the barrel, twists it round, snapping MA-MA'S fingers, which are caught in the trigger guard.

Then he wrenches the gun free.

MA-MA screams, clutching her mangled hand.

DREDD tosses the shotgun.

MA-MA tries to take a swing with her unmangled fist.

DREDD dodges, neatly moving sideways.

Then sends his own fist smashing into her face.

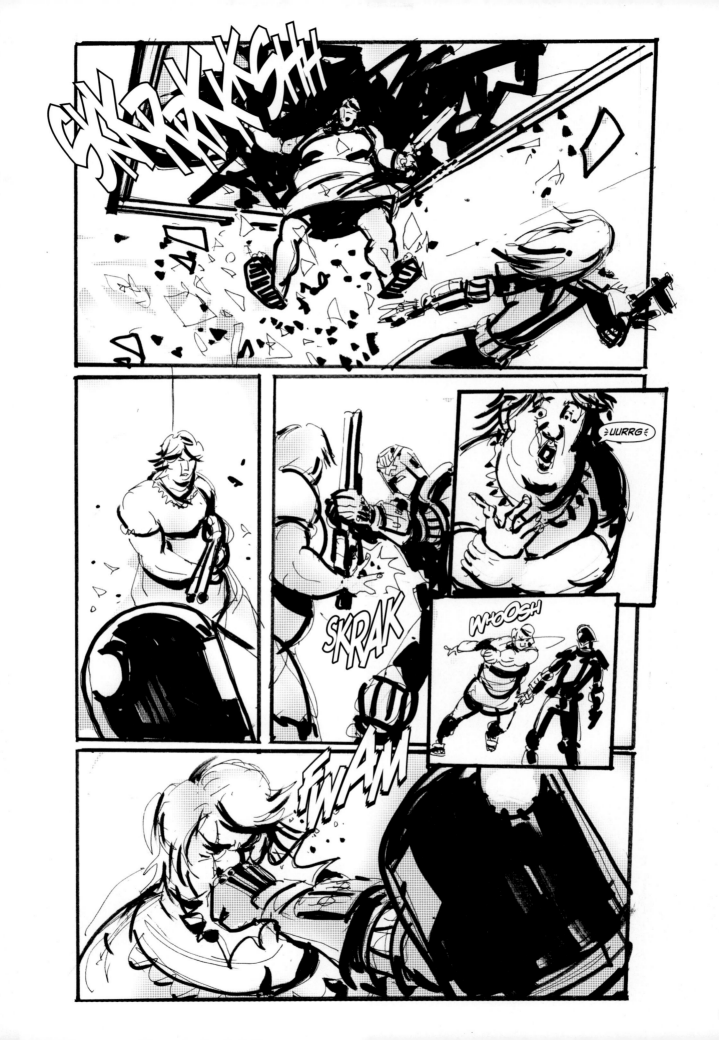

221

She staggers backwards. Towards the massive window to the ATRIUM.

He punches her again. Same blow, right hand, full in the face.

She staggers back more.

Stops against the glass.

DREDD looks at her a beat.

Then leans down. picks up a SLO-MO inhaler from the coffee table.

And JAMS IT in her mouth.

As he depresses the button:

> **DREDD**
>
> Citizen Ma-Ma. Your crimes are multiple homicide, and manufacture and distribution of narcotics. How do you plead?

MA-MA can't answer. So much gas is being pumped into her that we can see it escaping through the sides of her mouth and nose.

> **DREDD** (CONT'D)
>
> Defense noted.

He tosses the inhaler.

Then punches her one last time.

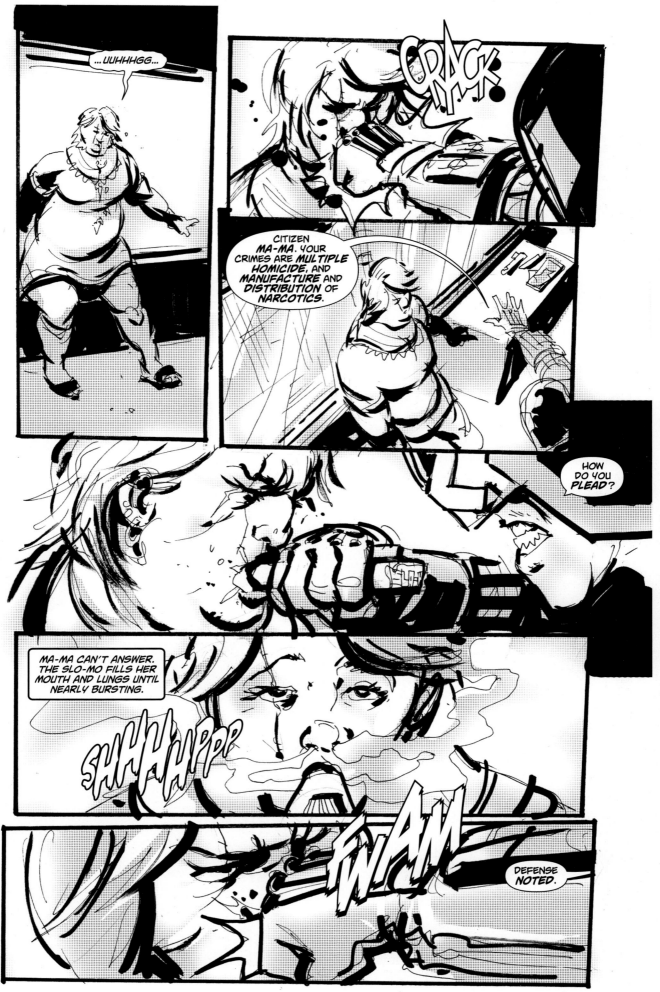

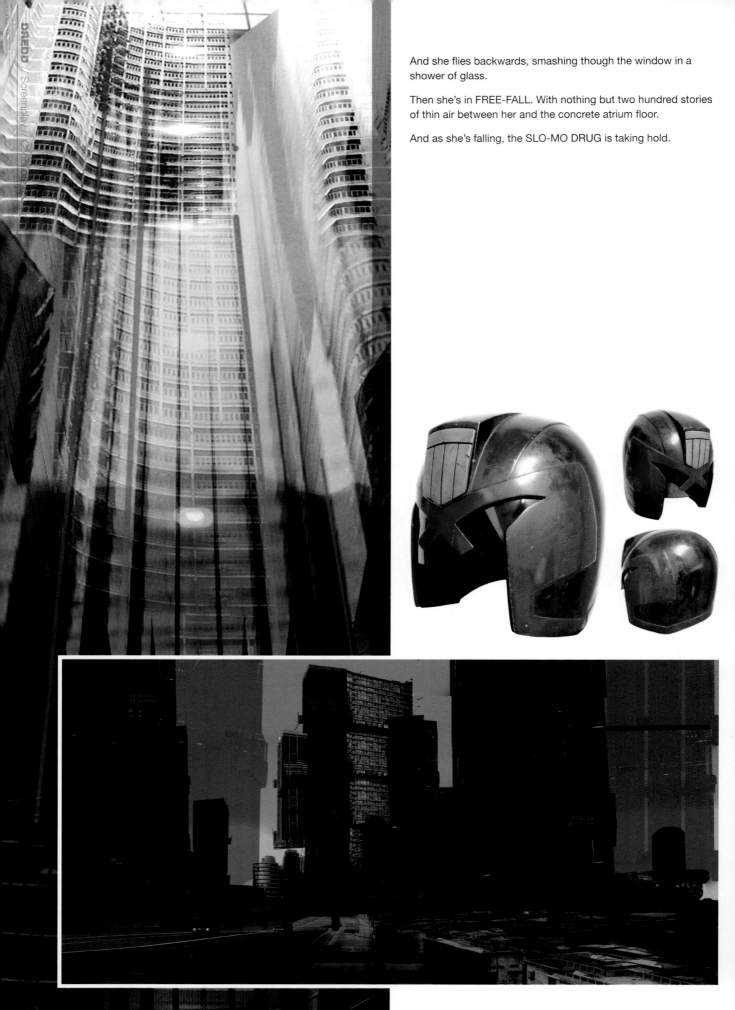

And she flies backwards, smashing though the window in a shower of glass.

Then she's in FREE-FALL. With nothing but two hundred stories of thin air between her and the concrete atrium floor.

And as she's falling, the SLO-MO DRUG is taking hold.

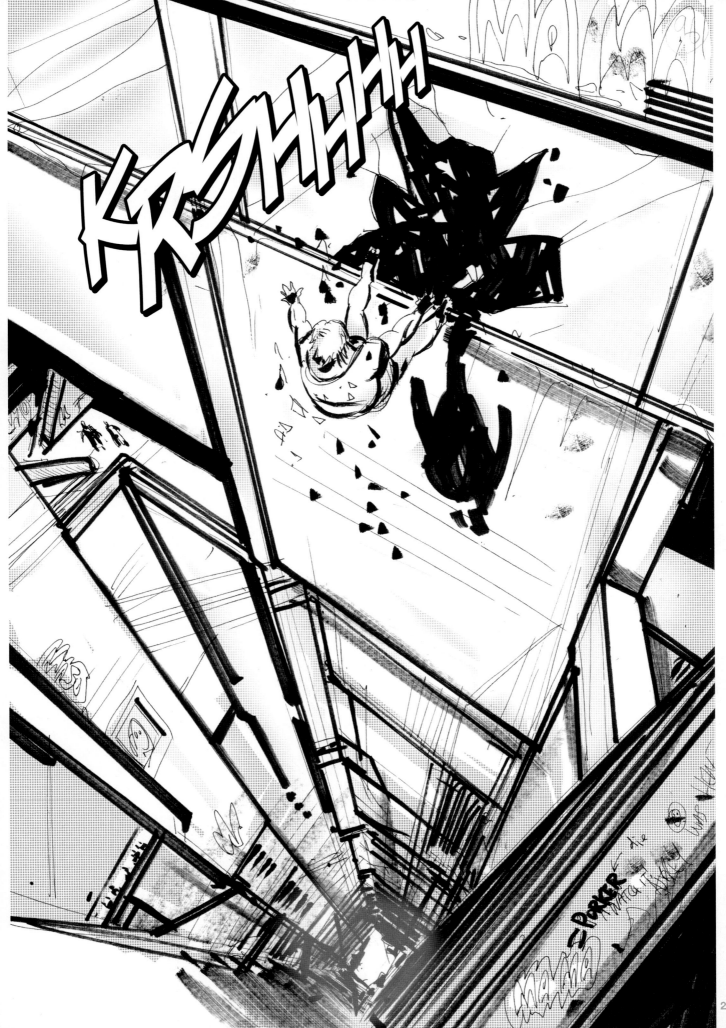

INT. ATRIUM - CONTINUOUS

BEAUTIFUL WEIRD FREE-FALL SEQUENCE.

Looking up at the fire blazing around level 190.

Through the smoke and flames, MA-MA drops, punching a hole in the smoke with the turbulence from her massive body.

All seen in the grip of the drug.

Watching the balconies drift past.

The surprised faces of the block citizens watching.

FLASH CUT TO -

- REAL-TIME, from the POV of the people on the balconies, as MA-MA zooms past.

FLASH CUT TO -

DREDD leaning over ANDERSON'S bloody body in the penthouse bedroom.

Her skin is pale. The blood is scarlet.

Her eyes are closed.

DREDD leans closer.

Their lips touch.

He is giving her the KISS OF LIFE.

CUT BACK TO -

- SLO-MO of MA-MA'S continuing fall.

The fat woman screaming.

More faces of citizens on the balconies.

Watching MA-MA'S literal fall from grace.

CUT TO -

DREDD pulling back.

ANDERSON'S eyes opening.

CUT TO -

MA-MA.

Alone.

Looking down, just as she -

- hits the ATRIUM floor.

Head first. Very slowly.

Hypnotic to watch ...

... her skull crushes, flattening.

And the rest of her massive body follows.

As the body is slowly pulped, **GO TO -**

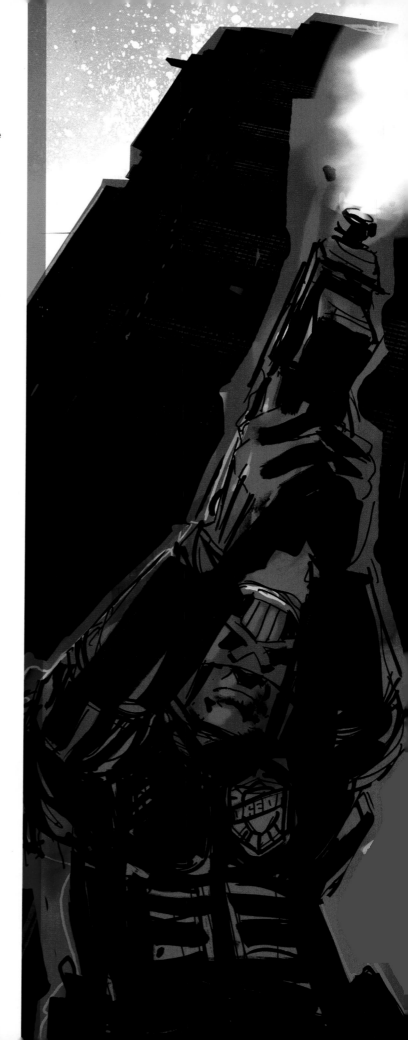

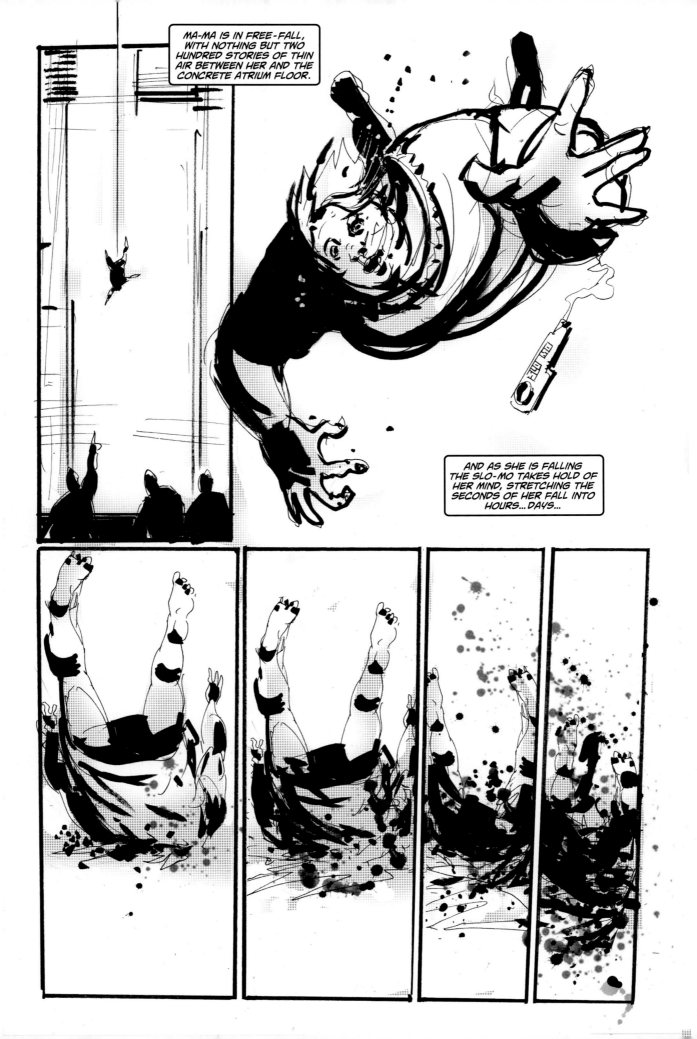

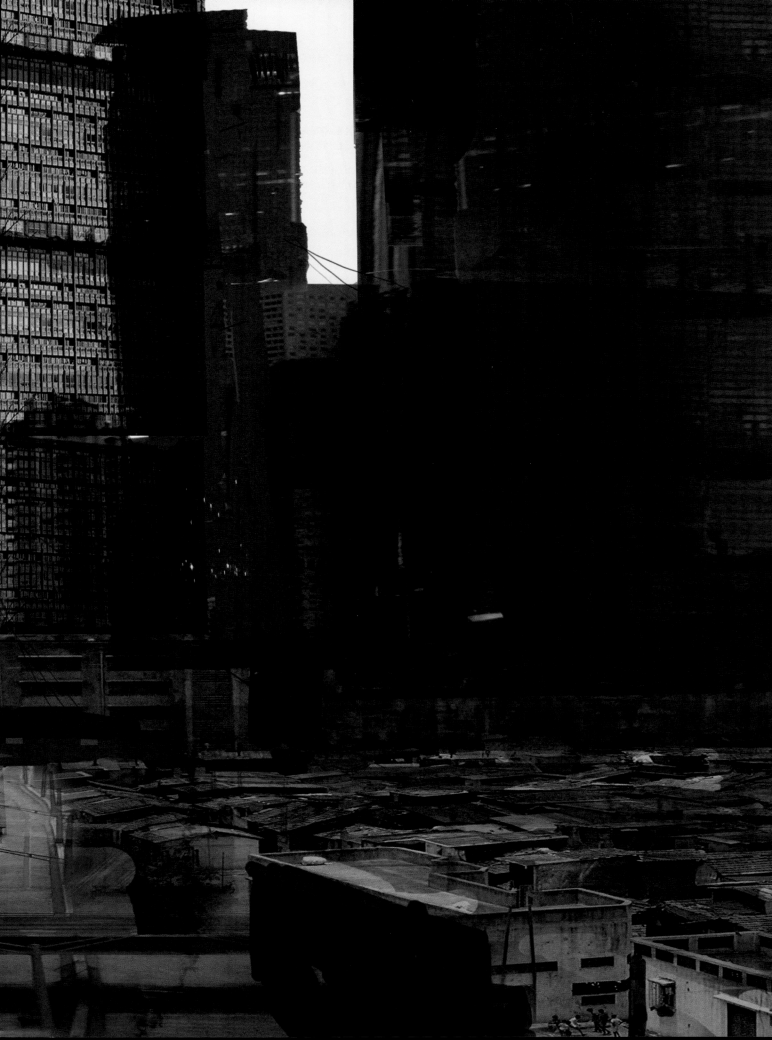

EXT. MEGA-CITY ONE - SUNRISE

- the sun rising over the city.

EXT. PEACH TREE BLOCK/SOUTH ENTRANCE - CONTINUOUS

The CHIEF JUDGE stands with a team of men with oxyacetylene torches, who are trying to cut through the massive blast doors.

Behind are MEDICS and an AMBULANCE.

Then ABRUPTLY the blast doors start to rise.

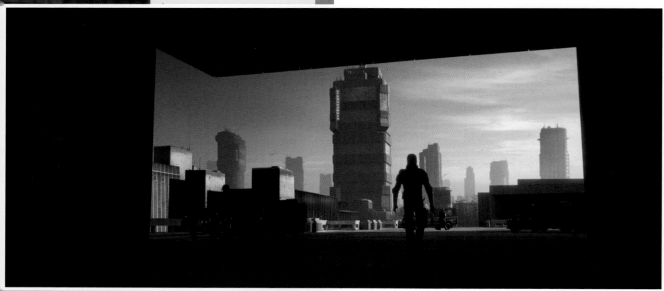

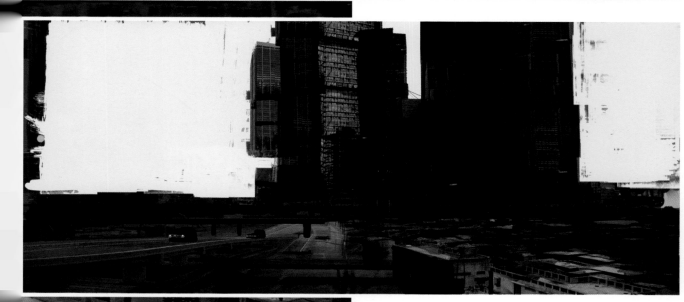

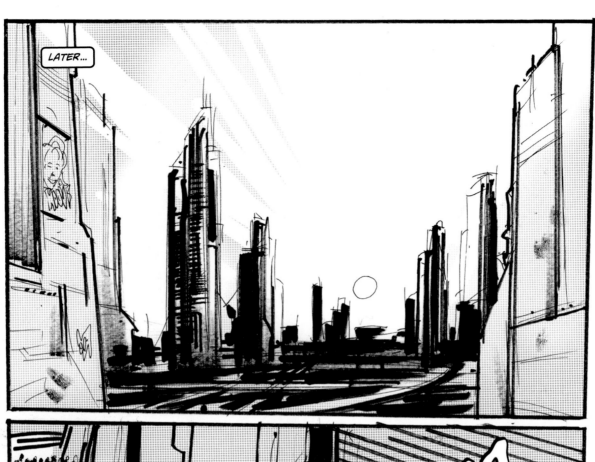

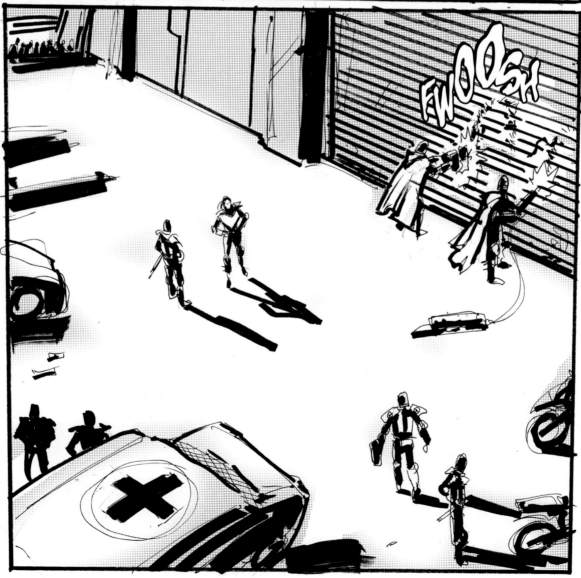

231

INT. PEACH TREE BLOCK/SOUTH ENTRANCE - CONTINUOUS

DREDD and ANDERSON stand side by side as the doors rise.

Both bloodied, both wounded, both standing independently.

In silence.

Then DREDD turns to ANDERSON.

> **DREDD**
>
> Your assessment is now over.

A beat.

Then ANDERSON unclips her ROOKIE badge, and hands it to DREDD.

DREDD looks at it.

But says nothing.

CLUNK.

The doors are fully open.

ANDERSON starts walking away from DREDD.

EXT. PEACH TREE BLOCK/SOUTH ENTRANCE - CONTINUOUS

DREDD follows ANDERSON out, into the throng of medics and Judges.

The CHIEF JUDGE approaches DREDD.

> **CHIEF JUDGE**
>
> When I heard you'd called a 10-24, thought I'd better check it out. Seeing as I forced the rookie on you.

She looks up at the MEGA BLOCK.

> **CHIEF JUDGE** (CONT'D)
>
> What happened in there?

> **DREDD**
>
> Drugs bust.

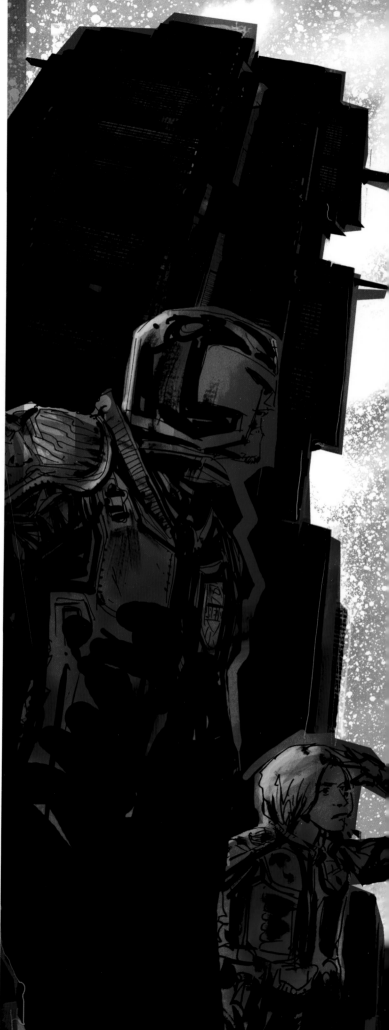

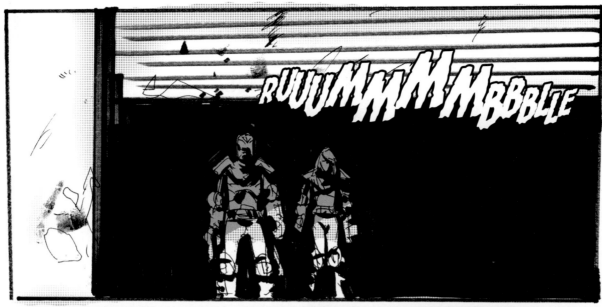

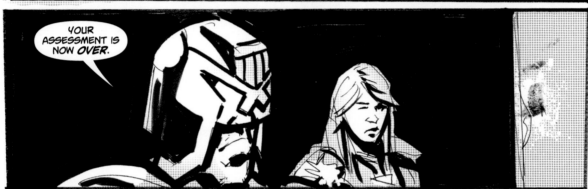

YOUR ASSESSMENT IS NOW *OVER.*

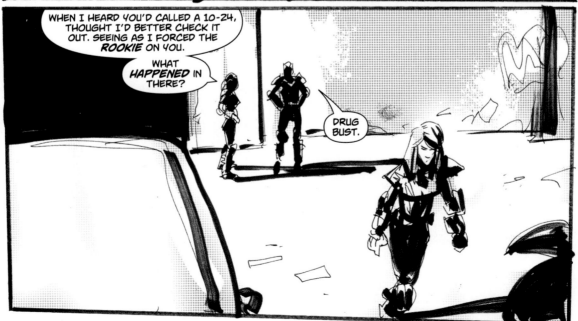

WHEN I HEARD YOU'D CALLED A 10-24, THOUGHT I'D BETTER CHECK IT OUT. SEEING AS I FORCED THE *ROOKIE* ON YOU.

WHAT *HAPPENED* IN THERE?

DRUG BUST.

CHIEF JUDGE

You look like you've been through it.

DREDD

Perps were uncooperative.

CHIEF JUDGE

Aren't they always?

The CHIEF JUDGE nods to where ANDERSON is being treated by the MEDICS.

CHIEF JUDGE (CONT'D)

So how did she do? Is she a pass or a fail.

On DREDD.

Looking towards ANDERSON.

As DREDD watches, two MEDICS approach her -

- and she brushes them away.

Then, underplayed:

DREDD

A pass.

The CHIEF JUDGE nods.

CHIEF JUDGE

Knew she would be.

PULL BACK from the scene.

ANDERSON entering an ambulance.

JUDGES entering PEACH TREES, where sunlight is punching back into the darkness as the roof shields reopen.

The CHIEF JUDGE looking up at the monolithic mega block, where a holographic peach tree flickers.

And DREDD walking back to his bike alone.

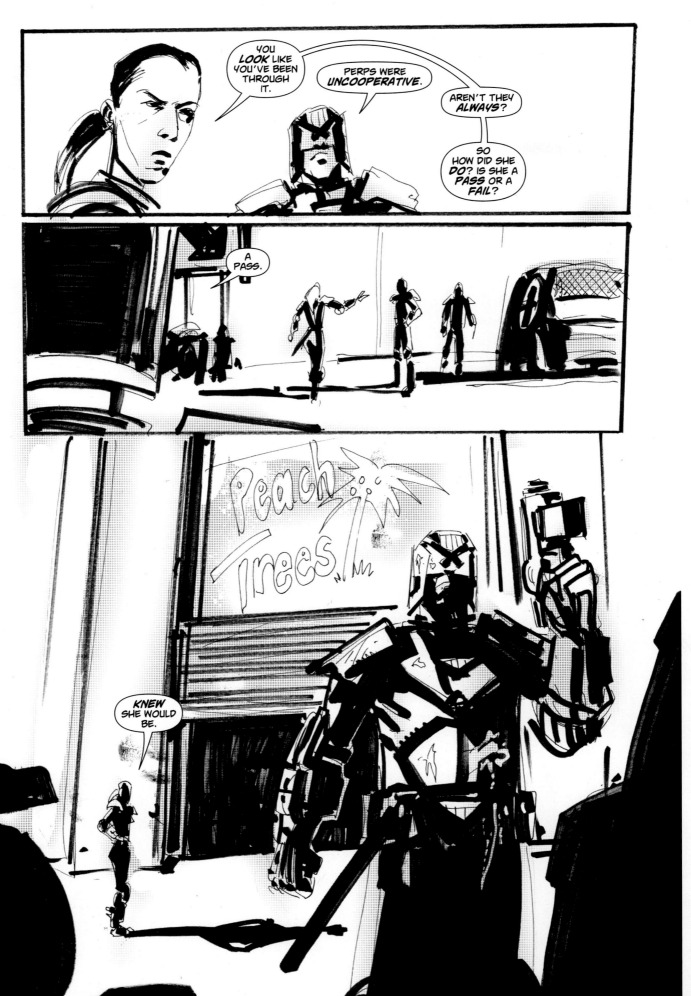

FADE IN -

CONTROL

(over radio)

All responders in vicinity of sector five leisure complex, we have weapons fired in Astro-dome. Four suspects on foot ...

CONTROL (CONT'D)

(over radio)

Suspect wanted in connection with three judge slayings seen leaving in dark coloured vehicle, heading for north boundary road ...

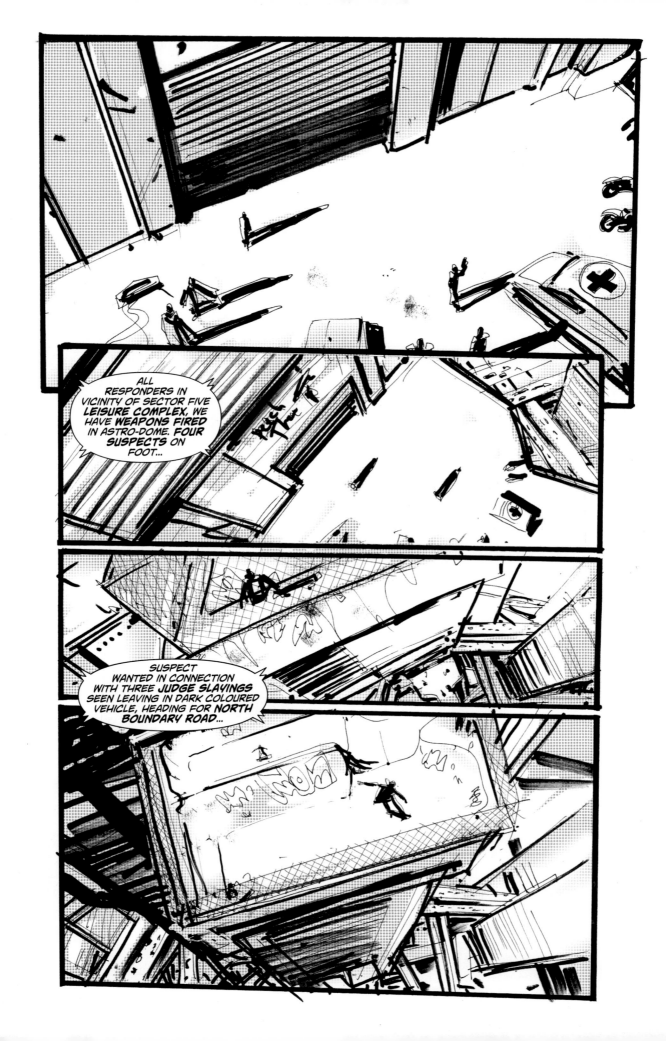

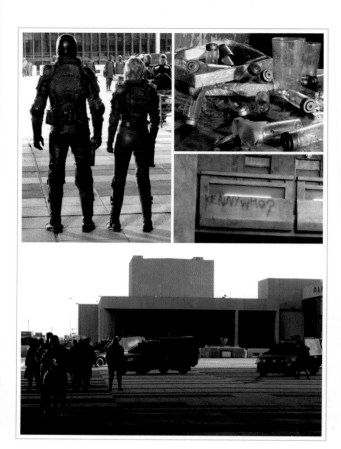

CONTROL (CONT'D)

(over radio)

Responders needed in sub-sector twenty, flyover five. Block riot has spread east. Judges on the ground requesting immediate support...

THE END

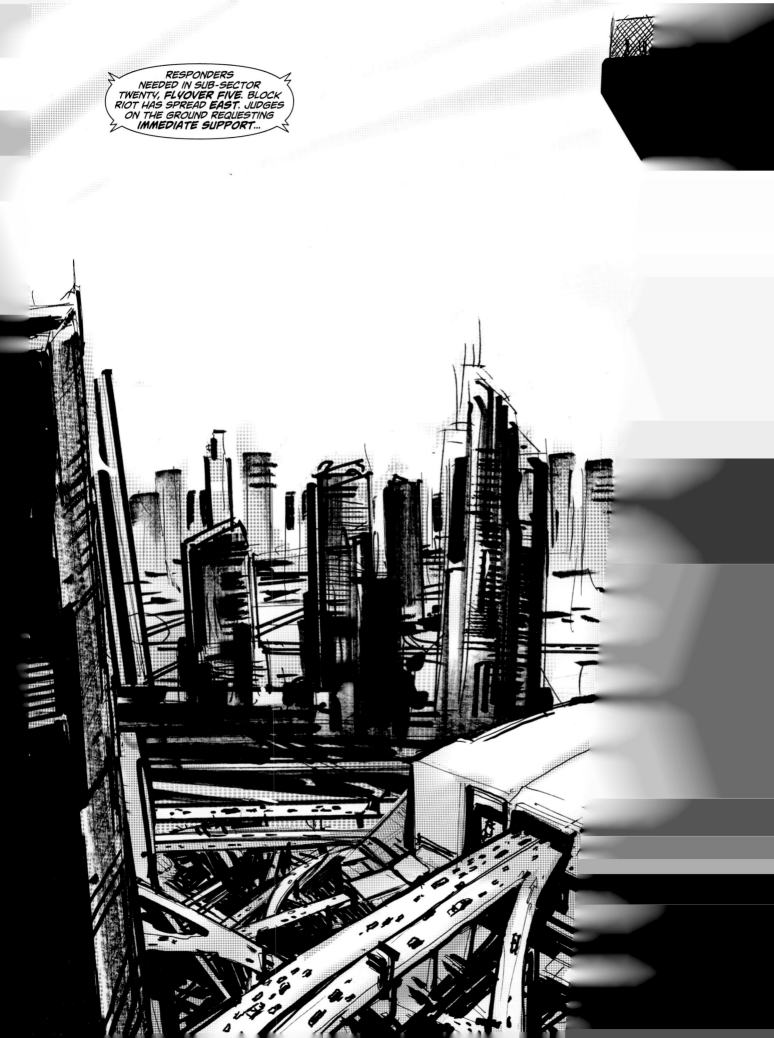